UNMASKED

ALISON POLLET

POCKET
BOOKS

books

NEW YORK LONDON TORONTO SYDNEY SINGAPORE

Special thanks to:

Vice President, Creative Affairs for Bunim/Murray Productions
Scott Freeman

Amaya, Kasey Barrett, Brian Blatz, Liz Brooks, Mary-Ellis
Bunim, Tracy Chaplin, Avery Cobern, Joyce Corrington, Ryan
Cummings, Judith Curr, Danny, David, Tod Dahlke, Twisne
Fan, Lisa Feuer, Flora, Dawn Garcia, Mike Glazer, Benjamin
Greenberg, Michelle Gurney, Penny Haynes, Russell Heldt,
Greer Kessel Hendricks, Andrew Hoegl, Erin Hogan, Jacob
Hoye, Jamie, Lauralee Jarvis, J.P. Jones, Julie, Justin, Kaia, Jeff
Keirns, Kelley, Kate Keough, Alaina Killoch, Matt Knickerbocker
(Fugi), Leif Knyper, Bob Kublios, Andrea LaBate Glanz, Rob
LaPlante, Suzanne Leichter, Tara Major, Jimmy Malecki, Matt,
Melissa, Melissa (Miami), Marlo Messina, Michelle Millard,
Glenn Morgan, Laura Murphy, Jonathan Murray, Donna O'Neill,
Ed Paparo, Paul Paparo, Paul, Peter, Rachel, Mark Raudonis,
Ruthie, James Sartain, Sean, Mahta Shafieha, Charlotte
Sheedy, Lisa Silfen, Robin Silverman, Donald Silvey, Jonathan
Singer, Lindsay Singer, Dave Stanke, Liate Stehlik, Stephen,
Angie Tarantino, Julie Taylor, Teck, Van Toffler, Rodger
Weinfeld, Kara Welsh, Maggie Zeltner.

Book design by EPHEMERA, INC.

An *original* publication of MTV BOOKS/POCKET BOOKS

POCKET BOOKS, a division of SIMON & SCHUSTER, INC.
1230 Avenue of the Americas, New York, NY 10020

ISBN: 0-7434-1127-7

First MTV Books/Pocket Books trade paperback
printing November 2000

10 9 8 7 6 5 4 3 2 1

Photo Credits:

Jimmy Malecki: front and back cover; pages 4 (bottom), 7, 9,
11, 12, 14, 15, 19, 21, 23, 24, 26, 27, 31, 32, 43, 45, 48, 50,
52, 53 (top), 54, 55, 58, 61, 62,.66, 68, 73, 77, 78, 81, 84,
86, 88, 93, 96, 100, 101, 102, 104, 107, 108, 109, 110 (top),
134, 138, 143, 147, 149, 151

Rob LaPlante: pages 69, 75, 80

Images of Belfort courtesy of Richard Sexton: pages 110-112

Images of *The Real World* Reunion 2000 courtesy of Clint
Karlsen/ImageDirect: pages 114-115, 118-119, 120-121

Image of Sean (page 127) courtesy of Dietrich Gesk

Image of Rachel (page 126) courtesy of Jonathan Ressler

Image of Rachel and Sean (page 124) courtesy of Coryn
Murphy

Images of *The Challenge* courtesy of Marc Serota: pages
122-123

Images of *The Challenge* courtesy of Angie Tarantino, Rick
Cummings: pages 145-146

Candids very kindly provided by: The cast of *The Real
World–New Orleans, The Real World–Hawaii,* Rachel, Sean,
Flora, Melissa, staff of Bunim/Murray Productions

All the cameras, film, and processing for the cast and crew
are courtesy of FUJI.

CONTENTS

Four Questions for Mary-Ellis Bunim and Jonathan Murray, Creators of *The Real World*

1. How does the New Orleans cast differ from its predecessors?

Mary-Ellis Bunim: Each season is defined by the cast members that we choose. This season, we sought out cast members who had issues we hadn't yet encountered.

For example, Julie, with her base in Mormonism, was forced to challenge herself without compromising her values. She managed to get through the season and learn a lot about herself. And Danny—who, incidentally, gets an exceptional amount of fan mail—had an interesting story, as he had only recently came out. Of course, the story of his relationship with military boyfriend Paul ended up being incredibly poignant. And, of course, we could only tell their story if we protected Paul's identity.

Jonathan Murray: How is this cast different? Well, let's see, they're wearing more clothes! Just joking! But, truthfully, it's very different from the Hawaii season. I think some casts derive their power from being outrageous and some from being relatable. I'd say this cast was very relatable to viewers. I think for that reason it's getting equally high ratings as the Hawaii season.

2. Next year *The Real World* will return to New York for its tenth year. How long do you see the show continuing?

Mary-Ellis Bunim: *The Real World* is reinvented every year with new people and new stories. There's no reason to believe it won't be around a long time.

Jonathan Murray: As long as we can keep it fresh, we'll keep doing the show. If people stop watching and it stops getting interesting, we won't drag it out just to keep it on the air. But, all the show does from year to year is increase in ratings. It's the number one show on MTV and one of the top ten shows on cable. Each year it finds a new audience.

3. What do you think of the reality TV trend? Is *The Real World* responsible?

Mary-Ellis Bunim: Well, what took everybody so long? We knew this was the next frontier for television programming a long time ago! And, frankly, even with the success of *The Real World,* we've had trouble convincing the networks about the viability of reality programming. It took the success of some shows in Europe to make a difference. I don't think we've scratched the surface of what reality television can offer viewers.

Jonathan Murray: I think it's safe to say *Survivor* took some tips from us. But, we'd like to borrow something from them—their ratings! Ultimately, the reality craze has turned out great for us. Because of the success of *Survivor,* buyers are much more open to reality programming. We have a new show about single people on a cruise ship and a show in development that involves young journalists starting up an Internet magazine in New York.

4. Any news on next year's *The Real World* ?

Mary-Ellis Bunim: Well, we start casting just after Labor Day. We'll be all over the country doing open calls. People should check out our Web site (www.bunim-murray.com) for information.

Jonathan Murray: And there's also a new challenge that will start airing this winter. It's called *The Extreme Challenge,* and it's filmed in the U.S., Canada, and Europe. We can't say who's on it, but yes, maybe, some members from the New Orleans cast are there!

MATT

You know what I think is unfortunate? I think that some people in the house are proud. In fact, I think they're too proud to be totally honest in the book. Out of pride, they will still hide things. I hope they don't. This book is the chance to clear things up.

I was the only one in the house who would admit I liked watching *The Real World*. Before I moved to New Orleans, I was a fan of the show—obsessed style. I'd watch marathons two times over. I used to love to sit in front of the TV and scream at it. Now having done the show, I think: "Oh my God, did I pass a lot of judgment!" I would just sit there and scream at Amaya and Kaia to get over themselves! It was sick. It's weird to be the same as them in terms of celebrity status, because thinking of them makes me feel star-struck. Especially Amaya. She was brave as hell to show it and tell it like it is. I did the same thing. I made it a point to show every flaw I have. I want the whole story to be told.

As a viewer, I used to wonder how anyone could bitch while living in a mansion. Now I realize that though we have a mansion with really cool rugs and furniture, we don't have a job to which we're committed; we don't have obligations. What we have is way too much time to think. And that's when the drama starts. ⚜ Do cameras alter how you behave? Well, camera crews alter how you behave. At 2:00 A.M., my favorite crews were on, and I knew they must have been bored. I mean, all they'd done that night was follow us to yet another coffee shop. I couldn't stop myself; I'd have to perform for them. I'd be cracking jokes and watching their faces turn purple, looking like they had to pee. I would tell them all these things I'd figured out about them. They were totally amazed at the stuff I pulled out! I figured out that one of them had just gotten married, and that one of them was a chain-smoker! Even though they can't talk to us, they can't hide everything! ⚜ I was particularly self-conscious around the cameras at bars. That's because of Ruthie. I was so scared that throwing drinks back would become part of my story. And it didn't help that on more than one occasion during my time in New Orleans, I'd be at a bar drinking a daiquiri, and somebody would scream "Ruthie!" There I was, acting totally normal, and people were screaming *"Real World* Ruthie" at me. It was absolutely annoying. There were times when I shunned alcohol as a result of Ruthie. I know that's ridiculous, but it seemed like these people lumped us together—two brown girls, you know! ⚜ One thing I learned in New Orleans is that I can no longer live somewhere that's not a melting pot. In Tampa, I'm a freak who's stuck. I'm Little Baby Jessica. But, in New Orleans, I saw people who looked like me. I was normal in the French Quarter! In New Orleans, I realized that if I'd grown up around people of mixed races, my life would be totally different. Where I'm from, there was racism on all fronts. ⚜ I grew up in the South, where kids always teased me. They'd whisper that my dad was black and my hair was big and my lips were big. They'd call me Blasian and Mutt. For a long time, I had no idea who I was. My parents taught me just to think I was

It's horrible to be picked on. I hope that if there are girls like me out there, girls who are getting picked on, that they see me and get some hope. I never wanted to be thrown into this life as a role model, but if I have something to say it's this: if the little girl with the buckteeth and the frizzy Afro with the funny mom and weird dad recovered from being a basket case, so can you.

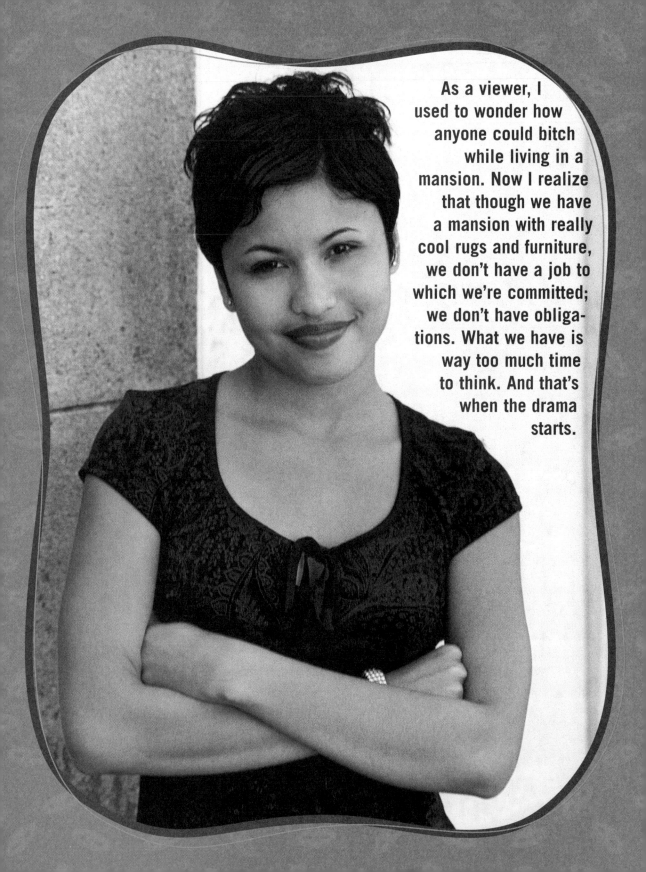

As a viewer, I used to wonder how anyone could bitch while living in a mansion. Now I realize that though we have a mansion with really cool rugs and furniture, we don't have a job to which we're committed; we don't have obligations. What we have is way too much time to think. And that's when the drama starts.

I'D LIKE VIEWERS TO SEE ME AS...

Melissa: I hope people see that I'm silly, and that I can be very, very funny. I eat conflict up for breakfast, lunch, and dinner, but I'm still that silly Melissa. I hope viewers don't confuse my honesty with bitchiness. If you lie to yourself on *The Real World,* you're going to be lying to the whole world. So I worked really hard to be honest.

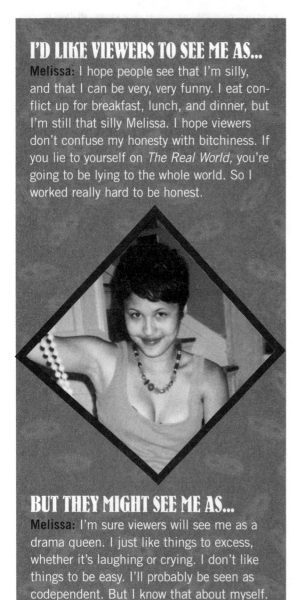

BUT THEY MIGHT SEE ME AS...

Melissa: I'm sure viewers will see me as a drama queen. I just like things to excess, whether it's laughing or crying. I don't like things to be easy. I'll probably be seen as codependent. But I know that about myself.

Melissa, and not to look for an identity beyond that. My mother has a third-grade education; she's barely Americanized. My dad has no college education, and is all military. I was practically a prodigy. I was in gifted classes with all white kids. I felt alone all the time.

I learned to get by with humor, and not to get upset in front of people. The depression that viewers see me go through on the show is rooted in the fact that I could never cry. Looking back on it now, I'm actually happy

about where my childhood and teenage years took place. I think it hardened me, but I think it also taught me to take good from bad. If I'd had more money growing up, if I wasn't biracial, I don't know where I'd be, where my strength was coming from. Those things make me who I am.

What will most shock your friends and family?

Melissa: My bout with depression. Usually I'm Melissa on ten. I walk into a conversation and think I can run things. I had a nervous breakdown in New Orleans, and couldn't take the show anymore. My friends and family will be shocked to see it.

How do your friends on *The Real World* compare to your friends at home?

Melissa: My friends on *The Real World* are friends I would never seek—a wealthy frat boy, a naive Mormon girl. What the??? My friends at home are into the same things I am, and I seek them out for that reason. On the show, you're forced to deal with people about whom you know nothing.

CREW VOODOO

Mary-Ellis Bunim: This little bundle of kinetic energy is going to knock everyone's socks off with her performing talent and her art. Melissa has soul, intelligence, and a natural, self-effacing humor. I can't wait to see what she does with all that talent!

Jonathan Murray: Someday, she will have her own sitcom. She is a natural entertainer and comedian.

Andrew Hoegl, Producer: Everyone just fell in love with Melissa's casting tape. She's so funny and insightful. She really understands who people are. She can break you down in a second. She can tell who you are and tell you who you are.

I think that Melissa's very funny, but she came in here with a lot of insecurities—particularly with boys. She needs attention and she's the first to admit that, and she gets it by being funny. I think when she realized that she was going to have to use more than humor to deal with the six other people, she was really uncom-

The **VOODOO** on...MELISSA

MATT. Now that Melissa acknowledges her past has shaped her for better or worse, she will continue to grow as a person and work through stuff she has hidden for a while. I'm really excited about it. It's just awesome. Regardless of the show, I would have paid to see that. **Will we keep in touch?** Oh, yeah.

KELLEY. Melissa had so much anger when she moved into the house. I think she has relaxed a lot since then. If Melissa continues to work at not harboring anger, then I think she'll be a very successful person. Just as long as she doesn't backtrack! I thought Melissa and I were friends. I've learned since the show ended that I was really, really wrong. Yeah, we had problems, but she dislikes me a lot more than I dislike her. **Will we keep in touch?** I have no reason to think we wouldn't. If she came to New Orleans, I'd see her.

DAVID. Melissa's all fireworks. What does that mean? Well, when fireworks die down, people walk away. That's what she is: melodrama and attention-getting. I'm glad Melissa found an art and a focus in New Orleans. But she's still unsure of herself. Everyone laughs at her. I guess that's because she's funny. Only I'm not laughing. **Will we keep in touch?** No. I do not consider her a friend.

JAMIE. Melissa is for sure my best friend in the house. She changed a lot in New Orleans. She used to be this little baby Farrakhan who's angry at the world. She's realized she can't stay angry. Melissa's a really original person. What pains me is that Melissa has this tendency to think about her life in terms of punch-carding, living paycheck to paycheck. She needs to have visions and dreams and goals. **Will we keep in touch?** Yes. She's doing a women's line for my company.

JULIE. Melissa is the person with whom I feel the most comfortable. We're both into dumb things, so we'll just sit around and be stupid together. Melissa's really willing to put herself out there. Has she changed? Yeah, I think she has opened her mind in lots of ways. She has become more considerate of people's feelings, that's for sure. **Will we keep in touch?** Yes. Definitely.

DANNY. In New Orleans, Melissa seemed to gain focus, but at the same time her ego increased tenfold. She wants to be the center of attention all the time. It's very funny, but it's old. She doesn't let people speak. I actually do not think it has to do with cameras—cameras or not, she wants to be the center. **Will we keep in touch?** Maybe, but probably not.

fortable and it brought up a lot of issues from her childhood. I think she got really frustrated three months into the project. This process forces people to look at things they don't like about themselves. She got depressed—I think—when she realized her humor couldn't carry her twenty-four hours a day.

Melissa's going to go out to L.A., and I think she's hoping to get discovered and go into show business. I hope she learns that she's going to have to deal with failure. It's one thing to be funny, and it's another thing to be a comedian. It's a craft she'll have to learn, but I think she can do it. She's one of the funniest people I've ever seen.

The Real World tests your beliefs and your stability. You think you're an adult, and you're questioning that all the time. You are digging so deep into everything, you feel like you're going crazy. It was as much as I could take. ⚜ At first, I was OK to give up my privacy. But then, about three and a half months into it, I wanted my privacy back. And by the last week, I couldn't take it anymore. I started figuring out that the cameras would be less likely to follow me if I were by myself. So I started doing everything alone. But then I'd come home, and be back in front of the cameras. I was going nuts. I couldn't stand having the cameras in my bedroom. I'd just be relaxing and there'd be all these lights on.

One thing that surprised me about living in the house was how easy it was to get bored and want to pluck your eyes out. I thought our days would be more jam-packed. We had nothing to do. We'd just be sitting around jabbing at each other. ⚜ It wasn't boring every day. We'd go through spurts when we found something new, but then we'd go through another cycle of boredom. There was a week when the weight of the project set in. It was right after Africa, and the excitement of the trip had worn off. We were all going a little bonkers. That's when Melissa met Lionel and started to paint, and we got those rocking chairs. That helped us all out a lot. ⚜ Kelley is definitely the only person in the house with whom I have a real friendship. I think the fact that both Kelley and I were in serious relationships brought us closer together. Peter is her first serious relationship, and Paul is definitely mine. It really changes everything. ⚜ Everyone in the house was really cool about Paul and about my sexuality in general. Definitely, there were times when I would get tired of being "the token." I felt I had to explain a lot of things. And sometimes I wished there was another gay person in the house. I'm very used to living exclusively with straight people, and I thought it would be nice to have a gay person with whom I could lighten things up. But, oh well. It was fine. And I think it says a lot that I was able to come into the house as the gay guy and have nobody care. Society is definitely changing. ⚜ There was no way I could be on this show and not be completely out. We'd go to clubs, and girls would hit on me. If I hadn't had cameras there, perhaps I would have just flirted. But because the cameras were there, and because I'd come to New Orleans

I remember being in high school and watching the Miami season of *The Real World*. Back in those days, I was in big denial about my sexuality. I thought Dan was such a flamer. I think on some level I was relating to him, but definitely not consciously. Mainly, I had a very negative reaction to him. To me, he was like all gays I saw on television, stereotyped. Remember the gay guy on *Melrose Place*? He'd appear every episode for one second and be a whiny bitch. As a kid, all I could think was: I don't want to be like that. If kids watch me on *The Real World*, I hope they will see me not as somebody totally weird and different, out there and flamboyant, but somebody normal.

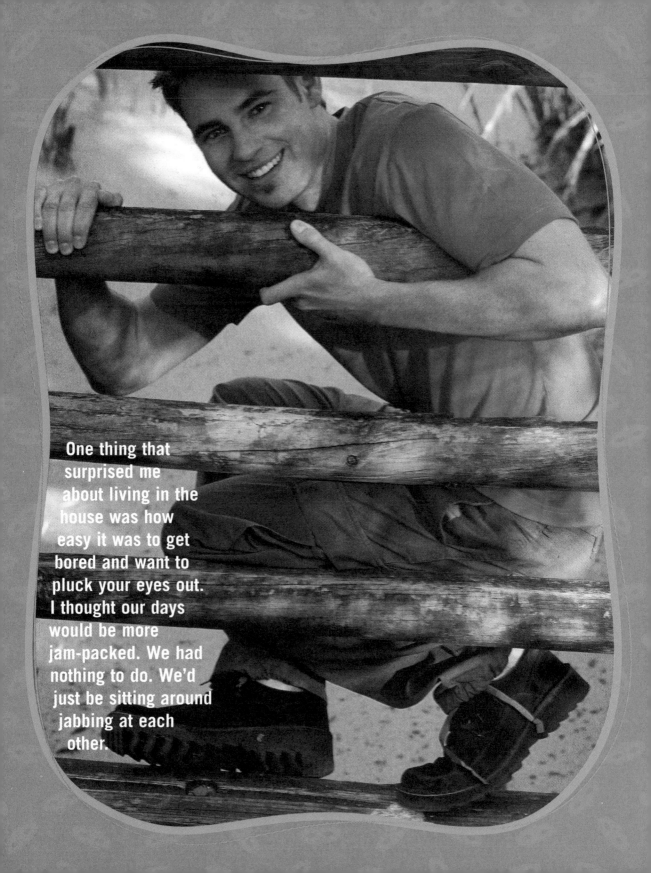

One thing that surprised me about living in the house was how easy it was to get bored and want to pluck your eyes out. I thought our days would be more jam-packed. We had nothing to do. We'd just be sitting around jabbing at each other.

I'D LIKE VIEWERS TO SEE ME AS...

Danny: If I could choose how I could be perceived, it would be as a well-balanced person who has no problems letting loose and having a good time.

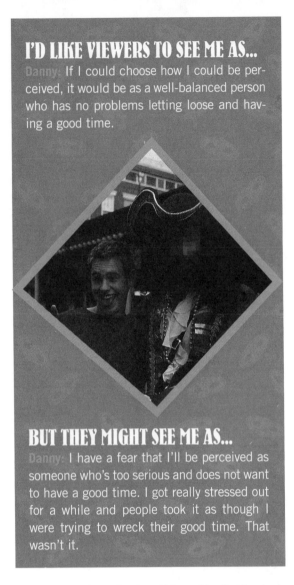

BUT THEY MIGHT SEE ME AS...

Danny: I have a fear that I'll be perceived as someone who's too serious and does not want to have a good time. I got really stressed out for a while and people took it as though I were trying to wreck their good time. That wasn't it.

to be my full self and not hide anything that has to do with my sexuality, I had to be up-front. Instead of flirting, I would just announce that I was gay.

I think it will also be good for viewers to see Paul. To me, he represents ten times what I want to represent. He's in the military. He's the opposite of what people expect a gay person to be. I hope he makes people think: "Don't think you know who's gay and who isn't." Believe me, you'd never know he was gay! Everyday it trips me out how brave he is, how much he put everything on the line for me.

Although I think my parents are going to have a hard time watching my relationship with Paul unfold, I think I'm going to make them proud. I'm sure they're very uncomfortable with my being gay. But I'm the same person I've always been. It was incredibly stressful to have them visit—and to meet Paul and to deal with the cameras. But I think it turned out all for the better. Guess what? After their visit, I heard from a childhood friend who's friendly with my mom. She told me my mom said that Paul was gorgeous. That was a damn good feeling.

What will most shock your friends and family?

Danny: I think a lot of people will be shocked that I'm gay. Even though my parents know, a lot of my friends and relatives don't know. That will be the immediate shock. Then it will be: Not only is he gay, but he's got a boyfriend who's in the freakin' military!

How do your friends on *The Real World* compare to your friends at home?

Danny: There's a huge difference between the people in the house and my friends at home. When my friends came for Mardi Gras and Jazz Fest, we were all listening to each other. In the house, nobody listened, but everyone was talking. Egos definitely got in the way. If somebody's going to be my real friend, he/she and I have to share stuff fifty-fifty.

CREW VOODOO

Mary-Ellis Bunim: Can I say I think he's the cutest boy (he'll hate that I used that word) we've ever had on the show? Danny's face is to die for, and I'm sure some smart film director will realize that before long. Meanwhile, Danny and Paul were wonderfully open and courageous to share their love story with us.

Jonathan Murray: Danny likes to stay back and not be the center of attention which, for a *Real World* cast-member, is something refreshing.

Andrew Hoegl, Producer: When Danny was in casting, he had come out to everyone except his parents. He told us he was going to come out to his parents at Christmas, which is what he did.

MATT: Honestly, it was hard for me to get to know Danny. It was hard to talk to him about things that were really important. The past was very painful and exhausting for Danny and he didn't want to discuss it. And when I talked about the present, he was often just irritated. Danny has a tendency to be very negative. He didn't always enjoy it when I tried to point to the bright side. But I really like Danny. **Will we keep in touch?** We will absolutely keep in touch. I think this situation prevented us from becoming total lifelong friends, but I know we'll hang out when we're both in Atlanta.

MELISSA: I always felt really comfortable around Danny and liked him very much. I never spent quality time with him; we never had any long, drawn-out, Oprah's Book Club talks. I'm glad he did *The Real World* because he's not stereotypically gay. If he didn't tell me he was gay, I swear I wouldn't have known. **Will we keep in touch?** Realistically, I think Danny and I will talk a few times a year.

DAVID: There's a time for everyone and now is Danny's time. We didn't talk so much, but at the end we started to talk more. **Will we keep in touch?** Yeah, I'll try to keep in touch with him.

JAMIE: I think Danny had a lot of painful things happen to him when he was younger. It's like once he deals with them, he can move on. I do think he changed in New Orleans. He's in love, and being in love changes you. He wrote me a letter saying he was really sorry for the way he treated me. He said his negative feelings about how I live my life have more to do with him than me. **Will we keep in touch?** Probably not.

JULIE: Danny is the catalyst for my change of mind about homosexuality. It happened instantly. That's because Danny is so awesome! Danny introduced me to raves. Through him, I rediscovered my love for that kind of techno stuff. **Will we keep in touch?** I hope I'll keep in touch with him. I'd like to go down to Atlanta.

KELLEY: Danny is the most caring, kindhearted person you could ever meet. If he changed at all, it's that he became more confident in disclosing things about himself. It's impossible not to adore that kid. People probably think I'm obsessed with him. I think he's going to be adored by the world and they're going to ride him on a big chariot wherever he wants to go. He's a good person, and good people will always be OK. **Will we keep in touch?** God, yes.

Seeing that this would be the first time he was free to explore his sexuality openly, we thought that Danny would just go nuts in New Orleans. And then, when he moved in, we found out very quickly that he'd met Paul and that he'd decided to remain faithful to Paul. That was a great story, but a complicated one because of Paul's military career.

Danny's role in the house was the voice of reason. I wish he'd expressed his thoughts more. I think he was afraid of confrontations but when he did share his opinions, he had a profound effect on people, especially Kelley and Julie.

Before I came to New Orleans, I had it all figured out: I was going to move into the house and be this Christian bitch. ❧ I imagined I'd spend a lot of my time preaching to my roommates, telling them how things should be. I thought I'd make a difference in their lives. What I didn't realize was that it'd be the total opposite, and that they'd affect my life more than I could ever fathom. I thought they were all going to be freaks. That's not a good word—freaks. What I mean is I thought that they'd have no morals or convictions, be all drugged and boozed up. I thought I was going to be the lone moral Christian girl sitting in the confessional spouting off about what was wrong with them. That wasn't the case at all.

I have to admit that moving into the Belfort prompted a bit of an identity crisis. Certainly, having Matt in the house threw me. I came into the Belfort with my religion, my yellow glasses and my skateboard, going, "I'm Julie." Well, Matt had glasses like mine and his own religion! I still had my skateboard, but then it turned out Jamie had one too! I thought I needed something to call my own. I got over that. ❧ Coming into the house with all these beliefs had its own set of problems. There were a lot of times I felt I was being held to these ideals that I'd set up for myself. Often my roommates would tease me by talking about sex and looking at porn. But then, when I'd come out and say anything sexual, they'd gasp in horror! It was like I couldn't win sometimes! Maybe I'm naive, but that's not the equivalent of being stupid. ❧ I say this in a loving way, but some of my roommates had the worst attitudes! They never wanted to do anything except sit around and eat in restaurants. It was a recurring joke that I was like "Hey guys, wanna do this? Hey guys, wanna do that?" When we met the *Road Rules* crew, I was foaming at the mouth. All the stuff they get to do! I didn't apply for *Road Rules,* because I have to go to church every Sunday. Looking back at it, I wish I had. I love anything that's out of the box! I love breaking the mold whether that means digging up the yard, or climbing up stuff that's dangerous, or trespassing. That's how I get my adrenaline. Am I compensating because I'm not allowed to have sex or do drugs? Maybe. I never thought of it that way before! ❧ My roommates loved to just sit around and talk about pop culture. I couldn't do it. I'm very ill-informed about television and movies. I'm not into pop culture at all. Actually, I want to fix that about myself. I even bought my first copy of *Teen People.* I think it's important to know what's going on—especially now that I'm a part of it, to some small degree! ❧ I loved living in the Belfort. I couldn't think about it as television. I'd get really pissed off when we'd talk about our lives as "a show," and that happened a lot. It would drastically change my behavior when I remembered I was going to be on TV. And Melissa knowing everything there was to know about every past *Real World-*er didn't help! At the begin-

I know on the show I'm sometimes going to look like a wishy-washy hypocrite. I'm looking forward to seeing that. Bring it on. Dealing with those issues, working through my beliefs; that's what made me grow. That's what made my convictions clearer.

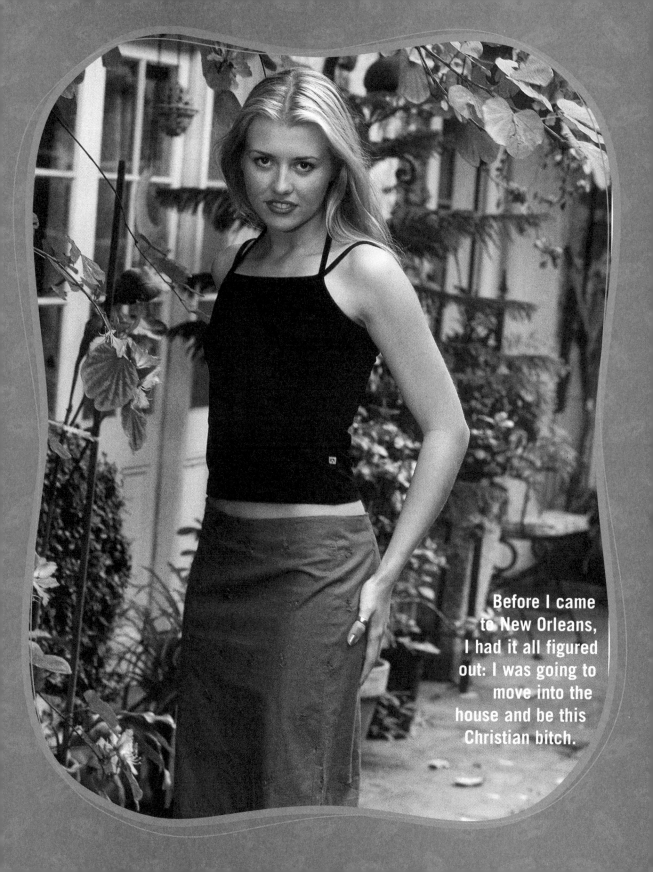

Before I came
to New Orleans,
I had it all figured
out: I was going to
move into the
house and be this
Christian bitch.

I'D LIKE VIEWERS TO SEE ME AS...

Julie: I'd like people to think that I'm open-minded, but that I have integrity; that I'm adventurous and into having a good time.

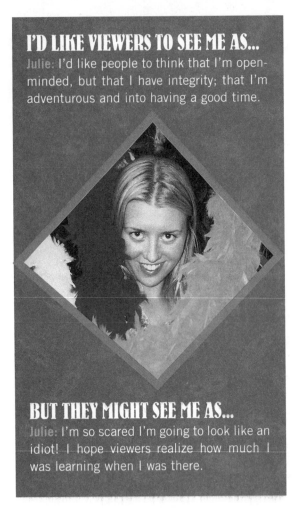

BUT THEY MIGHT SEE ME AS...

Julie: I'm so scared I'm going to look like an idiot! I hope viewers realize how much I was learning when I was there.

ning of the season, we'd go to the gym and watch *The Real World*. But that completely freaked me out. If I thought about the cameras and how I was looking, I'd start crying! Then, toward the end of the season, I made a huge mistake. Melissa and I went to the hospital and watched the Reunion show. I couldn't sit through it! I started wigging out. Everyone sitting on the couches looked so good! What was I going to look like? I'm not telegenic! I was a mess! I had to put those thoughts out of my head, just in order to live.

Before I came on *The Real World*, I had beliefs because I was told to have them. I'd never questioned my religion before. Now, I'm seriously questioning it—which is not to say I'm walking out of the Belfort as a non-Mormon. I'm still a Mormon. I'm still a virgin. But I have open eyes. There are some key things about my

religion that trouble me, but as for my overall convictions about how life should be lived, well, they haven't changed that much. It's not that I'm losing my religion. It's more like I'm finding it.

What will most shock your friends and family?

Julie: That I expressed sexual frustration! My parents actually think I'm asexual.

How do your friends on *The Real World* compare to your friends at home?

Julie: My friends at home are conservative. They would not deal with the drama in the house.

CREW VOODOO

Mary-Ellis Bunim: Julie was a gift to everyone on the cast, the production, and now the audience. When she started this show, she was like a flower about to bloom—she was just waiting for the right climate. Julie has a wonderfully positive energy and is a natural leader. She has solid moral convictions that gave her strength each time she was challenged with new life experiences.

Jonathan Murray: Julie was the emotional center of the New Orleans season and we will be forever grateful to her for her honesty and openness.

Andrew Hoegl, Producer: When we met Julie in casting, we could tell that she was ready to expand her horizons. In fact, I think she was hoping *The Real World* would do that for her. During casting, we were concerned because we knew she might change in a way that could dramatically affect her relationships with her parents and church. We talked to her a lot, hoping that she would consider all the ramifications of being on the show. She said she was ready for it, that the people in her life would have to accept her for who she is. I think that's an incredibly healthy attitude.

Want to know something funny? With the exception of Melissa (and only on occasion), Julie was the wildest one in the house—and she never drank a drop of booze. I would come to work in the morning wondering what Julie had done the night before. Had she stolen shovels (which she later returned) in the cemetery, or gotten into

The VOODOO on...JULIE

MATT: Julie came into the house sheltered, a little bit angry, rebellious, and yearning for independence and an identity beyond the Provo bubble. Julie is leaving an independent woman and every bit of it. Before, she would rebel in little ways. Now her rebellion is real. When you have a sheltered upbringing, you don't know if you can fly. Wow, did she fly! She grew up in the house. Her future will be difficult, but she'll approach it all with confidence in who she is. In the face of adversity, she'll really step up. **Will we keep in touch?** Yeah, how could I not? I know she'll keep in touch!

MELISSA: I think the world of Julie. She's spontaneous and adventurous! Oh, she's changed so much. She's always been very perceptive and very mature, but she's learned you can't call black people "colored." She didn't even realize that bagels had an association with Jewish culture! I'm scared she's going to have a hard time. She's about to be thrown back into her white Mormon world. I think Julie's very headstrong, but I think it's going to be hard for her to answer criticisms about her MTV life. I hope she stands up for her life and everything she's learned in New Orleans. **Will we keep in touch?** Definitely over the summer, yes. But I don't know how realistic it is to think we'll talk every day during the year. Her school life is going to be so challenging, she won't have time for my drama.

JAMIE: I've had some deep and intense talks with Julie. I've connected with her on a really deep level. She was also the only person who was able to rage—and that's without drugs or alcohol. She'd go skateboarding in parking lots or mud wrestling in the middle of the night. She's a lot of fun. **Will we keep in touch?** I hope so. I can't wait to see what happens with her.

KELLEY: To know Julie is a breath of fresh air. Coming to New Orleans, Julie had to take every belief she ever had, put them on a big chopping block, and decide which to keep and which to discard. I don't think I've ever met anybody so open-minded. The blessing of knowing Julie is that she keeps *you* open to new things too. I learned so much from her. She doesn't fight learning. She accepts it. **Will we keep in touch?** Definitely.

DANNY: Julie had a limited world view, and coming here has opened her up to so many things. In the beginning, she'd freak out if you saw her bra strap, and now she's down to sleeping in her bed naked. That's right: There were nights when Julie slept in her bed naked. The world's open to Julie. Anything's possible for her. **Will we keep in touch?** I will probably talk to her from time to time.

DAVID: Julie's making her way to being a stronger person, but when you limit yourself you can't expect the world to be limitless. I think she's going to have to give up some of her beliefs. Like Matt, Julie is the type of person who wants to connect with people, who wants to dig into people. But how can you communicate with a person who you feel is totally amoral (as she feels about me)? Is she my friend? We're connected with music, and that's a start. **Will we keep in touch?** We can't be friends until the walls she's put between us are taken down.

a boxing match with another girl? She's incredible!

I think that Julie has really grown up. Maturity-wise, she seems several years older now than when she got here. You know, I think she even looks different.

I've never been happier than I am right now. In New Orleans, I went through all these transitions: getting my business into make-or-break mode; falling in love for the first time; reawakening the spiritual side of me. I'm walking around with all this energy in me, and it's amazing. ⚜ I left the Belfort a better person, but that doesn't mean I had to climb a mountain to get there. Contrary to how it will seem on the show, I was never completely ignorant to the trials and tribulations of others. When I saw the Casting Special and the first episode, I thought I looked like a one-dimensional human being, a privileged white heterosexual male with racist homophobic tendencies. That is not who I am at all. I feel like I gave *The Real World* my true self and that it won't be represented in its entirety. That makes me feel incredibly frustrated and misunderstood.

Because of my frustration, I didn't go to the final wrap party for the cast and crew. It's not that I don't like the people who worked on *The Real World*; I like all of them. It's just that I felt I needed to protest how I came off in the first shows. ⚜ I learned early not to talk about the extensiveness of my travels and experiences when I was in the house. I could see my roommates being like: "What do you mean you went to Aspen? What do you mean you met the King of Saudi Arabia?" Although most of my roommates thought otherwise, my family is not ridiculously wealthy. My dad was always taking out loans. And as far as my business is concerned, money is the incentive but only in the sense that I need it in order to provide for my family and friends. Yes, I want to live my life well. I'll need money to do that, but that's as far as it goes. ⚜ I've traveled a lot—to mainland China, Hong Kong, Western Europe—and I've learned that by going away you learn what it's like to be home. I feel like living with my roommates was like traveling to six different countries. I learned a lot from these different people, but at the same time I figured out what it was like to be Jamie. Which is to say: I've enjoyed all the perks of *The Real World*— the traveling, the fun. But it's all shallow compared to the personal growth I experienced in New Orleans. For five months, I lived a very contemplative life. I had a lot of time on my hands. The nature of the production forces you to look inside and be introspective. At Cornell, this hyper-competitive school, you do not have time to think on a deep level. Dawn until dusk, you're constantly stimulated. With more time to think, I became a more spiritual person. ⚜ I've been accused a lot in this house of being a politician and a peacekeeper. I was a peacekeeper in that I didn't want people to squander this experience. Don't freak out about someone using your toothpaste! We have so much to learn from each other. We can all grow from this, and that's a fact! I know

So, at this point, I don't plan to watch the show. I'll be tempted, but I won't do it. Being a Buddhist, I have a big problem with this notion of the self and fame and the self-serving stuff that's associated with the show. It's not healthy. I'd just as soon exist in this world knowing who I am as a person and not being questioned by the masses.

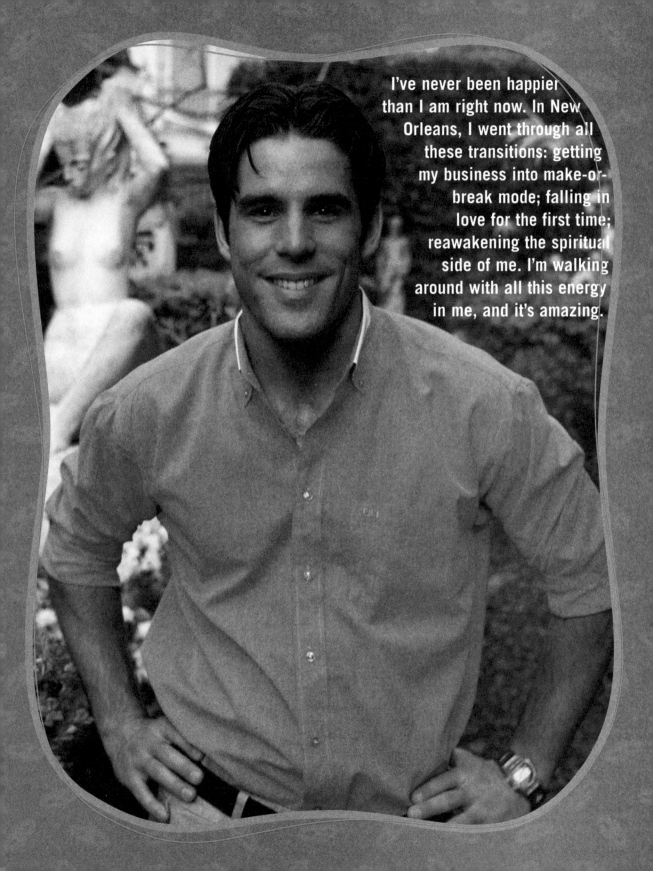

I've never been happier than I am right now. In New Orleans, I went through all these transitions: getting my business into make-or-break mode; falling in love for the first time; reawakening the spiritual side of me. I'm walking around with all this energy in me, and it's amazing.

I'D LIKE VIEWERS TO SEE ME AS...

Jamie: If I could pick how viewers would see me, it would be as a loyal friend, a loving kid to my parents, a really grateful person who grabs life by the balls. I'd like to be seen as a person who does what he wants to do and acts in accordance with the happiness of his friends and his family. I'm motivated by making my family happy.

BUT THEY MIGHT SEE ME AS...

Jamie: I think people might think that because I've lived a really good life, I'm a person who doesn't know s**t about living. I'm scared that people will think I don't know what it means to suffer and that I'm a shallow person because of it. I'm really concerned that people will think I'm ignorant. The weird ironic thing about it is that I'm much less ignorant about other cultures than some of my roommates. Some of my roommates don't even know Jewish people! I have a very global perspective.

some of my roommates saw the stance I took as being fake. That's frustrating. But then, these same people have accused Matt of being fake too. They'd see him going to the children's hospital, and think it was just for show. How about actually considering the fact that Matt is a genuine and caring person?

In the Belfort I realized that I'm a happy person. Maybe it's a chemical balance thing. All I know is I can sincerely say I love my parents. I have a very tightly knit group of friends. I love where I grew up. I hold luck accountable for my happiness, but I also think I process things in my brain differently from most people. For example, it never computed in my mind how my roommates could be pissed off and sad all the time. If you put me in a pimp palace in New Orleans, I could never be sad. I think I see the good in things.

What will most shock your friends and family?

Jamie: Me falling in love with this girl in Colorado! My friends are happy for me, but they think it's weird.

How do your friends on *The Real World* compare to your friends at home?

Jamie: This experience would have been even better with my boys from home. We have an immense loyalty to each other.

CREW VOODOO

Mary-Ellis Bunim: In about five years we'll be reading about Jamie on the front page of *Fortune Magazine*. He's a smart cookie, a promoter, and a charmer. I'd buy stock in that guy's company.

Jonathan Murray: Jamie learned, for the first time, that people who did not grow up with the benefits he did will resent him on first meeting him. And he learned that he will have to prove himself to them before they let those resentments go. A tough lesson, but one Jamie needed to learn.

Andrew Hoegl, Producer: When he came to New Orleans, Jamie had an agenda to promote his online company. Because he felt he wanted to represent himself in a very controlled way, he would never really talk about his feelings, and I think some of the roommates, like Kelley, began to resent him because of it.

Before coming to New Orleans, Jamie had been

The VOODOO on...JAMIE

MELISSA. I think Jamie's a good and whole person. This season taught him a lot, but he knew a lot coming in. I think the world of Jamie. He's one of my best friends in the house. With Jamie, my like for him was unwavering. And I feel like he stayed true to me the whole time. I honestly believe that he has learned a lot about how to deal with girls from me, which is ironic since I'm not a typical girl. **Will we keep in touch?** I plan on talking to him all the time.

JULIE. Jamie is a really loyal person. We're similar in that we were both somewhat sheltered—though he won't admit it. I think he'll be really successful in terms of his company. But, more important, he's gotten so much more spiritual. Sometimes I felt I was a lot younger than he is. He didn't know who Blink-182 was or Limp Bizkit! **Will we keep in touch?** I don't know if I'll stay in touch with him. I think so. I want to.

DANNY. If Jamie's ego wasn't so damn huge, I could have hung out with him more. Jamie supposedly learned compassion when he was here. I don't really buy it. All I see is him leaving here and having his business blow up. **Will we keep in touch?** Probably not. I'm open to keeping in touch with anybody, but Jamie's one I probably won't talk to.

MATT. Jamie was a pretty stable person when he came in. He was likable, loving, just an all-around cool guy. In the beginning, Jamie partied a lot. In the end, he barely partied at all. He was not promiscuous. He let his spiritual enlightenment affect how he acted. That was very cool to see. **Will we keep in touch?** Oh yeah, I'm going to see him a lot!

KELLEY. Jamie was playing a character the whole time he was in the house, like he was in a movie. I really did like him when he wasn't on camera. But on air, he put a lot of grain into creating an image that would help promote his company. He wanted to be extreme-sports maniac, Mr. I'm-so-fun, America's #1 bachelor, always happy, never in a bad mood. It was a lie. **Will we keep in touch?** I would like to keep in touch with Jamie. I'm hoping that someday we'll see each other at a reunion, hug, and move on.

DAVID. Jamie's almost a reflection of me. He's got that fire, that passion to succeed without limits or fear. Jamie will be successful as long as he keeps his passion and fire. Most definitely. **Will we keep in touch?** Maybe.

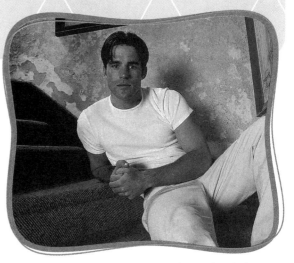

around the world, but I think he still had a lot to learn culturally. I know that he was really upset that we included his calling Kameelah "Shaka-Zulu" in the Casting Special. I think it also disturbed him that we portrayed him as being slightly uncomfortable living with Danny, but that's what it looked like to us at the time.

I don't think Jamie is a racist or homophobe in the least, but I do think that sometimes, when expressing his ideas, he sounded less PC than perhaps he imagined.

When Jamie does open himself up and tells people what he's thinking and feeling, which happened midway through the season, we saw that incredibly relatable and likable side to him. Ultimately, I think he had a profound effect on Melissa and Julie, and I think that when he let his guard down, they had a huge effect on him as well.

I was very apprehensive coming to New Orleans, because what I'd really wanted was to be on *Road Rules.* To me, *The Real World* was runner-up. I'd already gone through years of trying to figure out who I was, where I was going. I didn't think I'd get a lot out of it. ❧ But upon finishing the project, I feel like a million bucks. I haven't been this happy in a long time. If I came to any major realization in New Orleans, it's that my life is really good, and that the path I've chosen is really good. Knowing this is amazing. Now, I'm happy to be back to my life. ❧ I really can't believe that I fell in love while being on *The Real World.* Meeting Peter has affirmed everything for me. I feel like there was some kind of cosmic reason that we met. I'm so excited to see what happens when my life starts with somebody else.

My friends tell me that the most annoying thing about me is how I'm always trying to get stuff out on the table. In the house, I was willing to get it all out there. Not everybody else was. Honestly, you'd be surprised. People really didn't know what was being said about them in interviews. Since we've wrapped, I've heard so many things about what people have said about me. ❧ It pisses me off that people call me a bitch. I think it's because I'm a woman and I try to say what I think. When I'm your friend or your partner, it's a rare occasion to see me being a bitch. But if you don't respect me, then I don't respect you. ❧ I'm excited to see the show. I think it'll be good for me. I want to see if I'm really as bad as my roommates said I was. I don't want to sound like I'm Mary Poppins, but I think I'm a really kind and caring person. Here, people were telling me otherwise. Jamie called me a bitch, and I really didn't get it. I never sat down and thought, "Oh, let me take this person down." That never happened. But, maybe I come off wrong. I just want the reality to match my intentions. ❧ Sometimes, I think I didn't have a clue about what was going on in the house. I think that's because I wasn't there that much. People would tell me I wasn't going to be in the story that much. I'd be like, "Well, this is my real life. Yeah, that's right, my real life is mainly Peter." It's true that I came to the house mainly to shower and then leave again. ❧ If I hadn't met Peter, I don't know how I would have dealt with the house. There were so many times when I wanted to rip my hair out. Without Peter, I think I still would have grown, but in a different way. I saw what happened when people stayed in the house a lot and they would almost go crazy. There were moments for everybody—including myself—when insanity was an option. I think Melissa had a hard time, and I know Danny couldn't stand it a lot of the time. I think he needed me to be at home a lot more than I was. I wish I'd known that at the time. ❧ A lot of people in this house needed a lot of attention, and I realized I wanted and needed attention as well. There wasn't room for me to be myself completely. Melissa definitely took the gold medal for the person who needed the most attention. Julie needed attention too,

Here's the thing about me: If I don't like somebody and we don't get along, then I don't think about them much. When I think of my life, I think about the good things. In that sense, I think I might forget things I do. The second I'm a bitch, it's just eliminated from my mind.

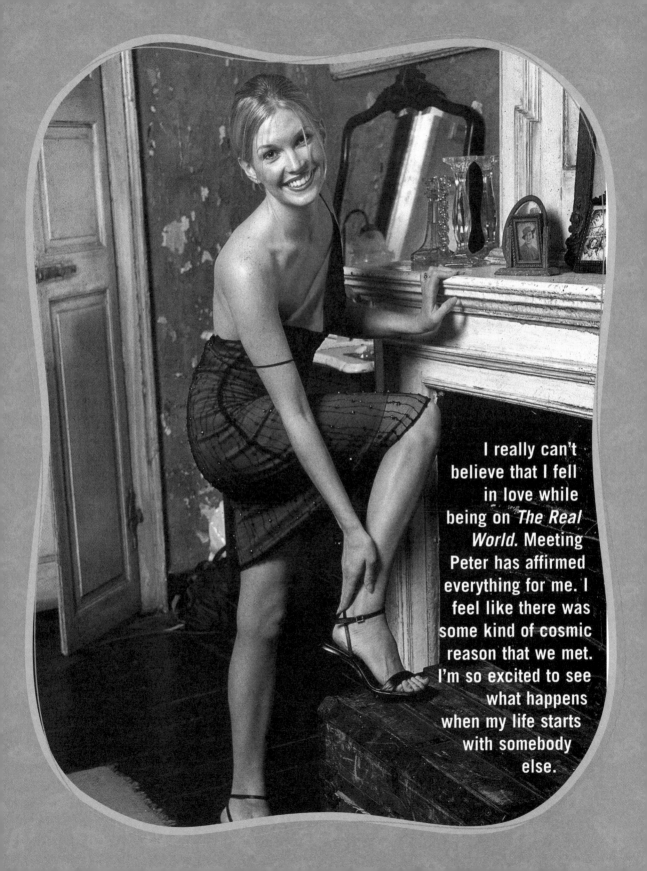

I really can't believe that I fell in love while being on *The Real World*. Meeting Peter has affirmed everything for me. I feel like there was some kind of cosmic reason that we met. I'm so excited to see what happens when my life starts with somebody else.

I'D LIKE VIEWERS TO SEE ME AS...

Kelley: This is going to sound really clichéd, but I want people to think that while I was in the house I was sensitive and really did care about what was going on, that I saw the importance of watching out for myself, as well. Trying to compete for attention in the Belfort was a lost cause.

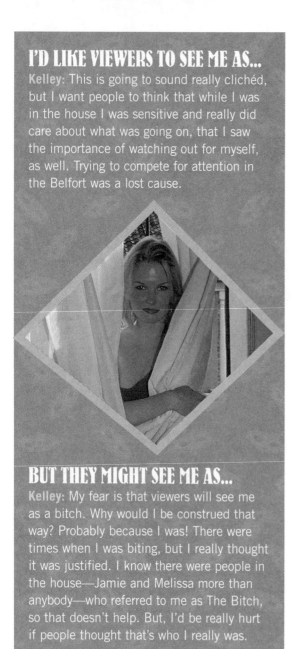

BUT THEY MIGHT SEE ME AS...

Kelley: My fear is that viewers will see me as a bitch. Why would I be construed that way? Probably because I was! There were times when I was biting, but I really thought it was justified. I know there were people in the house—Jamie and Melissa more than anybody—who referred to me as The Bitch, so that doesn't help. But, I'd be really hurt if people thought that's who I really was.

but that's because she was having so many new experiences. I always felt I was competing with somebody. Maybe that's why I retreated.

But the thing is, I was just happy when I was with Peter. It has nothing to do with his being part of the project or not. I was just as happy around Danny. I was happy to be around friends, people who weren't judging me, talking behind my back, trying to get attention.

In New Orleans, I decided not to care so much about what people think of me and be more willing to either say what I think or leave a situation when I want to. I realize there are people in the house who didn't like me. Before, I never would have been rude to them. Now, I don't care. I'm not nice all the time.

What will most shock your friends and family?

Kelley: My friends think I'm a lunatic, so nothing would shock them. I was so much more calm in New Orleans than I was at home. My parents, too, will find nothing shocking, but they will be very disappointed to see me smoking. It was just too stressful not to.

How do your friends on *The Real World* compare to your friends at home?

Kelley: My friends at home are the best. None of them really wanted to visit, because they couldn't see the point of being in front of cameras. Before I came to New Orleans, they were like: "Why would anyone who's a solid person go and do this?" They saw it as a place for people to have all these dramas and epiphanies.

CREW VOODOO

Mary-Ellis Bunim: Kelley applied to be on *Road Rules* and was initially nervous about the prospect of opening up her life to the extent that *The Real World* asks of its cast. But she seemed to be nurtured by the process and used it to push herself and everyone around her to grow from the experience.

Jonathan Murray: Kelley would have probably enjoyed working on the production more than being the subject of it; but I think, ultimately, she'll be better at what she does in life because of this experience.

Andrew Hoegl, Producer: When I met Kelley in casting, I felt really strongly about her. I thought she was very funny, very attractive, and didn't take any crap from anyone.

I really like Kelley, and I think that she's a great person. But it frustrated me that she tried to manage production and control what her image would be. I don't know that she was a different person on camera and off, but we never got the whole picture.

The VOODOO on...KELLEY

MATT: Kelley prides herself on being fun, outspoken, and playful. She was outspoken, but I don't know about the rest. She didn't enjoy this experience. I think she thinks she was supposed to evolve here. So now she has false nostalgia about memories I don't think she ever really had. The truth is that though she jumped into this experience head-on, eventually she was never here. So, really, these perceptions are from a distance. **Will we keep in touch?** Not sure, but I'd like to.

MELISSA: I don't think I know the good part of Kelley. When she was out of the Belfort, people say she was totally different, happy-go-lucky. But, when she was in the Belfort, all I remember her doing is sleeping and leaving and putting on makeup. I don't hate Kelley, but I think she believed I was out to get her. I think she and I have mastered a civil indifference to each other. **Will we keep in touch?** If I come through New Orleans, and she lives here, I would get in touch. I don't think we'll get to a point where we're singing "Kumbaya" together, but we could be very civil acquaintants.

DANNY: Kelley's got so much going for her. A) She's attractive. B) She's intelligent. C) She's personable. I see a lot coming her way quickly. She's like me, open to anything and willing to try anything. She only benefited from learning that she doesn't have to give a damn what people think of her. **Will we keep in touch?** Definitely, we'll talk. We'll also visit.

JULIE: The key word with Kelley is *recognize*. She's learned to *recognize* that she can be bitchy and irritable, and whether she chooses to change herself—that's up to her. She's an awesome, perceptive person. She came here very confident in what her deal was. For that reason, I don't think she was as open as some people in the house. Coming here was the final challenge before moving on to a stable life, her true transition into adulthood. I'm very young-minded, she's mature. I'm MTV to her VH1. **Will we keep in touch?** I hope so! Yes!

JAMIE: Kelley's very hardheaded. She's very stubborn. We had a talk when production ended. I told her why we're not friends. I said: "You're negative and irritable and I don't choose to associate myself with you." It felt good. Kelley thinks she never makes mistakes in this world. She wants this image of the powerful woman. Just open up and realize your flaws. **Will we keep in touch?** No. Sure, there will be a bond that everyone in this house shares, but realistically, we won't keep in touch.

DAVID: Kelley is a perfectionist and I like perfectionists. She has the beautiful look and the attitude and the intelligence. I don't know what her focus or her goal is, but you can never go wrong when you strive to be perfect. She's the person in the house I'd most likely call a friend. **Will we keep in touch?** Sure, from time to time.

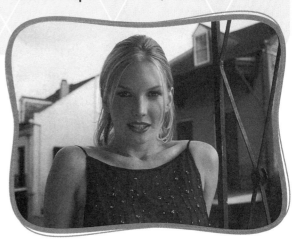

Kelley came into the house wanting *not* to be perceived in a certain way. She very much wanted to fight the image of the pretty blond airhead, and spent a lot of time trying to overcompensate for that. She didn't want to be perceived as the mean and ditzy girl, so she tried to be a peacemaker. Ultimately, it was when we came back from South Africa that she really let her hair down and personality out, and we finally saw the real Kelley.

I wish Kelley had been open with us from the beginning. It would have saved both of us a lot of frustration.

I'm the seventh roommate. What does that mean? That you can pair off the roommates three times, and there's one left over. That's me. I'm the outsider. ⚜ The outsider's supposed to be a scrub. I'm no scrub. I think that bothered my roommates. I think they just felt: "Damn him." I'm strong-willed. I play with all these girls. I have sex all the time, yet I'm ending up with Deanna, the finest girl possible. I've got mad talent on the mike. I'm too focused. It's like "damn him, damn him, damn him." ⚜ In every aspect, I'm the seventh roommate. I'm the one standing alone. I'm the warrior. I'm a one-man-army type person. I knew coming to the house that I was going to have to work on a team, and I wasn't sure if I was going to be able to do it, to put down the "I" and embrace the "we."

As it turns out, I wasn't successful. I should have been part of the seven as opposed to being the seventh. I guess I get caught up in thinking I was like Job in the Bible; in the end, it was him and God. That's it. There were no family, no friends. He was on his own. For example I thought the shows we did for NOATV (New Orleans Access Television), could have been done so much better if I were doing them by myself. Even the show I produced—I felt I wanted to do it without anybody else. I know you're supposed to delegate, but that's not how I'm used to doing things. No one can do it like I can. I cleared the music. I got the girls. My roommates got a week off. My set was the tightest set, but nobody gave me credit. It doesn't matter, I've been underestimated all my life. I know everything turned out right on the show I did. You're only as strong as your weakest link. ⚜ Having finished the project is a good feeling, though it's mixed. That's because the future for me is so uncertain. I'm the type of person who likes to know what they're stepping into, and right now this is the darkest realm into which I'm going. Being on *The Real World* was the greatest experience in the world, but it's like, what comes next? It's the scariest thing. Will things happen? I don't know! What kind of job am I going to get? There are so many uncertainties. ⚜ I knew of *The Real World* before I came to New Orleans, and as my time approached I watched some of it. Am I as big a player as Teck? Ha! Teck is minor-league. He does have game. But I'm another level. Teck is funny. Teck is cool when he goes out. But I'm charming. We both can get panties, fine. But the thing is when you get down to it: Does he have a better body? No. He can flow, but his flows are slow. He can maybe freestyle better than I can. Going head-to-head with Teck would be bad for him. He's taller, but that's about it. I'm Obi-Wan Kenobi to his Luke Skywalker. I see his potential and respect that he can feel the force.

No, I'm not having any withdrawal with the cameras turned off. The only time I even noticed the cameras was in the gym; that's my sacred realm. Otherwise, they were no big deal. Switching off the cameras doesn't mean anything to me. I never switched off from being David, because I never stopped being David. Yeah, I would say I changed the least. I'm a person who strives for perfection, and I always will be.

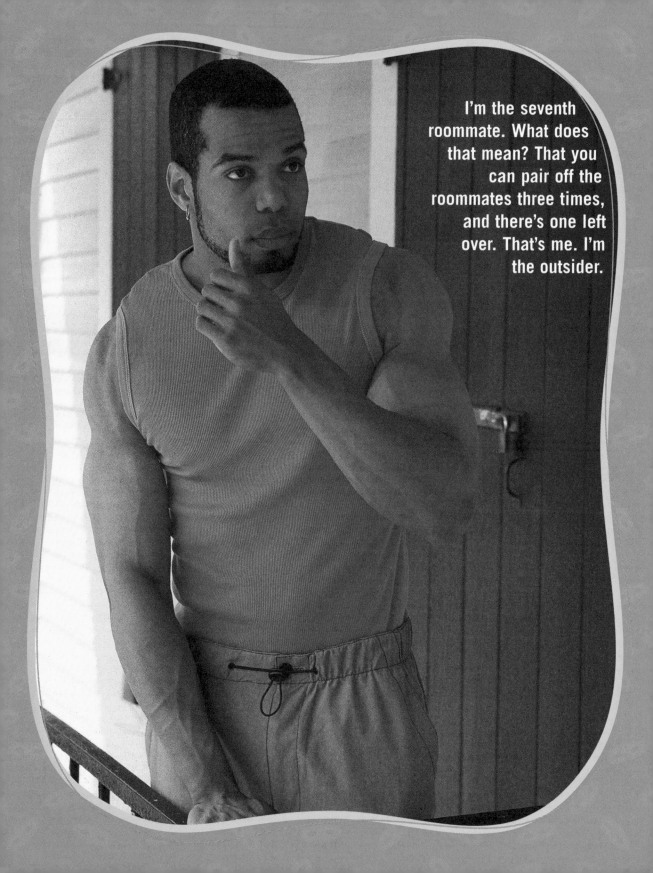

I'm the seventh roommate. What does that mean? That you can pair off the roommates three times, and there's one left over. That's me. I'm the outsider.

I'D LIKE VIEWERS TO SEE ME AS...

David: I'm so tired of saying *player*, because that's so played out, but I'd like to be seen as a person who *loves* to have sex. I'd like to be seen as a person who works out diligently to the point of too much, who's extremely independent and just does not care about anything but the final goal.

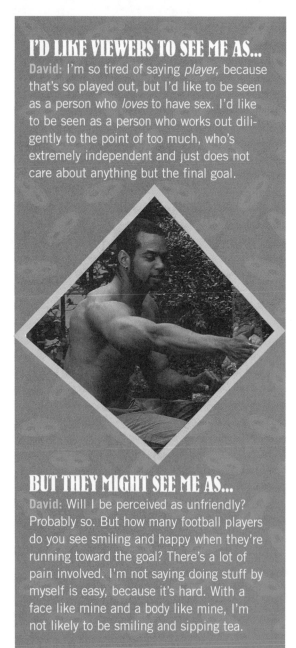

BUT THEY MIGHT SEE ME AS...

David: Will I be perceived as unfriendly? Probably so. But how many football players do you see smiling and happy when they're running toward the goal? There's a lot of pain involved. I'm not saying doing stuff by myself is easy, because it's hard. With a face like mine and a body like mine, I'm not likely to be smiling and sipping tea.

My main goal is I want to blow up in the music business. Am I ready to be on stage like Method Man or something? No. I want to be voice-trained. It would be great if someone would take me under his or her wing. Like Luther Vandross or Mariah Carey. Even Madonna. Anybody! Just someone who knows the ropes. Then, once I learn, I can break loose.

My secondary goal is to build up my body even more. I'm definitely going to do that. I'm very focused to the point that I'll drive through anything that gets in my way. Nobody and nothing can stop me. I'm the underdog, the one underdog you don't want to mess with. I'm aiming for the best and the highest. I'm hoping that I get on a Challenge and that the next time viewers see me I'll be even closer to perfection. I want to be 210 pounds. That's thirty pounds more than I am now. I just want to be massive, huge.

What will most shock your friends and family?

David: Well, my dad's side of the family will be shocked just to see me on national TV. We haven't spoken since my dad and mom got divorced.

How do your friends on *The Real World* compare to your friends at home?

David: At home, my friends are down for whatever—sex, fun, you name it. They're not worried about the limelight. That's why I've got their backs.

CREW VOODOO

Mary-Ellis Bunim: When we cast David, we knew he was musical, but I had no idea how incredibly talented he is. He can sing and play anything by ear. His escapades with the ladies were certainly controversial, though, and he had some difficulty communicating with his roommates. David was never without strong opinion—on anything and everything.

Jonathan Murray: David was so engaging in the casting process. I think we were surprised that he was such an island to himself in the house.

Andrew Hoegl, Producer: David was the single most entertaining person I have ever encountered in casting. And, believe me, I've watched thousands and thousands of casting tapes. He was—by far—the most engaging personality I've come upon. However, I was very concerned—and I told him this during semifinals—that he might have a tendency to disengage and cut himself off from the group.

This process is not about being perfect; it's about

The VOODOO on...DAVID

JAMIE. David's whole world view and way of thinking is sad. He lives a very lonely life. He's a man who feels he's fighting this war alone. He doesn't let people in. He chose not to be part of the house. Each and every one of us questioned ourselves in terms of how we got along with David. We kept thinking, "God, what did I do?" Then, we realized: It's not us. It's him. **Will we keep in touch?** I can't see getting in touch with him, but I'm happy to help him out. He had dinner with me and my dad, and my dad was like: "Look, we can make it happen for you if you want a job."

MELISSA. I think David's annoying and insecure. I think it's shameful that he's trying to perpetuate the angry black male stereotype. He can't have been that way during casting. I don't think MTV is out to cast ass****s. In the future, I hope he learns that the best relationships are grounded in communication and respect—two things he lacks. **Will we keep in touch?** No.

MATT. I really like David. My relationship with him was not easy at all. I don't think anyone can be in a relationship with David and have it be easy—not even his mother. He was not raised with brothers and sisters, and so he hasn't learned a lot of lessons. In the house, he shared least and gathered least. You only get what you put into it. **Will we keep in touch?** Oh, yeah.

JULIE. David's the roommate with whom I had the most conflict. It's not that he's so exceptional at everything that makes us resent him. It's how he talked to us and dealt with us. Maybe watching the show will give him more awareness. If he can learn to communicate with people and work with people, I think he has a beautiful career in front of him. **Will we keep in touch?** I'd like to keep in touch. I don't think any of us should walk away from this and not keep in touch.

KELLEY. David is a really sensitive person. That's why he's such an extremist. He's really not that tough and that hard. When this is over with, just like me, he'll be able to watch himself and see—really see—how he behaves. It wouldn't be so bad for him to show his weaknesses sometimes. He will absolutely be a success. If someone would just give him some props, maybe he could come down for a while and take a nap. **Will we keep in touch?** I hope so. I can't guarantee anything.

DANNY. I really had little in common with David. I don't know very much about him. If he changed very much, I don't know. I know that the main reason he was here was to put his foot in the door, get a career in music. I hope this helps it happen. **Will we keep in touch?** Probably not.

dealing with your flaws. David was on a quest for perfection and if people don't live up to the level of perfection that he expects for himself, he doesn't deal with them. I think a lot of the roommates felt that he didn't care about them. In watching his interactions with them, I could see how they felt that way.

I'm glad that the cast confronted him, although in the end, I think the cast wrote him off in the same way he wrote them off. David is a good guy. He can speak kindly and intimately. I also think he is extremely talented, but he has to learn how to express himself through means other than music.

The entire time I was in New Orleans, I was normal. There was no façade. I was myself the whole time. ⚜ A lot of people in the house had skeletons in their closets—some more than others. I didn't have any skeletons. I come from a beautiful background of family and friends. I had the benefit to not have to protect anybody, any skeletons. Melissa, Julie, and Danny all had those skeletons to protect. These are the realities they were dealt. So, they didn't put all their guns on the table. Jamie and I did. We put all our guns on the table. How those people acted in order to protect their skeletons will affect how viewers perceive them, how real they come off.

I had many conversations with my roommates about whether cameras change how you behave, and before this project I would have sworn they didn't. After all, I was a veejay. I was used to cameras. But here, people's moods changed with the cameras. The cameras made people behave inconsistently. Melissa, you could control her behavior by lifting up and putting down the camera. Julie, too, would get more flirty, behave more outrageously when the cameras were around—although not to the caliber of Melissa. ⚜ About halfway through the project, it became evident to me that unless you were going to talk about issues in the house or with your family, the camera wouldn't want you. In my real life, I don't talk about relationships—at least not like the people here who do so 24/7. ⚜ I realized that if I didn't start talking about relationships, I'd just be the guy in the background. So I made a conscious decision to get more involved with my roommates. I realized that I needed to do that to get on camera. I know the point of the show is to be real, but it's also to be famous. Maybe people don't admit that, but it's true. ⚜ I figured you only get on *The Real World* once. So, while I didn't get involved in the tempestuous drama of the house to the extent the others did, I did do the token talking about relationships, emotions, and issues. I'm someone who *does* things. Sitting around and talking about yourself 24/7 was a very foreign concept to me. In the beginning, Danny, Kelley, Julie, and Melissa spent all their time relating and chilling. Jamie, David, and I were left to do things. I couldn't let go of the idea that I had to have something to do. I lost some of my self-worth just playing all the time. I had to force myself to taper off my productivity. I did pretty well, I think. ⚜ It's important to me to know day-to-day that I've accomplished something, done something worth living. To create something each day is Godly to me. We're created in God's image. He creates therefore we create. I didn't have the creative outlets here that I have in Atlanta. There's no real hip-hop culture. Among other things, that was my leisure, my identity in Atlanta. Robbed of that, I had to find

Yes, I wore makeup during *The Real World*. Yes, I once wore makeup on a night out. But that's it. It's not a matter of pride; it's not a challenge to my masculinity. Makeup makes you look better. Girls have known this for centuries. Guys should get a clue. I actually asked the girls to take me to the store and tell me which products to buy. I wore fingernail polish for about two years. I liked blues, metallic, iridescent colors, not black.

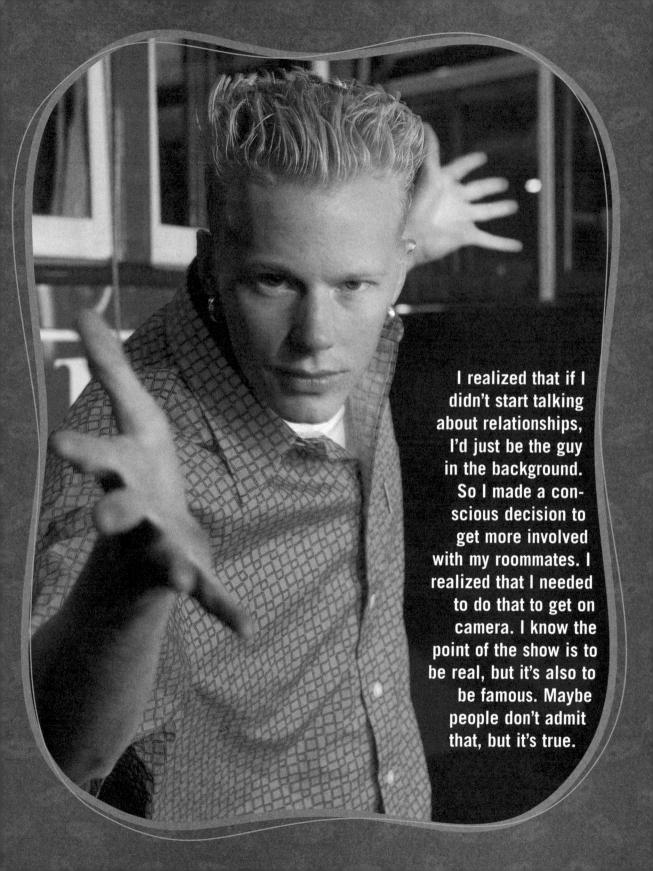

I realized that if I didn't start talking about relationships, I'd just be the guy in the background. So I made a conscious decision to get more involved with my roommates. I realized that I needed to do that to get on camera. I know the point of the show is to be real, but it's also to be famous. Maybe people don't admit that, but it's true.

I'D LIKE VIEWERS TO SEE ME AS...

Matt: I want to be seen as an honest stable, likable, passionate, creative, loving, selfless, focused, devout man.

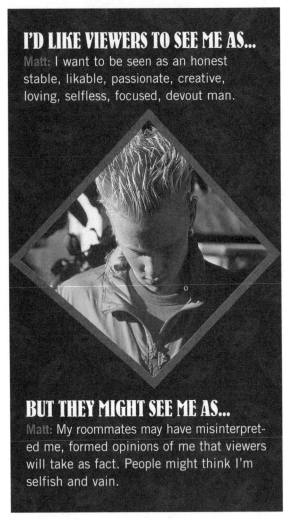

BUT THEY MIGHT SEE ME AS...

Matt: My roommates may have misinterpreted me, formed opinions of me that viewers will take as fact. People might think I'm selfish and vain.

other outlets. Julie helped when she told me to think of relationships as something worth creating, as a means of productivity.

Living with cameras made me more careful with how I spoke. Sometimes people were trying to beat each other to revelations, so they could sound insightful. Sometimes I would realize things and not share them out loud, because I thought I'd look like a tool, like someone who was just saying things to say them first. I also tried never to make assumptions about my roommates. I can't say the same for them. It's weird, but often I felt victimized by my roommates' sense of accuracy and certainty. I'm speaking specifically about a particular instance when Kelley told people I wore makeup.

I know it doesn't sound like a big deal, but it's just an example of something that would happen in the house.

I feel some of my roommates felt they were being robbed of their lives because they were on a television show. I think Melissa, Kelley, and Danny all expressed that sentiment. They felt that regardless of what they did, they were going to be portrayed in a certain way and there was no escape. That's bull. It's self-handicapping to think "I know I'm going to get screwed over. I know the production is out to get me." It's like they blame the system for their own actions. I take full responsibility for anything I said and did. I've never before been so accountable for my words and actions. No, this is not real life. But, still, I am responsible.

What will most shock your friends and family?

Matt: The Julie thing. None of my friends really know about it. Only my mom does.

How do your friends on *The Real World* compare to your friends at home?

Matt:: Well, one tends to be drawn to people like one's self. With my friends at home, I have a shared past; I don't have to break down every action, every word.

CREW VOODOO

Mary-Ellis Bunim: Matt is rad. Totally stylish, smart, and funny. I wish we had been given the opportunity to know him better, but he seemed a little afraid to share who he was.

Jonathan Murray: I think Matt would make a great late-night talk show host. His wit is so dry and his comedic timing is impeccable.

Andrew Hoegl, Producer: Casting Matt, I saw someone who was an anomaly. He was this guy who came from this really rural town and had totally embraced hip-hop culture; and he was an incredible designer with really strong convictions. When Matt stepped into the house, I thought that he would express those convictions a little bit more than he did. I don't think he ever really let it out.

The **VOODOO** on...MATT

DANNY: Matt and I have some common bonds. We both grew up in small towns. We followed the same path, both ending up in Atlanta. But we're very different. Especially in the way we deal with conflict! I'm the first one to leave a conversation I don't like. Matt stays. **Will we keep in touch?** Yeah, probably. We live pretty close to each other, so it will be easy.

JULIE: When I met Matt, it rocked my world. He's Catholic! I never knew I could have a crush on a non-Mormon. I want to stop having a crush on him, but it's hard. What does bother me is his ego. I wrote him a note telling him that, and he told me his boasting was comedy, how he dealt with things. I don't know if I believe him. **Will we keep in touch?** Yes, even though I'm not Mrs. Supa Fly.

JAMIE: Matt's a really great designer. Everything about him emits this flair. They way he dresses, talks, interacts with people. He's going to be really successful. His talents are so needed in this world right now. He's so marketable. He has a bright future. He does have his own problems. He looks only to God to make things straight. But he's a happy person who's gotten to levels some people never touch. **Will we keep in touch?** Yes. He's doing some designs for my company.

KELLEY: Matt was a little putty-ish at first and he got a lot harder—no pun intended. He's got a lot of inner strength and I think that's going to carry him very far. Matt has become less protected. He's also become slightly more egocentric. (Can you put a *hee hee* there because I mean that in a good way.) He's going to be more successful than anyone in the house. **Will we keep in touch?** God, yes. I've got to be around when he gets laid for the first time.

MELISSA: Matt is the most patient person. Also, he doesn't half-a** anything. He's straightforward. He's a go-go-go kinda person. He will also be the most awesome boyfriend. I've never heard a boy talk about spooning and getting married so much! **Will we keep in touch?** Oh yeah, we'll keep in touch. I'll need his advice on building a Web site.

DAVID: Matt is this devout religious person who has his views on sex and stuff. But the problem is that everything he's against, he actually wants to do. I think it's making him crazy. If Britney Spears was in the room, he'd hump her in a second! **Will we keep in touch?** Maybe, yeah.

I think he was very affected by the cameras. There were a couple of times when I think Matt was really hurt and really angry, and he just let himself be hurt and angry. In interviews, I was constantly encouraging him to say what he felt and act on his feelings. He got mad at me for harping on it.

He's a really good guy and I think that this experience will have a lot of residual effects on him. I think this process started to open him up.

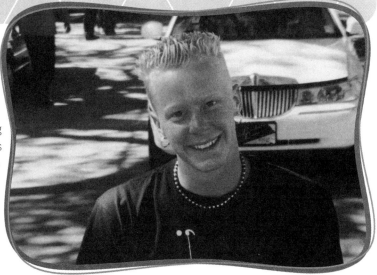

Pick Your Favorite

Cookie: Grasshoppers
Ice Cream Flavor: mint chocolate chip
Guilty Pleasure: masturbation
Book: *Brave New World* by Aldous Huxley
Movie: *American Beauty*
CD: Smashing Pumpkins, *Siamese Dream*
Real World-er (past or present): Heather B. from New York
Road Ruler (past or present): Dan *(Road Rules-Northern Trail)*
TV Show: Any nature or travel show
Cartoon Character: Scooby Doo
Scent: Nag Champa
Hair Product: Murphy's pomade
Item of Clothing: the gray turtleneck sweater I wore during the show
Actor: Jared Leto
Actress: Whoopi Goldberg
Cocktail: Tom Collins
Coffee Drink: iced coffee with a shot of almond
Teen Movie You Most Identified With: *The Breakfast Club*

Best Dressed: Kelley, when she got dressed
Worst Dressed: David
Best Dancer: me
Worst Dancer: Kelley
Best Cook: Kelley
Worst Cook: Julie
Cleanest: Matt
Messiest: David
Most Diligent: Matt
Biggest Procrastinator: Julie
Best Smelling: Jamie

In the House

How many hours did you sleep a night on average?
10
How many naps did you take every day on average?
1 or 2
How many times a day/week/month did you exercise?
daily
Get a haircut? once a month
Shower? daily
Which roommate did you see naked? Kelley
How many confessionals did you do a day/week/month?
1 every two weeks
How many hours did you spend online a day/week/month? 30 minutes a day

Pick Your Favorite

Cookie: Soft Batch chocolate chip
Ice Cream Flavor: chocolate
Guilty Pleasure: shoe shopping
Book: *Black Like Me* by John Howard Griffin
Movie: *Welcome to the Dollhouse*
CD: *Get Up Kids: Something to Write Home About*
Recording Artist: Erykah Badu
Real World-er (past or present): Cynthia from *The Real World-Miami*
Road Ruler (past or present): Yes from *Semester at Sea* (damn, he was cute).
Web site: mulletsgalore.com
Magazine: *Jane*
Writer: Maya Angelou
Artist: Lionel Milton
TV Show: *Dateline* with Stone Phillips
Cartoon Character: Dexter of Dexter's Laboratory
Scent: Victoria's Secret (discontinued) Vanilla Lace
Hair Product: Luster's Pink Oil
Item of Clothing: Pink floral Lily Pulitzer dress
Actor: Kevin Spacey
Actress: Parker Posey
Cocktail: baybreeze
Soda: Cherry Coke
Coffee Drink: I hate coffee
Teen Movie You Most Identified With: *Welcome to the Dollhouse*

Best Dressed: Jamie
Worst Dressed: David
Best Dancer: Jamie
Worst Dancer: Kelley
Best Cook: Kelley
Worst Cook: David
Cleanest: Matt
Messiest: David
Most Diligent: Matt
Biggest Procrastinator: Kelley
Best Smelling: Danny
Worst Smelling: David

In the House

How many hours did you sleep a night on average? 8
How many naps did you take every day on average? 1
How many times a day/week/month did you exercise? never
Get a haircut? once
Shower? daily, twice sometimes
Which roommate did you see naked? Danny
How many confessionals did you do a day/week/month?
lots of confessionals
How many hours did you spend online a day/week/month? not many, Matt was always on the computer

KELLEY

I got so much out of New Orleans: Danny and Julie who are great friends and Peter who's the love of my life. For all the bull you have to deal with, I feel like I got to walk away with the gold medal. Lasting relationships are the Real World.

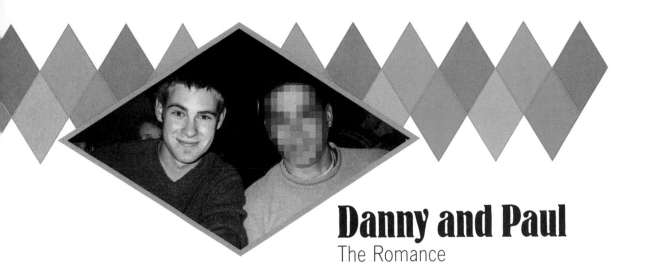

Danny and Paul
The Romance

DANNY: I know it seems strange to viewers that Paul and I knew each other for only a week before I got to New Orleans. It's just that the minute we met, there was this energy. In the first hour talking to him, I felt like I knew him. We hung out for three days straight. (That's when we took those pictures I put up in my room.) It was right before I left for New Orleans that I said, "I love you." I know that sounds nuts. I told Paul, "Look, I know you're going to think this is weird, but I feel like I love you." I couldn't believe I was saying it. He said, "I don't think that's weird, because I feel the same way." ♥ Having just met Paul, I didn't know how much energy I wanted to put into the relationship. I called and told him I wasn't sure I wanted to make anything serious out of it. But talking to him made me realize he was really into me. And then, when he visited me, that just made me realize how special this was. He was willing to come down to New Orleans, and put his career on the line. Every day that passed, I got more and more into him. He ended up making four visits. And we talked on the phone about four times a week. ♥ The reason I'm so into Paul is his personality. How to describe Paul? He's got a lot of energy. He tries to be positive about everything. For me, that's really important. I just don't want to be around negative people anymore. He has a lot of the same interests as I do. He likes to camp and spend time outdoors. He's the most genuine person you'll ever meet. We're opposite in the sense that he's really open about how he feels and I'm really reserved. But, being around him, I'm a lot more open. His openness wears off on me. ♥ We have little things in common, like music and clothes, though Paul's preppier than I am. He's a total Abercrombie & Fitch guy. I hate Abercrombie & Fitch, but he gave me a bunch of sweaters from there that I love. It looks like that's all I wear on the show!

For all of you who have only seen a blur, you should know that he's got black hair and dark gorgeous eyes and a damn nice body. He has a beautiful body. It really pisses me off that he can't be seen. I want people to see him and how gorgeous he is. I'm so proud. But it's all about the military and the freakin' laws.

When Paul came to New Orleans, we'd close ourselves off into a cocoon. We'd stay in the room together and just cut out the roommates and everything else in life, except each other. Paul liked all the roommates on a surface level, but honestly, when he came to visit I was the only person to whom he paid attention. Actually, the truth is, Paul thought some of my roommates were ridiculous spoiled brats. He's a little older than they are, and he just didn't want to be around them. Especially Jamie. He likes Kelley and Julie and he likes Melissa to a degree, but she too got kind of annoying. Paul was coming into a situation he couldn't stand. That meant a lot to me.

We did a lot of running from the cameras when he was here. At first he was really nervous. The second time, he relaxed. The last time, we were used to the cameras, but we were sick of them. We ran off to a hotel room and no one knew. It was great.

If I regret anything, it will be what Paul sees in the Mardi Gras episode. I regret all of Mardi Gras. The only creeping I did was when I got busted making out with that guy in the confessional. It was one of those party fouls, a big oops. Paul will see that, and that's pretty bad.

THE AFTERMATH

The minute I got off the plane from New Orleans, Paul picked me up. I'll admit I was nervous. We had not spent that much time together, and I knew this was going to be *the test*. We went on the road together for three weeks. We went to Arkansas to visit Kelley. We went to my parents' house. They love Paul. My dad will sit there and talk to Paul all day long. He loves all the military stuff. He talks to Paul more than he talks to me. After the trip, I felt twice as much for him as I did before.

I live with him now. It couldn't be any better. We watch a lot of movies and spend a lot of time on the beach. We go camping a lot. Definitely, I was very nervous about moving in with him. But I've never felt better. Since the show, we've learned a lot about each other. Certainly, we've learned some bad things. He realized it's hard to pull a lot out of me and that there are certain things I just don't talk about. I know I have to overcome this.

There's been a lot of press requests for both of us. Most people want to talk to me about "the Paul issue." We just want to lay low. Except for *The Advocate,* I basi-

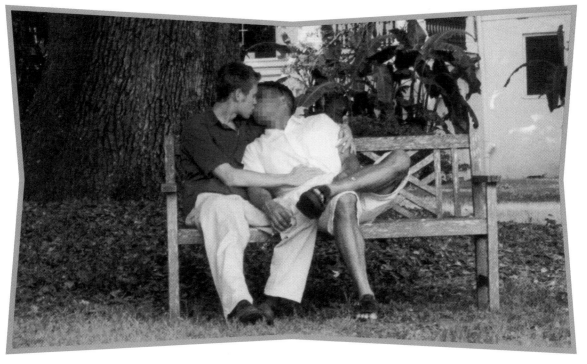

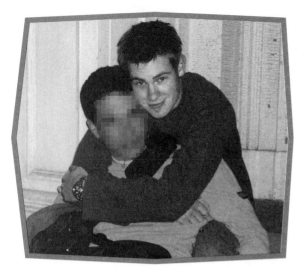

cally turned everything down. *The Advocate* is a big gay magazine, and I felt I wanted to speak to that sector of society. I felt I could do that magazine, and be done with it. I don't want to do anything else until Paul's out of the military.

Paul just wants *The Real World* to go away. I think he felt that when I came home, the show was over. I don't think he realized it was only just beginning. Yeah, he likes watching the show. I'm always complimenting him! He likes seeing that.

PAUL. You always think love at first sight is never going to happen. But the minute I met Danny, my chest started hurting. I wasn't having a heart attack, so I guess it was love. It was like I saw him, and I knew I'd be in it with him for good.

What's the best thing about Danny? Everything. A minute does not go by when I don't think about him. Actually, twelve seconds don't go by when I don't think about him. (Yes, we actually figured it out once!)

Before he moved to New Orleans, we were like, "Oh, it'll be fine. We can *not* see each other for five months." Yeah, right. Five minutes after Danny left on the plane, I missed him terribly. It's true.

I was scared as hell when I first went to visit him. I drove by the house in the taxicab about three times. I was so freaked by the house. It was lit up like a Christmas tree. So I told the driver: "Drop me off at the drugstore up the street." I called Danny from a phone booth. He was like, "Come over. It will be fine." I hid

behind a tree and he came out. Then, the cameras did. At first I was defensive. When the cameras first surrounded me, I was going out of my mind. We had to break the rules, and have a sit-down with the directors and producers. Danny was holding me when we were talking. I wasn't comfortable at all, and I was really scared. But I decided to put my trust in the crew. I asked them to empathize with my decision not to show my face on camera.

I did not want to put any pressure on Danny to stay faithful. I didn't want to put rules on him. But I told him I loved him. I told him I wouldn't screw around. I said, "As far as I'm concerned, you're it, written in stone."

"Enough said," was his response. "You don't have to say anymore." He echoed my feelings. It was so meaningful. To have someone you're head over heels in love with say the same thing back! There's nothing I can't say to him. There's no hiding. I feel comfortable telling him anything. He knows more about me than my mom does.

Going into the *Real World* house was weird. Everything there was going a mile a minute. Camera crews make life go fast. I spent most of my time there trying to get away from that atmosphere. It was too busy for me.

I know the roommates thought it was bad, but we couldn't keep our hands off each other. My hands start tingling if I don't touch him for an hour! I go into Danny withdrawal. Our carrying on is pathetic, but we're just pathetically in love.

To be on *The Real World,* you have to be willing to be displayed. I did not go there to be displayed. I went there to see the person I love. My life is personal to me. It's also a matter of keeping my job in the military. I want to serve my country. I want to get out on my own accord without them telling me to get out because I'm a homosexual. I want to do my time. Not because I owe it to them, but because I want to.

I don't expect the military to change overnight. Change doesn't happen overnight. I don't know if seeing Danny and me on television together will do anything good for the world. I guess I feel that the more gay people on television, the better—especially more different kinds of gay people.

The VOODOO on...DANNY and PAUL

MELISSA: Danny and Paul's relationship is so awesome. I hope being on TV doesn't have scary repercussions for them. I hope their love story doesn't get cut short.

MATT: Danny and Paul, I don't know either of them very well. I do know they really love each other. The entire time he was in New Orleans, Danny yearned to be with Paul.

DAVID: I think Danny and Paul will make it together. But they'll both have to be stronger than humanly possible.

JAMIE: I think Paul and Danny will stay together. I think it's great. It's hard to find somebody who really resonates for you.

KELLEY: Danny and Paul, I think they're awesome. I think they're so in love with each other. I don't think that. I know it.

JULIE: I think Danny and Paul are going to be together for a long time. Danny and Paul are more committed to each other than a lot of married people I know. There's a lot of love there. I admire that.

I guess if I want to tell people watching the show anything, it's that *true love is out there*. Love at first sight happens. When it's right, you have to go for it. Jump right in, feet first, and do a lot of dog paddling—then you'll know how to swim.

My friends used to tell me I was too picky, that I'd end up an old man on a porch with my hound and a shotgun all alone. Well, ha! I beat them at their game! All those people who don't believe in the concept of true love—they're the ones who will be sitting on the porch.

DANNY'S SONG by JULIE (For Danny and Paul)

VERSE ONE
Walking down this lonely beach I feel the sand
beneath my feet and think of you.
The wind blows warm across my face and my slow fingers
gently trace the way you do.
I hear your voice. It's so close to me now. I see your face
every time I turn around.

CHORUS
I love you with everything I have and all I am.
No one else but we ever needs to understand.
You paint a portrait of me with your life and
with your hand.
I have faith in our love.

VERSE TWO
Time pushes you away, but the time moves closer
every day that I'll be with you.
I see my future in you. It's in everything you say
and do.
No hateful words will ever kill this for me.
In my life your love is all the world I see.

REPEAT CHORUS

CREW VOODOO

Andrew Hoegl, Producer: Before Paul walked into the Belfort, I saw him standing outside. He was literally shaking. He was very scared, full of fear for his career. The crew felt terrible. One of the directors assured Paul that we'd be able to hide his identity. Certainly, we didn't want him to lose his career. And we didn't want to keep him and Danny apart.

It's terrible that our government asks Paul to hide who he is as a person. Paul was really brave to allow us to film their relationship. The fact that he's blurred just represents how ridiculous the military's policy is.

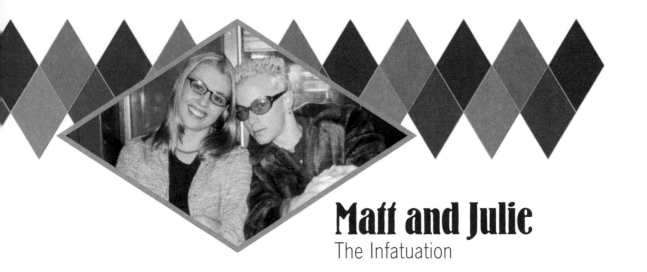

Matt and Julie
The Infatuation

MATT: There were never times when I thought I had a crush on Julie, but there were times when I admired her more than I did other girls in the house. ♥ I would have feelings for her that were beyond friendship, but it never came close to a crush. I really liked Julie and respected her, but I'm really picky. I haven't chosen to be like that. That's just the way I am. I aim high. ♥ I think that Julie made efforts to stop liking me. In doing so, she decided to pretend I was someone I wasn't. It was like she wanted me to be asinine and selfish. She ran around talking to everyone about my faults. I can't say I liked that. I'm not going to pretend this was a 50/50 situation. Julie was the one with the crush, who was going through turmoil; I was the stable guy, the one who was happy with his life. ♥ And there were elements of her behavior that I really resented. I would be taking a nap, and she'd come up and sleep next to me. Now, I've shared beds with girls, when it's at slumber parties, or they're my sister's friends. But, this situation is different—particularly because it's being filmed. Now, let's say she comes and cuddles in my bed without my knowing it. We sleep through the night. In the morning, you know what will happen: we'll wake up with a camera in our faces. In my real life I wouldn't care. But, how is it going to look on the show? What does that say about my beliefs? For that matter, what does it say about her beliefs? ♥ I admit that when she first started being affectionate, I was pretty squeamish. But, so what? I was concerned about how it would look. And, yes, I was more uncomfortable

> **The majority of our problems were Julie's, not mine. Here's how a normal day in the Belfort would go: I'd make my coffee, check my e-mail, take a walk, and then at the end of the day come home to find out I'd somehow made Julie furious. She'd just fabricate things in her head.**

> **I didn't want Julie to look like the seductress she isn't. I didn't want her to look like a floozy. I wanted to protect her. This was not casual flirting. She's a *very* affectionate young lady.**

when it came to bed-oriented stuff. I would just have to get up and leave. If I had made a big deal about her nappy-time cuddle habits, been up-front about how I thought it was going to look, then it would have been recorded on my microphone and I would have been asked about it in interviews. So I was careful not to make an issue of it.

During Jazz Fest, I was lying on the grass. I fell asleep. When I woke up, Julie was cuddled up on top of me. I didn't feel violated exactly, but I didn't feel great, either. I wanted to push Julie off! I wanted to ask her what she thought she was doing!

I had to learn how to deal with her affections. Of course, I occasionally wanted to reciprocate, give her warm fuzzies or a kiss. But, that would have led her on. I didn't want to be a tease. OK, sometimes I'd shake my butt or do stupid dances for her. But that was just for fun.

I imagine most guys would love to wake up with an attractive girl on top of them. Believe me, I think it's cool that someone on *The Real World* liked me, but I don't think I'm the s**t because of it. This is not me ego-tripping. I acknowledge that Julie might be Mrs. Perfect, but I don't think she's Mrs. Matt.

JULIE:
At the end of our time in New Orleans, Matt became nicer to me. Not in front of the cameras, of course! But, off camera, he got sweeter. He even let me kiss him on the lips once. We were lying down on a lawn. It was cool. Then I asked him, "What are you thinking about?" His reply? "You." He said he was thinking about all the little things I'd done for him in the house, like the one time I brought him a doughnut in bed. I said, "You know, I would have done more things for you if I'd thought you'd wanted me to."

He said: "It's just that I've waited so long for somebody to do those nice little cute things for me and now that it's here, I don't know what to do." I asked him why he was afraid of me, and he just gave me these puppy-dog eyes. I know he wants the next person he kisses to be the future Mrs. Supafly. OK, fine. It's not like I wanted to have Matt's children, but I did have a crush.

Our kiss was nice, but it wasn't anything serious. It wasn't sexually driven. It was a soft little kiss and then it was done. One tiny little peck from Matt was so much cooler than kissing Jamie for minutes. Matt's just sweet.

I think Matt wouldn't allow himself to like me. His battle cry was always "I'm Mr. Constant-unchanging-the guy-who-doesn't-step-outside-the-box." If it looked like he was starting to like me, he'd seem inconsistent.

If Matt had one time told me to lay off, I would have stopped flirting with him right away. I mean, it took me months to tell him how I felt about him. Then after that, I felt like we could be open and I could joke about it. He never told me, "Don't do that." He totally played it out. I think he wanted there to be a story between us, but he didn't want to instigate it.

Supposedly, he's trying to protect me from how I'm going to look on camera! Oh, is that why he didn't want me to flirt with him? 'Cause he thought I'd look like a hussy? Well, that's sweet, but I don't buy it. I don't see why he wouldn't just be honest with me. Matt was preoccupied with image. He wanted to be like Teck in Hawaii, giving the camera only what he chose. I don't believe in trying to manipulate the system. I came here to learn. He wanted to seem consistent; that was his main goal.

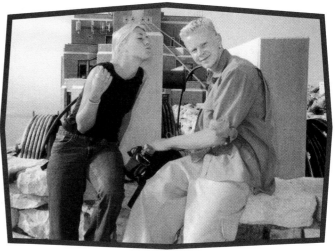

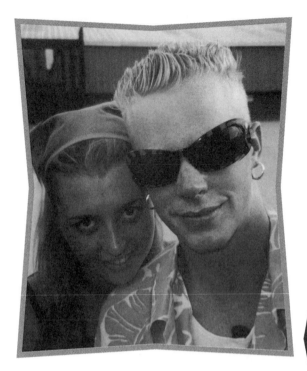

He just felt that he'd already established who he was on *The Real World*, and he didn't want to look "confused" to viewers.

Julie and Matt played footsie and pool, but what they both truly needed was a good f**k. If they got together, it'd be perfect, a cute little thing.

Matt will be successful in life, but his morals are going to hold him back. His high-horse thing is going to keep him down. Especially where ladies are concerned. We've talked about him meeting "the one." Well, it just so happens that "the one" might be somebody who's already had sex. I think he'd drop someone because of that. That would be ludicrous. He could be alone for a long time. And Julie? That girl does not even believe in masturbation. I think she might explode!

> **Julie: I'm a virgin, yes. But I'm very confident in my sexuality. One thing does not preclude the other.**

Melissa: Both Julie and Matt would talk to me about the other. This girl was tormented. When would she ever meet another spiky-haired religious guy who was into the Internet? Matt was perfect, and she couldn't have him. It really brought her down. It was a simple crush. So many girls can relate to that, myself included. I think Matt should have given it a chance. I don't think he was ever open to the idea. That would have been the cutest thing if they'd hooked up. Holding hands and tongue-kissing! Ooooh, scandal!

CREW VOODOO

Andrew Hoegl, Producer: I thought it was really funny to watch Matt and Julie's relationship. To everyone on our side of the wall, it was so painfully obvious that Julie was just pining away for him every second of the day. For the first month and a half, Matt was totally oblivious and then afterward he was uncomfortable. After she realized he was uncomfortable, she did it more. She'd try to kiss him on camera! His squirming just made us laugh.

I confided in Matt, and he threw stuff back in my face. I told him things about my relationship with my dad that I didn't tell anyone else. I'd tell him about how scared I was to go home, about my life, and then he'd accuse me of putting the bulk of my problems on him. What? When Matt and I talked, it was in circles.

Matt and I would be bad together, bottom line. But knowing that doesn't stop me from liking him. I don't know if I'm just a lusty person, or what. It's just hard to turn off something you feel. When I look at Matt, I like him. I just think he's so good-looking. Maybe I just like baby-faced guys, I don't know.

At the airport, I knew Matt was going to try and kiss me good-bye. At first I didn't let him. I was thinking, "Dude, don't do me any favors. Don't make camera candy out of my feelings." But then I let him. It wasn't even a kiss. It was more of a peck. Still, I was all giddy afterward. I was typical Julie falling over myself. I didn't take it seriously, but it made me a little bit happy. I believe in owning your feelings.

David: Julie's horny. She wanted Matt bad and he wanted her. Definitely, he wanted her. As adamantly as he denied it, he knew Julie was exactly what he wanted.

Jamie and Kelley
The Secret Liaison

JAMIE: I came into this process with this belief that there are four kinds of women you never hook up with: 1. Your next of kin. 2. Your best friend's girlfriend or ex-girlfriend. 3. Prostitutes. 4. Your roommates on *The Real World.* ♥ Kelley came to New Orleans talking about how she didn't want to have a boyfriend, how that was the last thing on her mind. Well, she told me that though she wasn't looking for a boyfriend, she thought that we could hook up without a relationship. She wanted us be kindred spirits and best friends. To me, that sounded like a pretty significant connection. ♥ I think Kelley is codependent; that she gravitates toward having a man in her life. I really had the sense that Kelley might be a psycho woman after we hooked up. There were nights when she wanted me to come to her room. I just didn't want to go there. I think that started to bother her. She'd say, "Jamie, you want to deny me, so that when this airs, all girls will think they're better than me 'cause you denied me." When she saw that I was shocked she said that, she passed it off by saying, "Oh I'm just joking." ♥ Kelley would try to talk about this stuff with me. She'd be like, "Why are things so messed up? Why are things so messed up?" I'd be like, "Kelley, I think that maybe we're both attracted to each other and there's tension there. Period. End of story."

One night early on in the season, Kelley came into my room. She was being really stealth about the whole thing. I was lying in bed, and she jumped on top of me, telling me to keep it low. We didn't do anything major. We just rolled around, and did the making-out kind of thing. Although it didn't get that far, I could imagine she'd be good in bed, yeah.

♥ Aside from being attracted to each other, Kelley and I didn't get along for many reasons, mainly having to do with her. Kelley needs to look inside herself. She's so thick-headed and stubborn. I'll admit that I can be insensitive, but you have to take ownership of the things you think. As an example: Kelley claims she's not biased, but one of the first things

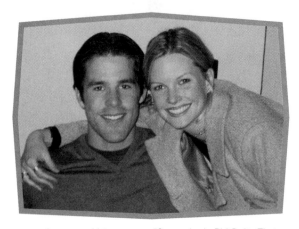

she ever said to me was, "So, you're in Phi Delta Theta. That means you're an a**hole. I know what those guys are like." That's not biased? In my opinion, that's a really weird way of making friends. Kelley doesn't like me. She should just own up to it.

I feel like I occupied Kelley's thoughts in negative ways all the time. It didn't have that much to do with me. It was the same thing that was happening between Julie and Matt. Julie was calling Matt an ahole, yet there she was thinking about him all the time. Matt and I were continually being like, "No, I'm not thinking about you. No, I'm not thinking about relationships all the time." We did so much girl talk in the house, it was draining! You get drawn into it by the women in the house. I think all of them have some growing to do. They live in this constant paranoia as it relates to guys.**

Kelley's a good-looking girl, but now that I know her I wouldn't flirt with her at all. Yeah, at one point I called Kelley a psycho bitch. That just crystallizes a whole host of adjectives I think about her.

I know this is going to come off like I think Kelley wanted me in some big way. Whether she did or didn't, I don't really care.

KELLEY: There were only two times when Jamie's and my relationship got physical. Once in his room and once somewhere else. We kissed. Period. That's it. And that's the truth. When something happened, it was a kiss immedi-

ately followed by a freak-out moment. No, there was never a make-out session. It was stupid kid stuff.

In the beginning, I actually liked Jamie. I thought he was hot. Of course, I thought he had bad ideas about women. But I dug him. That doesn't mean I wanted to have an in-house relationship. I'd seen *The Real World-Hawaii!* Plus, I'd just gotten out of a relationship.

I hope that our being physical isn't what ruined our friendship. I wrote him a letter that said "I'm really attracted to you, but I don't think this needs to be part of a story. Neither one of us wants to have a relationship, so we're both on the same page. This doesn't need to go anywhere."

I kept saying to him, "I hope you're not offended but I don't want to revisit that moment." I meant it. I never wanted to experiment with Jamie physically. Aside from kissing him, I had no desire to take it any further than that. I had no desire to go there. I just like to kiss people. So sue me.

I admit that our relationship did start off kind of badly. I made a mistake on the second day by asking Jamie whether he was the typical frat guy. That was a stupid mistake, an offhand comment that he held against me the entire season. I'm sorry I said that.

But our rocky start doesn't make up for the fact that I think Jamie used what happened between us to his advantage. Jamie used the camera as a tool to cater to his image. He wanted to present himself in this ladies' man way to the cameras, and he used me to help him do so. For example: We'd be having a normal conversation, and then the cameras would come around and immediately he'd start in on me. We'd have been talking about nothing, and then he'd suddenly up and say, "Kelley, I don't want to have a physical relationship with you." I'd be so confused. There we'd been talking about baking cakes, and he was changing the subject to make me look bad. I'd look shocked, and say something like, "Huh?" What I should have said was "Well, I don't want one with you either." I was just never prepared. Jamie used the cameras to his advantage and at other people's expense.

I think it's hard for Jamie to accept that everybody doesn't love him and that every woman isn't falling down to be his girlfriend. He couldn't accept that the problems between us had more to do with who he is than the fact that we were attracted to each other. He was still saying that to me when I was with Peter. I would just be like, *"What?"*

People at home need to realize that in normal life you don't hang out with people you don't like. On *The Real World,* you do. Plus, you have to talk about the people you don't like, dwelling on their downfalls. It's part of the show. The truth is that in my real life, I would never spend time even thinking about Jamie.

Danny: Jamie and Kelley kissed several times. Jamie was always doing that, kissing people off camera. He kissed Julie. He kissed Kelley. I think it's funny.

I know that Jamie has problems with Kelley. A lot of it has to do with the fact that he doesn't like to be questioned—especially by females. Kelley was the person in the house who questioned him the most. I think that's why he hated her the most.

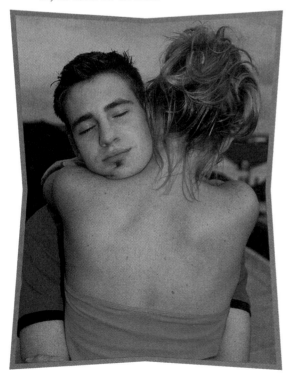

Andrew Hoegl, Producer: I know there was more going on between Jamie and Kelley than they let us see. I know that there was some offer to hook up. They were both really cautious with the cameras, I don't know why. We followed their story, but it never really boiled over. When Kelley met Peter, anything between her and Jamie died. We did once see a note in Jamie's room that Kelley had written him, telling him she liked him. It said that she was attracted to him. She was opening the door. I think she's always been frustrated because he didn't respond to that.

Under the Covers: Danny and Kelley

Danny: Yeah, I was doing some making out with Kelley, but that was nothing. I felt nothing. I wasn't hoping to feel something. I would have been annoyed if I'd felt anything. If there's an episode having to do with me and Kelley kissing under the sheets, I'll crack up. It was just us getting drunk and doing stupid things. It was nothing to talk about.

Kelley: One time Danny and I were at a bus stop and we were like, "Maybe we should kiss just to see how we kiss." We kissed and then we were like, "Ewwwww." I swear, there was no real making out! I never even had my top off with Danny in bed.

Matt: Here's what I really think. I think Kelley had a crush on Danny the whole time and would very much have liked for him to be straight. If he were straight, they would have hooked up and Peter wouldn't be in the story. Kelley always teased Danny, "Don't you know I have a crush on you? If you weren't gay, you'd be my boyfriend." She'd make those jokes all the time. You know, they're not *that* funny. It makes you wonder what they were actually saying. No, I didn't witness their feisty under-the-covers make-out sessions, but I figured they happened.

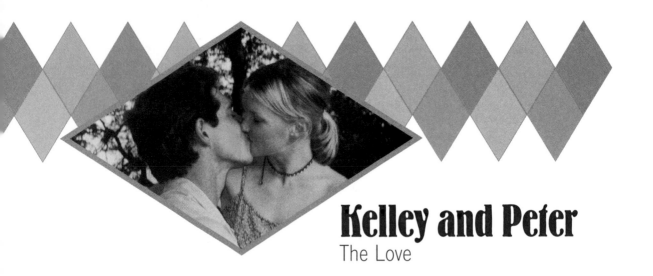

Kelley and Peter
The Love

KELLEY: When I got to New Orleans, I was hoping I could meet friends outside the house. There was so much drama in the Belfort, and I wanted to find friends—male or female—to just chill with. Well, it was hard to find somebody who could relax in front of the cameras. People either became huge larger-than-life hams or huge recluses. ♥ Peter was different. The minute we met, he seemed comfortable in front of the cameras. When I first saw Peter, I just died. We were at the Superior Grill, and I thought he was the best-looking guy there. We were talking and I was just thinking, *This guy is perfect.* When he told me he had a girlfriend, I told him—and this is really how I felt—that I enjoyed talking to him and I'd be OK if all we could be was friends. ♥ I gave him my number. I told him if he wanted to call me, great; if not, I understood. *The Real World* is not your normal circumstances, and I thought he might not want to deal with it. Well, when he didn't call for two days, I was freaking out. I was really upset about it. It turned out that he had paged me, but he didn't end up calling me. In the end, I think I called him. ♥ There were moments when I think the cameras were really hard on the relationship. I wanted to protect him. I didn't want to alienate or expose him in any unnecessary ways. Think about it: He has to maintain credibility in his medical career. And of course, there were times when I wanted to get to know him without the influence of a camera. There were parts of the relationship I didn't want the whole world to share. It's nothing torrid. It's just that having a relationship is not always fair game for everyone.

> There was just immediately a connection between us. There was a definite attraction, for sure. Then, with the personality, it was like, *Bam! It's over!* It was two days until I talked to him again. I was bouncing off the walls when we spoke, I was so happy.

> In the beginning, we were just hanging out. Then one day, he just up and said: "I'm in love with you and there's nothing to do about it. If the trade-off is that I'm going to be on *The Real World,* then that's the sacrifice I have to make."

Our first kiss happened off camera. We were in Peter's car. The "Ninja" {crew} van was following us, but there were two or three cars between us. All of a sudden, Peter just leaned over and kissed me. It wasn't a huge kiss, but it was so sweet. It was great, of course. I mean, I'm just very attracted to him. He just looks amazing all the time. But, yeah, he looks pretty damn hot in his scrubs. Also, he has the best chest I've ever seen on a human being in my whole life.

Peter was a saving grace for me. There were times when being in the house was really hard. He would hug me and talk to me and work me through my thoughts. He'd never tell me what to think; he'd never make opinions about people in the house. He's really open-minded. I think that comes from experience.

What would we do together? Just sit around acting all goofy. Or sometimes we'd drive to the levee. We'd eat mac 'n' cheese in bed, and laugh at all the dumb drama in the Belfort. Getting away from the house made me

realize it was all pretty humorous. Not to underestimate people's growth or anything.

I am absolutely impressed and amazed at how Peter dealt with the situation. Everybody liked him. Jamie's favorite thing to say to me was: "How could Peter be with you when he's so awesome?" I don't think there was anybody involved in the cast or crew who didn't like Peter. They're pretty much right on the money there.

PETER: I met Kelley in this really cheesy place. It's the kind of place you go to point and laugh at people, not actually meet people. Well, I couldn't believe there was a girl like Kelley there. There were a lot of made-up people in that bar, but she just stood out for being really pretty. "Damn," I thought. "That's a really pretty girl. She has such a pretty smile."

I wasn't sure whether I'd introduce myself, but she pointed at me and motioned for me to come over. I didn't go over immediately. I thought I'd give her the five-

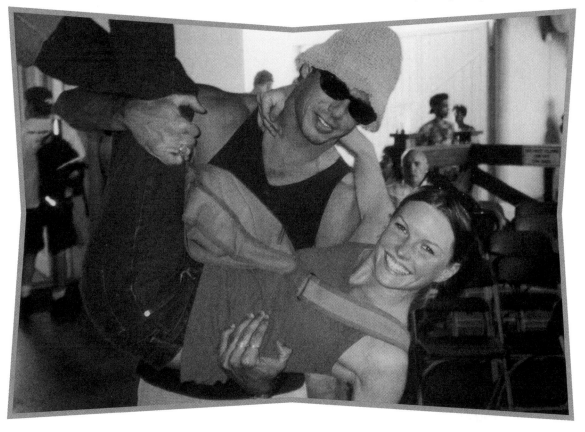

MATT: The truth is that until Kelley met Peter, she wasn't very happy in the house. Before she met Peter, all she did was eat, sleep, and go to movies. My perception of Kelley is really from a distance. The relationship with Peter gained more and more momentum—until she did not live in the house anymore.

DANNY: I definitely know that Peter was sick of the cameras. It was definitely a stressful part of their relationship, and it caused some conflict between them. Peter was definitely not planning to have *The Real World* enter his life.

MELISSA: Kelley and Danny were together 24/7 and Kelley got a boyfriend just about the second we got to New Orleans. I don't think it's a bad thing to be codependent. You're a girl who likes boys, so what? I liked Peter, though. I hope they work out.

JULIE: Kelley and Peter are both at comfortable stages in their life. Unless she gets some kind of fever back, she's going to be in a stable thing. He's a nice guy, perfect for her. Visually, they look like a good couple.

DAVID: Kelley and Peter will be fine. I can see them together. He'll finish his residency and she'll stick by him. I think they're both very solid. Sometimes you see a relationship, you think, *What made him pick her or her pick him?* With them, it's obvious. They're just movie star-looking. Everywhere they go, people are trying to hook up with them.

JAMIE: A lot of the roommates are swaying in the wind, taking whatever opportunities come their way. Supposedly Kelley's going to live in New Orleans with Peter for the next few years, but I think she's the type of girl who wants to run. I don't want to question her love. I know she has deep feelings for Peter, but whether she's ready for forever, I don't know.

I think Kelley has no direction. She's just "See where the day takes you." She didn't finish up at school and she bounced around. I suspect Peter is just another step in the journey.

I like Peter. I would totally hang out with that guy. I don't get it. I like him. She likes him. So why is there so much tension between me and her?

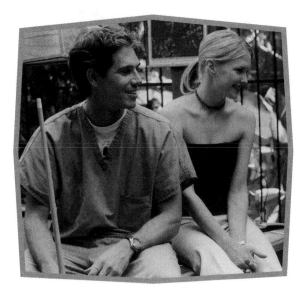

minute wait period, you know, not run over like a puppy dog. But I did go up to her first. My first impression was that she was really cute, but a little young. I told myself: If she's younger than 21, I've got to get up and walk away. I was actually the one to lie and tell her I was 28. (I'm 31.) Then she told me her old boyfriend was 30, so I realized that age wasn't an issue for her.

At first, we both held our cards, didn't say anything about what either of us did. We were just doing flirty talk about this and that. Then, all of a sudden, she turned her shirt inside out and showed me her mike. I was freaking out. I had no idea what she was trying to tell me. I thought she was an agent for the DEA who was trying to get me to be on a sting team!

All she would say was that she was working on a project! It took me a few minutes but I figured it out. "You're on *The Real World?*" I asked. The minute I said that, it was like the cameras came out of the bushes and surrounded us. The crowd wouldn't leave us alone. Danny and Paul were there, too.

After that, Kelley and I just snowballed, we just clicked. It was when she went to Africa that I could tell this was going to be something. I was waiting for the phone to ring all the time. I hadn't felt that way in a long time. We were just goo-goo-ga-ga the whole time. We're super sappy. I've never told someone I love her as much as I've told her.

Mostly, I was trying to kidnap her. Often, Kelley just wanted to hide at my house. To me, that meant she wasn't trying to get as much camera time as possible; she wasn't all *me me me.* I grew up in L.A., and I'm really not into fledgling actresses. I myself didn't ever feel 100 percent comfortable in front of the cameras. Especially when we were having arguments. During one argument, the camera guy got so close to us he hit me in the face. Seriously, I would have rather not been on camera. At first you get so nervous, you can hear your voice trembling. But you get used to it.

All the roommates were cool to me. Do I think people were jealous of us? No. But maybe they were jealous of what we had. Kelley had a place to escape and they were like prisoners. Melissa was always like, "Where can I get me a Peter?" I enjoyed Melissa. She's always funny, but she's such a dominant person. It's just like wind her up and let her go.

As for Jamie, he didn't do a lot of the outdoor extreme stuff he said he did, but I never called him on it. There was only one time when he gave me a weird vibe, it was a "What are you doing with my girls" territorial kind of thing. I was in the hot tub with Julie and Melissa at the time.

Danny will be the one person in the cast with whom we'll keep in touch. He's my first gay friend! After the show, he and Paul came up to visit me and Kelley at Kelley's parents' place in Arkansas, and it was so great.

They were like, "if we get married, you guys will definitely be in our wedding."

I guess if there's anything I want to say it's that I love Kelley. In the past I've been careful not to use those words. But, now it's like I want to tell everyone. It's like I found a religion and I want to share it with the world.

CREW VOODOO

Andrew Hoegl, Producer: I think Peter's a really cool guy. Peter and Kelley make a really good couple. I think Kelley had a real relationship with him, and as a result she didn't have to deal with her roommates.

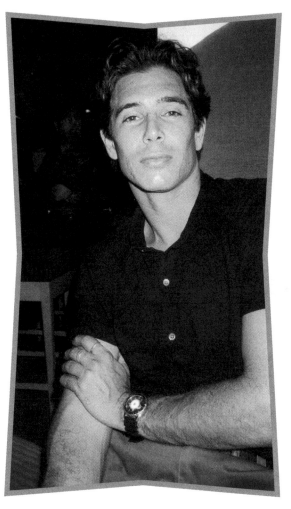

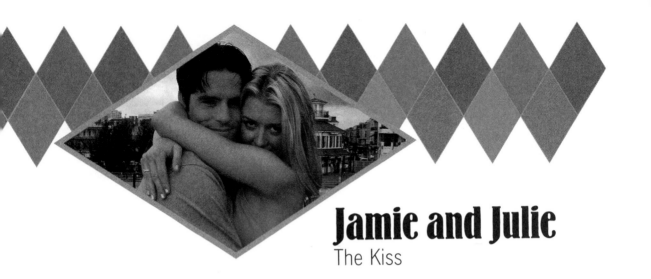

Jamie and Julie
The Kiss

JULIE: Yes, I kissed Jamie. It happened on a few occasions. That night of the mud wrestling, I think I was cursed (because I took shovels from the graveyard). Why do I think I was cursed? Well, because that night Jamie ended up sleeping in my bed. I was asleep and I woke up and we were kissing. I just rolled over and was like, "Good-bye Jamie." I don't know if he was drunk or what. ♥ I probably shouldn't say all this. I can't keep a secret when it's about myself. But, on the last night, most of us slept together. I ended up sleeping next to Jamie. I was pretty sure everyone was asleep. It was the middle of the night. Anyway, we were lying there, and Jamie just started to kiss me. At first I was like: "No." Then I was like, "This is not

I wasn't so attracted to Jamie. I tried to be, but I wasn't. The night after we kissed the first time, I had to ask him, "Jamie, did we kiss last night?" And he got a goofy grin on his face and was like, "Yeah." I told Kelley about it, but not Melissa. Melissa loves Jamie and she'd freak out on me. I don't know why I did it. I'm not attracted to him at all. I really wasn't into it. Jamie has a really big mouth; it's not a bad thing but it's definitely different. Oh, and he's very aggressive.

that bad." This time, I definitely kissed him back. I think kissing is fun. I really do. There's no reason you have to get all freaky about it. Maybe I was kissing Jamie because I was sad the project was ending; I don't know. ♥ It didn't take long for Jamie to get all aggressive. This time, he was more touchy and less kissy. It was just weird. Melissa wasn't actually there at that point. I hope she's not pissed off. Honestly, I wasn't into him. I'm not really attracted to him at all. He grosses me out, in fact. There are so many better boys to be kissing than Jamie.

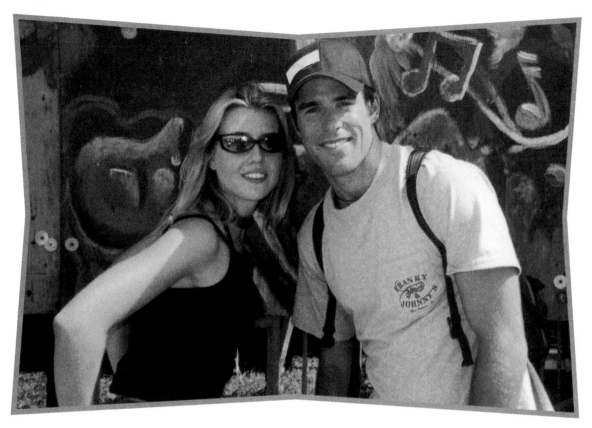

JAMIE:
I'm one of many people whom Julie kissed in New Orleans. She likes kissing. She just likes to do it. That's all she can do, so it's a good thing she likes it! There's no relationship story here. Julie will kiss anybody. It's fun for her. She's very physical, very charged. She's in the schoolyard running around kissing boys. I definitely think that she has this intense libido. As a man, I'm attracted to that.

That last night when Julie and I kissed went like this: I woke up and Julie's face was right up to my face and we were just breathing. She was right up in my grill. Then we just started smooching. It was nice. It was fun. It was totally innocent. No, I wouldn't have tried to go further. I know Julie. That would have caused ridiculous amounts of problems.

I think Julie is definitely cute. She's young, though. I never date younger women. Melissa would be upset if she knew, yeah, I think so. But it was really not a big deal.

Kelley: What do I think of Julie and Jamie making out? It completely makes sense. Jamie wanted and needed the attention of all the girls. He's a ladies' man. He did that in the house, tried to get all the girls to like him. Julie told me that's why he didn't like me—because I didn't like him like that. He wanted to have all the girls in the bag. With Melissa, that was easy.

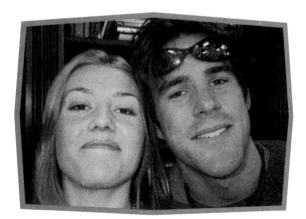

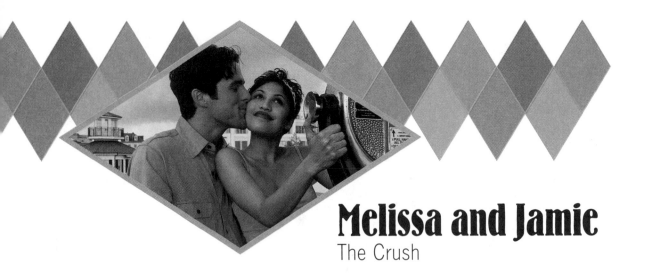

Melissa and Jamie
The Crush

MELISSA: Later during the season, Jamie got really into this girl Elizabeth; I admit a little part of me died because of that. I had to be mature. Crushes are designed to be painful. The truth is, Jamie and I are incompatible. Of course I can't have him. I flirted with Jamie every day I was in the Belfort. I asked him to shower with me once. I was always kissing him. Jamie and I give each other little piglet kisses. They are little kisses on the neck and ear when you make a little grunting sound. Jamie loves them. He loves them so much that when I gave them to his friends he got all mad. ♥ It wasn't only because of the cameras that I took the high road. I seriously saw Jamie as someone I wanted in my life. He's so funny! He does these dumb dances and uses lame slang words! He wears clogs and a kilt! I swear Jamie can wear culottes and little wooden shoes and everyone would think he's hot. ♥ Could you imagine dating someone who's smart, self-made, attractive, and as equally silly as I am? He's so cute. He just kills me.

It's *horrible* to have a crush on someone on camera. I was faced with: Should I admit this out loud or should I look like I'm in denial? In my real life, if I had a crush on Jamie, I would have stalked him, been in his business all the time. But, here I tried my hardest to take the high road. That was very hard for me.

JAMIE: Would Melissa and I have fooled around if we weren't on *The Real World?* I don't know. With Melissa, I never wanted to mess something up and change the vibe of the relationship. In a guy-girl relationship, there are so many facets. With the removal of the physical facet, we're OK. What we can glean off each other is so much more than physical. ♥ Melissa is also sort of codependent. She's had such screwed-up relationships with guys. ♥ I do think she's a beautiful girl. She's awesome. Was I ever really tempted? No. For me, it was always like we were just friends.

successful male. He's good-looking, smart—sometimes—and personable. I think she felt that if she could get him, then it would prove to her that she was worthy.

CREW VOODOO

Mary-Ellis Bunim: They had us on pins and needles all through the shot. I was so sure they were destined to be together...and to this day, I don't understand why they haven't hooked up. Melissa and Jamie are so diametrically different from each other, yet would be a fascinating couple. I think they'd add tremendous dimension to each other's lives.

Andrew Hoegl, Producer: Here's the thing: Melissa was totally in love with Jamie. If he asked her to marry him, she would. From casting, we knew that Jamie had never had anything more than physical relationships with women. At first, Melissa had the same goofy sense of humor that Jamie liked, and they got along on a surface level. When they went on the swamp tour, the tour leader referred to a certain bird as a "n****r goose," and Jamie told Melissa not to get upset. That's when their whole relationship changed. By forcing Jamie to take her issues with racism seriously, Melissa pushed the relationship past a flirtation and they became close friends.

Danny: Jamie and Melissa clung together because she needed attention from a guy and he needed someone to not question him. It was completely a relationship of convenience.

Kelley: How does one explain Melissa's attraction to Jamie? I think that to her Jamie was the epitome of a

David (the Player?)
The Genesis of a Relationship

DAVID: I love sex and love to have it as much as possible. I was playing the field the whole time in New Orleans. ♣ Here's the crazy thing about the house: Melissa didn't have sex. Julie didn't have sex. Matt didn't have sex. Jamie, he was down with whatever. Danny and Kelley, they did it. But I was the only one who's downright doing it. It would almost pain my roommates to see me having it so good. I was doing what they wanted to do: having sex and loving it. There were plenty of times I had sex in the room with somebody or somebodies (Yeah, I had a couple at a time). ♣ When I got to New Orleans, I scouted out the area for girls. As soon as I scouted the area, I was comfortable. How many people did I have sex with in New Orleans? Contrary to popular belief, it's not eighty-seven, which is the number of phone numbers in my pager. Well, let's see, I had eight during Mardi Gras, so altogether maybe nineteen, give or take a couple. That's a safe number, yeah, nineteen. ♣ But then I met Deanna, and I had to switch gears. Deanna was one of the models I had for the little fashion show. She's beautiful. She sings. She's incredible. She is all worth it. She's trying to finish up school. She's extremely busy. In New Orleans, we'd have to meet at two in the morning just to be able to hang out. Wherever we went, the cameras followed us. (I guess me settling down—finally—was a good story!) ♣ If the crew wanted to make an episode about me and Deanna being unfaithful, all they'd have to do was show this one time I went to visit some girl's crib at 3 A.M. The truth was, the girls had a tape of the promo for the Casting Special. I really wanted to see it. I knew what it would look like to the

The biggest problem with the cameras was that girls wouldn't talk to me when the cameras were there. Yeah, sure, the cameras missed a grope and a kiss here and there, but basically they got the gist of everything I was doing, which was being a player.

54

crew, and I wanted to make it impossible for them to see me chilling. So I took off my mike. But I got busted. Whatever. It doesn't matter to me what is portrayed on TV. If they want to make an episode about me cheating, that's OK with me. The truth of the matter is still the truth of the matter. I know what I did that night, but for the sake of good TV it might seem like I did something else.

When the show ended, I missed her a ton. That's why I'm going to move back to New Orleans to be with her. You don't get a taste of heaven like that and decide to leave. People don't leave heaven.

Are Deanna and I going to be faithful? I can only say I'm going to try, but yeah. It'll be hard. The game, it's been so good to me. I'm really going to have to be strong and not look around. That's a hell of a challenge for me. She has guys coming up to her all the time, so it will be a challenge for her, too—but less of one. It's really shocking that I'm trying to do this, I know.

I wasn't expecting to find somebody like this. It's just wicked, just really wicked. I set my standards really high. I just won't settle anymore—at least where a relationship is concerned.

I'm sure people don't think that Deanna and I are going to last because I'm so not monogamous. Whatever. I've been underestimated all my life, and this will be nothing new. I'm the underdog, one underdog you don't want to mess with. I take everything to the next level. Don't doubt me.

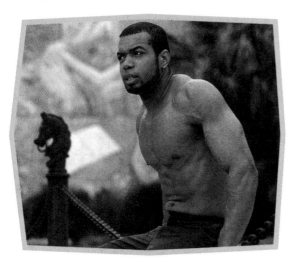

Melissa: Off camera, David asked me on dates three times. And then he'd be as crass as to say: "Melissa, when are we going to fk?" He says he found me irritating, but he was still trying to get into my pants. Would you go on a date with David? It'd be a tuna sandwich, a protein shake, and sex. No, I don't think so.**

David: Yeah, I asked Melissa out a couple of times and she said no. I ain't gonna sweat nobody. It's fine. I wasn't hurt about it or anything.

Julie: David's always "Love the playa. Hate the game." Well, I want him to know he's hurting people. Women would come up to me in bars, forlorn, upset, saying that they'd spent the night with David and were head over heels.

We had to get our number changed, because he gave it out to so many women. We were getting so many crank calls. He gave his number to anyone who had ts.**

I like David for the person he is. If he's just playing with women who aren't getting hurt, then fine. But the way he'd treat people, I saw it as degrading. He'd pick up the phone, saying, "Play on, playa. Who's this?" It was bad, because sometimes it'd be my dad calling. In fact, my dad once called five times and hung up, thinking he'd reached a strip club or something.

Whatever David's going to do with his sexuality, he's going to do. Don't hurt other people. Don't degrade women to have fun. There are so many times when I've seen him turn things back on the girl. I totally relish the moment when David decided to have a real relationship. He's trying to have one with Deanna, really? Well, I hope it works out. But it's going to be hard for him to move on. He's really used to this player life.

Melissa: I think Deanna has a lot of patience. I hope David respects her. She's gorgeous. I don't know how he pulled that out. Even my dad kept saying she was fine. (It was so embarrassing.) Deanna does not take any s**t. She does not play that crap. I hope he listens to her. I hope he learns from her. I really do.

Pick Your Favorite

Cookie: Fig Newtons
Ice Cream Flavor: I don't really like ice cream
Guilty Pleasure: doing boy-band dance
Book: *At the Foot of Heaven* by Kevin Max Smith
Movie: *The Shawshank Redemption*
Recording Artist: Britney Spears
***Real World*-er (past or present):** Jon *(The Real World-Los Angeles)* and Julie
Road Ruler (past or present): I don't know any. James, I guess.
Web Site: supa-fly.com
Writer: Loomit
Artist: Picasso
TV Show: *The Simpsons*
Cartoon Character: Ralph Wiggum from *The Simpsons*
Scent: a girl
Hair Product: "Freeze It" hair gel with 18 hour hold
Item of Clothing: My orange and white Hawaiian shirt
Toy: my computer
Actor: I don't pay attention to their names. I don't watch many movies.
Cocktail: Coke
Soda: Coke
Coffee Drink: Toasted almond coffee
Vegetable: artichoke
Teen Movie You Most Identified With: There aren't any country to concrete, Catholic, hip-hop punk, Internet pimp-type characters in those movies.

In the House

Best Dressed: Me
Worst Dressed: David
Best Dancer: Me
Worst Dancer: Jamie
Best Cook: Kelley
Worst Cook: Me

How many hours did you sleep a night on average? 8
How many naps did you take every day on average? none, I've never been a napper.
How many times a day/week/month did you exercise? lifted weights five days/week, skateboarded every day
Get a haircut? every four weeks
Shower? at least once a day, depending how hard I worked out
Which roommate did you see naked? Most of Kelley and Melissa, most of Jamie, and all of David. None by choice!
How many confessionals did you do a day/week/month? one/week
How many hours did you spend online a day/week/month? I averaged an hour online. I started out online more because I was working, but near the end I wasn't on the computer at all.

Pick Your Favorite

Cookie: Cinnamon Goldfish
Ice Cream Flavor: Coconut Joy from Wholly Cow
Guilty Pleasure: cat juggling
Book: *A Heartbreaking Work of Staggering Genius* by Dave Eggers
Movie: *Romeo and Juliet*
CD: Zero to Nothing
Recording Artist: Blink-182
***Real World*-er (past or present):** Puck
Road Ruler (past or present): Theo
Web Site: Hotmail.com only because I frequent it. If I wasn't so humble, I'd say planetJulie.com.
Writer: Shakespeare
Artist: my sister Lisa
TV Show: *The Simpsons*
Cartoon Character: Sailor Moon
Scent: *Anything* that isn't Old Spice. That crap is Julie *repellent*. The fact that Matt was constantly wearing it was reason enough for us *not* to hook up.
Hair Product: A brush. When I'm feeling extra crazy, a rubber band
Item of Clothing: My Gÿ

Best Dressed: Matt
Worst Dressed: Jamie
Best Cook: Kelley
Worst Cook: Matt
Cleanest: Matt
Messiest: David
Most Diligent: Matt
Biggest Procrastinator: Me

In the House

How many hours did you sleep a night on average? 4
How many naps did you take every day on average? 0 (I had insomnia!)
How many times a day/week/month did you exercise? Ran around all the time
Shower? at least once/day, depending how hard I worked out
How many confessionals did you do a day/week/month? countless!
How many hours did you spend online a day/week/month? Dunno. I tried to spend time online developing my Web site, Planet Julie.

JON MURRAY

We've always had people of different faiths on the show—though Julie and Matt are probably the most devout in the show's history. Matt and Julie have strict rules and desires to test limits, and interesting things happen. Having Julie and Matt on together reminded me of the year we had Pedro and Rachel on the show. They were so different, yet from similar backgrounds. I think it's fun to break stereotypes.

Julie

Believers, Nonbelievers

WHAT are viewers *not* going to know about Mormonism from watching the show? Well, that's a loaded question. ✝ For one thing, I don't think people are going to understand missions. My brother Alan—he's the most important person in my life right now—he's gung-ho to go on his mission. You spend two years of your life preaching the gospel. Women can go too, but usually when they're twenty-one. I feel that it's really important that people go on missions if they feel so inclined. It's a suggestion, but not law. ✝ I think it's important for viewers to know that though I have issues with Mormon culture, I do not have as many issues with the religion. Mormon religion offers a doctrine of laws called "Words of Wisdom." They are suggestions, not laws. For example, there's nothing in the religion that says you can't have caffeine. But the culture is biased against it. As a result, caffeine is not sold on BYU campus. Then, what happens? Kids start drinking Mountain Dew and feel guilty and that guilt just leads to bad things. I think the problem with BYU is that kids have morals and no convictions behind them. Kids are ill-informed. I feel like doing things just because you're told they're dangerous. ✝ It's true that Mormons are not allowed to marry non-Mormons. And, yes, it's taboo to have non-Mormon boyfriends. Am I going to marry a Mormon? Before I came here I would have said: "Yes. One hundred percent." Now, I've learned that love has no boundaries.

I don't need to tell everyone the nitty-gritty of my religion. Some things are sacred. But I do want people to know that there are so many good things about the religion. It creates good people and good things. You find joy through Christ and accepting atonement and realizing you're not alone. That's what brings ultimate happiness.

Getting the Boot

Julie: The hardest part of being in New Orleans was knowing I had to go back home. I was nervous in the Belfort. I had bad insomnia (which I still do). It's like I was nervous because I knew what was going to happen. The Mormon media is huge. I knew my being on *The Real World* would be a really big deal.

I was right. When the show ended, I found myself in the middle of this huge BYU controversy. It started when I was supposed to be a counselor at this Mormon camp called Especially for Youth. That was two weeks after the show. My bags were packed, and two days before I was leaving, I was asked not to come. The MTV thing was going crazy, so they didn't want to deal with me.

I felt very conflicted and hurt. There was a lot of pressure on me. I still didn't know whether I was going to go back to school. I kept getting all these really cool e-mails from Mormons calling me the Mormon icon, saying they "hoped I'd been good." All I could think was: "Well, it's too late now."

Part of me wants to be the Mormon icon, and hopes I come off a perfect angel; the other part of me resists wanting to be the perfect Mormon and hopes I'm shown seriously questioning my faith. At BYU, they published an editorial saying that by being on the show and living in a co-ed situation, I was terrible. People think that either I'm a hero or the devil's spawn.

I was about to go on *The Challenge*. I had my plane ticket in my hand when I received the letter from BYU saying that I'd broken the honor code (by cohabitating with guys) and would be kicked out of school, but that I could reapply for admission in a year. (I knew, by the way, that I'd never get back in.) The letter really offended me. It insinuated I'd slept with guys, and done things I hadn't done. I called them and they apologized for any misinterpretation. That was the last time I had any contact with them. It was kind of, "See ya." I guess I left on good terms. I don't even care. Worrying about school was absorbing my entire life. I just wanted to be finished with it, and go somewhere else finally.

At first my parents were really upset. They were sending press releases and making calls and going nuts. They initially said I should think about living somewhere else other than home. Well, they've calmed down. I think this will be good for my family in the long run. And I'm twenty-one. I should be living out of the house anyway.

Not being at BYU makes me sad. My brother, Alan, is going to be there. I have friends there. But I'll have fun wherever I go. I'm applying to different schools, maybe Berkeley or maybe UCLA, and this will be a whole new chapter in my life. Not only am I changing schools, but I'm changing communities. My life, as I have always known it, will not be the same. It's probably the change I should have had going to college the first time.

I'm happy to say that though BYU kicked me out, my life is not miserable. I appreciated my time at BYU. And *The Challenge* is amazing—it made it worth getting kicked out!

Jamie: I think Julie's courageous. She's questioning her family and community. That's unbelievably heroic. If you want to know my honest opinion, I think Julie needs to shed as much of the Mormon community as possible. I hope she doesn't take what seems like the easy path, and revert back to her old ways. In my talks with her, I've said, "Julie, the dogmatic structure of your community is necessary for some people, but it restricts the real Julie from shining."

I tried to look at Mormonism with an open mind. I went with her to services once. At church, there was a little kid—probably like 3 or 4—standing at the podium declaring that he knew the truth and that Prophet Hinckley is the prophet. It scared me. How does this kid know "the truth?" Like Julie, he's a product of his environment. She doesn't see it that way. She thinks her religion is the truth, and that's so ignorant.

All religions are pathways to the same thing. Julie and I talked about a common perfection of people and all living things. If she believes in that, then how can she continue grabbing on to this Mormon dogma? Does a rabbit know Mormonism?

There's this Buddhist notion that religion is the boat that takes you from lost to found. Once you get across the river, you can let it go. I hope that's what Julie can do.

JULIE'S MOM:

Initially, I was very upset about Julie going on the show. We didn't have cable, and honestly one of the reasons was the kind of programming that's on MTV.

My husband was very upset—more than anyone—that she tried out. I said, "Come on! There's not a chance in the world she'll get on!" On the day she made it to the finals—it was Thanksgiving—I couldn't really eat. Then, when she did get on, we were inundated with calls detailing the worst episodes—"the Shower," Ruthie's drinking, nudity. Then we got really concerned about the environment Julie was going into. We tried to talk her out of it. But that was impossible. I decided that because she's my daughter, whom I love, I'll support her.

Being in New Orleans made me much more comfortable with the situation, but I admit I was really bothered by the cameras when Julie and her father had that fight. Alan and I tried to intervene, but Julie was not interested in breaking it up. When I saw them go at it, I decided just to wash my hands of it. I went into the pool room. The cameras hovered around me, but I wouldn't give them their reaction shot.

I was afraid that was going to happen. I know how Julie and her dad are. They like recreational arguing. Before I went down, I said to Julie's dad: "Please don't get into it with her. You both like to argue. Just don't do it in front of the cameras." I kind of had an inkling it was going to happen anyway.

It's been a real experience. Watching the show has been interesting. But I have to admit, I have a 9-year-old daughter who's eager to watch her sister on television, and I'm not about to let her see everything!

JULIE'S DAD:

We had knots in our stomachs up until we got to New Orleans. We were scared she'd break under the peer pressure, start drinking. But we were relieved when we got there. Our first impression of the roommates was that they were very nice people. I was expecting them to be more derelict.

My take on Julie's and my argument was this: living in that house, Julie picked up some casual swearing. I believe that if you fill in adjectives with expletives, it is the sign of a weak mind. My religion enforces that notion. The fight we had in New Orleans happened when I corrected Julie's language. It just went downhill from there. She might have overdramatized it. I didn't think she should be stooping to those depths.

I might have been a little more poised than normal by having cameras in my face. I said what needed to be said. She started to drag up dirt, and I did my best to refute it. Then she walked away and feigned a cry. I was not happy that happened, but the truth is, we've had worse fights at home.

Coming out of *The Real World,* I feel Julie's priorities have shifted in both negative and positive ways. You'd really have to understand the church we belong to. The set of ideas she came home with conflict with the church. But kids question things. I did that when I was her age. That's how I ended up joining the Mormon church.

Julie's standards and beliefs may change. She's in a very visual position, and I hate that millions of members of our church will see her faith dwindle. I don't want to see the church and school dragged through the media muck.

Julie's in a position where she can do a lot of good. On *The Real World,* she looks like a model young person, having fun without drinking. She's reaching a segment of today's youth that is not accessible to the normal clergy. Maybe her example will encourage kids her age to think they don't need to sleep around, drink to have fun, do things that cause problems in society. I am proud of her. I love her and I wish her well in her career, whatever it may be.

CREW VOODOO

Andrew Hoegl, Producer: I think Julie realizes that the confrontation with her father wouldn't have happened without the cameras. I knew that her parents weren't big fans of MTV to begin with, and I think they were consciously trying not to make scenes. But I think that Julie's relationship with her dad is very volatile. We were all braced for something to happen. I was really rooting for Julie. I think she got to say things she wanted to say.

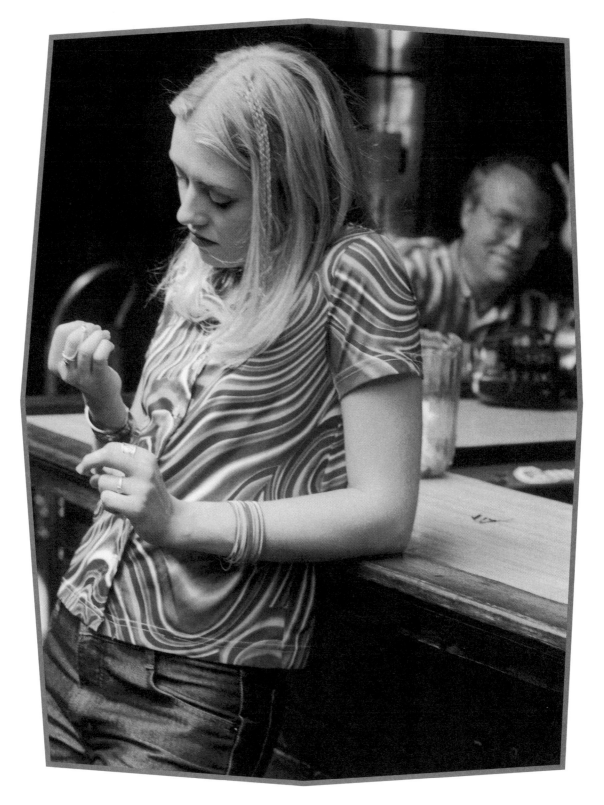

Matt
Believers, Nonbelievers

HERE'S something viewers won't know: I went to Mass Monday through Thursday and then on Sunday. Going to Mass is very important to me; the experience there is what I live for. I like to escape once a day to think about who I am. In Africa, I didn't go for two weeks. Not going to church in Africa was really hard because I missed my daily reflection time. I longed to have some quiet time. I was very happy to get back to New Orleans and go to Mass. ✝ The most important story that the camera didn't get was when Jamie and I went to Mass on Holy Thursday. Holy Thursday is the day when Jesus washed the twelve apostles' feet, signifying that God is not too high to wash somebody's feet. At Mass, members of the congregation sit in the front row while the priest washes their feet. At the congregation we were in, everybody had a chance to do it. ✝ Jamie looked at me and was like, "Do you want to do this?" "Yeah," I said. I got on my knees and washed Jamie's feet and then Jamie got on his knees and washed my feet. Afterward we just hugged. It was a brotherly hug. ✝ After all this BS, we'd humbled ourselves to the lowest level. It was such a beautiful, beautiful moment.

A great thing that happened was David, Danny, and Jamie started coming to church. That made me so happy. We didn't all come in the house as churchgoers, but almost all of us came out churchgoers. Whether I'm responsible, I don't know. But I feel good that what I did wore off on people. God put me here for a reason. God put all of us here for a reason.

Melissa: When I found out that Matt and Julie were devout Christians, I was scared. My previous experience with devout Christians was that they were judgmental. I'm not a very religious person at all. I was baptized Catholic, and my mom likes me to go to church. But organized religion scared me. Two religious people in the house! I never would have expected that. And it was pretty weird that they didn't bond on their religious feelings. It was like "God said that." "No, God said that." They'd sit around and argue

about the particulars of praying. As far as I can tell, praying is praying is praying.

Danny: Jamie went to church with Matt? That was Jamie in a politician moment, showing up somewhere to be seen. Maybe he was curious, but he probably didn't really give a damn. He totally played up the fact that he went to church with Matt. I think he's full of bunk. He didn't do it for growth purposes; he's trendy. Right now, it's trendy to be spiritual.

Oh, and Jamie says he's a Buddhist? That's total crap. He has very limited knowledge about what he's talking about. He's a freakin' suburban kid who went to good schools. That doesn't mean he knows what he's talking about. He claims to be a person he's not.

He's nothing like Matt. Matt's really patient and religious. I would not say I'm religious. I would say I'm spiritual, but I'm not religious. The difference is that spirituality is noting that there's a higher power that's in charge and being humble to that. Religion is bowing down to a social system that incorporates spirituality. The society corrupts the spiritual.

Julie is someone who's breaking free of the mold, and trying to step out. Matt probably wants to break free too, but doesn't have the guts. I don't think he's living his life to the fullest. I think it's great that he has this moral and religious code, but he's just trapped in this mold. He likes the mold, so that will probably never change.

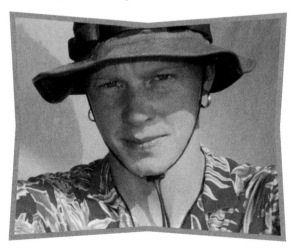

David: If religion's your bag, that's your bag. They do what they want to do. Whatever. It didn't affect me to have so much religion in the house.

Matt on Julie

Matt: Julie's future will be difficult, but she'll approach it all with confidence in who she is. In the face of adversity, she'll really step up. Will she maintain her religious conviction? Well, she will maintain her faith.

I can't stand being compared to Julie's father. Julie would often tell me I was acting like her father. Usually it was when I was telling her not to write on the walls, because, gee, we'd have to pay for it. When she's told not to do things, she'll tell me I'm like her father. Well, her father and I, we're nothing at all alike. I'm nearly livid at the possibility. I'd tell her I'm not her dad telling her how to live her life.

Julie's dad epitomized Mormon culture and that wasn't a really positive thing in the house. They hold so strong to really petty things. A whole college can't watch MTV? Who are they kidding? Curfews? What you have are 23-year-old Mormons getting out of college and going buck wild! I don't know many Mormons. This is just what I've gathered from Julie.

There's something interesting about the fact that I'm a devout Catholic and she's a devout Mormon, but it's completely different. Sure, we have things in common: I'm a virgin. I think premarital sex is wrong. But I don't have to bear the cultural stigma of my faith. There's such stigma surrounding Mormonism. No one questions Catholicism.

The things that Julie's been told about Catholics are shocking. She once asked me, "Are there Catholic missionaries?" I was like, "Well, of course, there are about a billion Catholics in the world." I don't blame her for not knowing stuff.

It'll be interesting to see if Julie sticks with her Mormon faith. She definitely does have a lot of doubts. I told her that she shouldn't disregard her religion, but she should test it. She shouldn't give it the finger.

JAMIE

Pick Your Favorite

Cookie: chocolate chip
Ice Cream Flavor: chocolate chip cookie dough
Guilty Pleasure: piña colada
Book: *Atlas Shrugged,* by Ayn Rand
Movie: *Fight Club*
CD: *All You Need Is Live* by Cowboy Mouth
Recording Artist: Fred LeBlanc of Cowboy Mouth
Real World-er (past or present): Melissa
Web Site: Soulgear.com
Writer: Thich Nhat Hanh
Artist: Lionel Milton
Hair Product: any
Item of Clothing: belt buckle
Actor: Mel Gibson
Actress: Annette Bening
Cocktail: Red Bull and Kettle One
Soda: Sierra Nevada Beer
Coffee Drink: black
Vegetable: artichoke

Best Dressed: Melissa
Worst Dressed: David
Best Dancer: Matt
Worst Dancer: Kelley
Best Cook: Kelley
Worst Cook: Julie
Cleanest: Matt
Messiest: Julie
Most Diligent: Matt
Best Smelling: Melissa
Worst Smelling: David

In the House

How many hours did you sleep a night on average? 7
How many naps did you take every day on average? 1
How many times a day/week/month did you exercise?
5 times a week
Get a haircut? once
Shower? daily
Which roommate did you see naked? all of them
How many confessionals did you do a day/week/month? 1
a month
How many hours did you spend online a
day/week/month? a ton

KELLEY

Pick Your Favorite

Cookie: Pepperidge Farm Geneva
Ice Cream Flavor: Rocky Road
Guilty Pleasure: pizza
Book: *Beach Music,* by Pat Conroy
Movie: *Braveheart*
CD: Dave Matthews (anything)
Recording Artist: Prince of course
Real World-er (past or present): Danny
Road Ruler (past or present): Yes
Web Site: supafly.com
Writer: Shakespeare
Artist: Rhonda Pittman
TV Show: *Ally McBeal*
Cartoon Character: Road Runner
Scent: Allure
Hair Product: Bed Head
Item of Clothing: broken-in jeans—Levi's
Actor: Vince Vaughn
Actress: Angelina Jolie
Cocktail: Stoli and tonic
Soda: Coke
Coffee Drink: Mocha
Vegetable: potato
Teen Movie You Most Identified With: *Ferris Bueller's Day Off*

Best Dressed: Matt
Worst Dressed: David
Best Dancer: Julie
Worst Dancer: me
Best Cook: me
Worst Cook: Julie
Cleanest: Matt
Messiest: Julie
Most Diligent: Matt
Biggest Procrastinator: me
Best Smelling: Danny
Worst Smelling: Danny (he could be both!)

In the House

How many hours did you sleep a night on average?
8 hours sleep/day
How many naps did you take every day on average?
2 naps a week
How many times a day/week/month did you exercise?
2-3 times a week
Get a haircut? Twice
Shower? Daily
Which roommate did you see naked? Danny
How many confessionals did you do a day/week/month?
1 a week maybe
How many hours did you spend online a
day/week/month? 3 hours a week

MATT

I would say my best friend in the house was either Julie or Jamie. If David had to pick a best friend, he'd pick me. But I wouldn't say the same for him. I think that Kelley, Danny, or Melissa could have been my best friend in the house, but it didn't work out that way. We did what we could in the five month bracket we had. Alliances formed. Divisions were made. If we had another five months, who knows what could have happened?

Belfort Voodoo
Kelley and Danny vs. Melissa and Jamie

KELLEY: Melissa wants to believe that I hated her and I just didn't. I don't have any bad feelings toward her. She refuses to accept the fact that I don't hate her. I thinks she's an attention whore, but that's no big secret. Melissa thinks I'm just fabricating an uneasiness between her and me. But what happened between us started three or four weeks into the season. Melissa and Julie were at Wal-Mart (where the cameras didn't have permission to film), and Melissa told Julie she wanted me to *go down*—whatever that means. Julie told me this, and I believe her. Julie told me Melissa said: "I don't care what Kelley does, I'm not going to like her." It was an "I'm out for blood" type conversation. Melissa was always telling me she "wanted to hate me." How are you supposed to react to stuff like that? I always told her I didn't hate her, but I was reacting to her and things she said. She told me I was just paranoid, that it was all in my head. I don't know why Melissa ever bothered hanging out with me if she wanted me to *go down*. Yes, in the beginning of the season, we did actually hang out together. We went to a spa together; we had coffee, went to lunch. I considered it the beginning of friendship; I guess she saw it otherwise. Melissa didn't want to like me and she was looking for reasons not to like me. I honestly have no idea why. She just didn't want us to get along. The worst incident between us was on the plane to Africa. Up to that point, I hadn't really thought about the show airing, how everything was going to look. Well, I realized while I was on the plane that I'd said something very personal during casting that I really really regretted saying. All of a sudden, I realized I'd spilled this detail about my life I did not want to be part of a show.

There I was crying about something personal, and there she was making the whole thing about her. She even had the nerve to ask, "Is it about me?" It was crazy. Even Julie told her she was being cold and ruthless. Julie got up and walked away. Then I got up and walked away.

So, I was sitting in my seat, minding my own business, and just crying about this thing. Of course, I didn't want to tell anybody what I was upset about because, well, once I did, then, duh, it'd be on camera. But Melissa kept asking me what the problem was. She was harping on it and harping on it, and I wouldn't tell. She blurted out: "That's BS. I can't believe you won't tell me what it is. You think you're better than me."

It became this huge thing. Melissa got pissed that she was the brown girl being left out. That's so insane. First of all, it had nothing to do with her. Second of all, she's *never* left out of anything.

I kept telling her it didn't have anything to do with her, that what I was upset about had nothing to do with *The Real World*. It has zero to do with the dramas existing in the house! Not everything is for public consumption.

The whole thing made me upset. But she was furious. She promptly wrote me a letter asking me what my problem was, telling me she was sick of my saying she was out to get me—something I've never said. It was all about her feeling left out and how she always feels this way. She told me I'd claimed to trust her, and here I was going back on my word.

I just turned to her and said "I don't feel like talking to you about your life right now." And I just put my headphones on. She was freaking out because she felt insulted. I was upset because the longer this fight went on, the more the *thing I'd regretted saying* could become a story.

Melissa won't let anything go. She'll hang on to something—whether it's a race issue or a problem between us. You can talk it out, have a huge hugging fest, and she still wouldn't be over it.

After the show, I called all of my roommates on the phone. I wanted to see how they were doing and make sure they were OK. I talked to Melissa. We had a perfectly good conversation. Then I found out from Julie that Melissa called me a cold bitch, and said I didn't help her at all. I think she gets so caught up with the drama in her life that she can't see people trying to be her friend.

If one hundred people say they like her and one person says he or she doesn't, she focuses on that. It's not worth it to try to be nice to her.

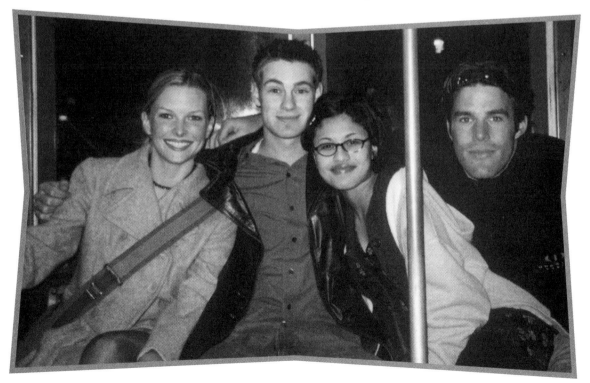

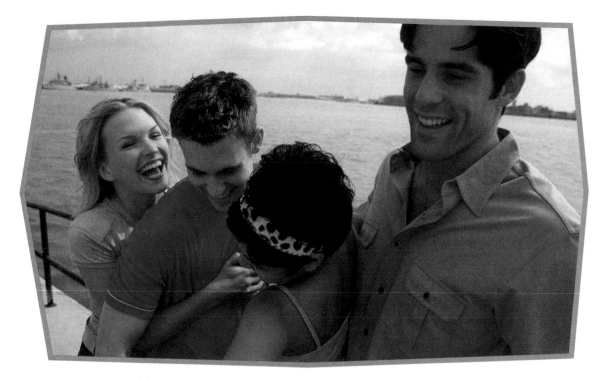

MELISSA:

I bet Kelley is going to say all this sugar about me. That's her strategy. After the big fight we had in Africa, she was like, "I can't wait for you to see the show and see that I've said only good things about you." She doesn't like to tell things straight. All I've said about her is I think she's irritable, paranoid, and codependent. She doesn't believe herself to be any of those things, so I'm not allowed to say them. Off camera, Julie told me the only time she'd ever said anything bad about me was when she was talking to Kelley. There was a little rut in our relationship right after Africa, and I didn't know where it was coming from. Then, in private, she told me it was because of things she and Kelley had discussed. I have no idea what Kelley learned in New Orleans. Kelley always said I was out to get her, but that I was paranoid. Please give me some evidence of that. Relationships with women have been hard to build in my life. Kelley's life in high school was like *Heathers* on crack where girls treated her like crap. I attribute her thinking I'm out to get her to those girls. When, at the end of the season, she asked me why we weren't friends, I was like, "You can't build a friendship on false assumptions and conspiracy theories and there's not enough time for us to backtrack and start from the beginning." It also didn't help that Jamie was one of my best friends, and he and Kelley hated each other. I think her and Danny's relationship was very solid, but I really don't know much about it. I never wanted to be a third wheel. Anyway, the third-wheel thing doesn't work with her. If you made plans to go to dinner with her, she'd warn you beforehand, "You can't bitch about money or the food." Well, who needs those rules? I guess she ate fancier than the rest of us. I never saw her eating Ramen Noodles or Happy Meals. I don't really like to talk about Kelley, because I don't want to feed her conspiracy theories. I think she had a really big problem with me. She thinks I'm egotistical and uncaring. The crazy thing about that is she doesn't even know me. I liked Kelley more in just the few conversations we had after the show ended than I did during filming. I am not saying we are going to band together and start a Babysitter's Club, but she's a lot nicer off-camera than on.

I'm not going to be the back-stabbing bitch. If they put it on the show that our issues are my problems at all, I swear I'll sue somebody. Our problems were hers, too and they were for real.

Danny: I remember the moment that Kelley realized she didn't have to care about what other people thought. It was after she'd had an argument with Melissa on the way to Africa. Melissa was so mean about Kelley without any backing. Afterward, Kelley just felt like, "Forget it." She was freed. She was like, "That's it. I don't give a damn what anyone thinks of me." Melissa did her a favor.

Matt: Kelley came into the Belfort headfirst. It happened for all of us like that. We all came in here optimistic, like we were going enlighten the world. But I think Kelley quickly realized that she was going to be portrayed in a manner she didn't like. As a result, Kelley got very irritable, very testy, short-tempered, confident, and sassy. She did not exude joy or warmth. In fact, at many times she was outright cold—especially in the morning.

One night this just dawned on her. Jamie, Kelley, and I were having this conversation about how Kelley wasn't happy. She complained that she was being portrayed inaccurately. She said she knew this was the case because in interviews they were always asking her about being nasty and ill-tempered, and—here's that word again—a bitch.

Well, if that were me, if I found out that perhaps my roommates thought I was inaccurate, the way I'd prove them wrong was to act like a kind person, be generous. Don't talk about it! Act on it. Deal with it. But, she didn't. She just fled.

That's the difference between her and Melissa. Melissa admitted her faults and dealt with them. Melissa walked out of here with her head high. Kelley, not so much.

Kelley and Danny's relationship was the perfect solution for codependents. I think they both like being around someone pretty. They're both feisty rebel sexpots who are naughty sometimes and proud of it.

I'm glad that they had each other in the house, but I think they encouraged unhappiness in each other. You'd think they would vent and then be over it. But really, they'd vent and get *more* enraged. I'm a positive upbeat person. Sometimes they sought to disprove the authenticity and realness of the people in the house, to make themselves feel better for not being happy.

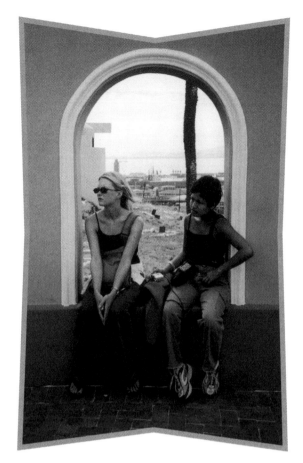

DANNY: Even when the show ended, I was still having bad dreams about Jamie. I think it's because he represents everything I don't like and don't want to be. He's the type of person who does not deserve to be given a chance.

The kid is so fake, I think he's got himself fooled. Fakeness is seeping out of his pores. He just drives me f*ing crazy. He's so into his facade. Everything he does revolves around his being happy. He's terrified of not being happy. I think he's got to work through this fear.**

He feels like other people have problems and that their problems are bringing him down. Yeah, well, that's because he runs away from his problems. When other people have problems or issues, he feels like they are raining down on his parade. That's just not how life works.

Let's take Melissa as an example. She would talk about how racism would upset her, and he'd be like,

"Get on with it." Jamie has had an easy life. He does not understand how bad things happen to you and how you can't get over things in your past. Supposedly, he's willing to listen to that stuff now. I doubt it, though. I think he's learned to look compassionate on camera. Whether he's actually that compassionate, I'm not sure.

Throughout the show, I had a suspicion that Jamie didn't like us the whole time. I thought he was faking liking all of us—including Melissa. Matt started clinging to him, and he pretended to be all buddy-buddy with Matt. He's got this leader-like charisma, like a politician. But, as everyone knows, many politicians are corrupt.

I am talking such smack. I don't care!

Melissa: After the show, Kelley tried to talk to Jamie. She told him she saw in him more than what he was giving. They're both golden children, she told him. She thought that's why they were competitive. He was like, "What? Why would we be competitive?"

KELLEY: Jamie always made me feel like such an old a**. He made me feel like I never had fun. My response? "You're never out with me. You don't know." I'm only 23, but in this house I might as well have been 50. These people, some of them have never left their hometowns. It's just a completely different mentality. Sometimes I wished I wasn't so mature, so I could just kick back. Getting up on bars and stripping looks like fun, but I don't feel like I can do it anymore. OK, I joined Melissa and David once. It was fun, but I didn't take anything off.

Jamie led two lives. He'd take his mike off, leave the house, go have sex with a girl, come back and pretend it didn't happen. I think Jamie thought he could control the process—not to mention *us*. He was always yelling at us for brooding or feeling bad. That just perpetuated the problems.

After the show was over, I told him I felt our relationship was hindered by the cameras. I thought this would lead to us talking things out, but then he flat-out said: "I don't like you and Danny 'cause you're negative. The end." I don't think he's a bad person or I'm a bad person, but we just don't see eye to eye. I have called him since then to see how he was doing and we got along fine. I don't know. I don't even care. But talking bad about people makes me like I'm a big ball of negative energy and that sucks.

JAMIE: I hate when people point fingers and critique what other people are doing. Danny and Kelley do that. The problems with Kelley and Danny and me started when I went home to Chicago for a day. I called the producers and told them, "I can't get back 'cause of the storm." That was partially true. I really just wanted to stay at home. It was great. I got a night off from *The Real World*. I paid the price for it, though.

When I got back, it was amazing how much anger I got from Kelley and Danny. They were so pissed I'd gotten to go home and spend a night without the cameras at my house. There was a huge jealousy thing going on. They were so pissed.

Why were they mad? Because while they were in the Belfort, all they wanted was out of there. They felt I'd gotten away with something that I shouldn't have. They were just pissed they didn't have the guts to do it themselves.

Soulgear: Fair or Unfair

Jamie: One thing that bothered me is that few of my roommates realized the sacrifice I made coming to New Orleans. With regard to my business, I truly sacrificed a lot.

A lot of my roommates thought I was "using" *The Real World* to promote my company. They found it very frustrating. Well, wouldn't I be an idiot if I didn't leverage this in some way? I was like: "Come on, it's the natural move." People resented it. They were jealous or something.

They didn't want to promote my company. They didn't want me to get any play. But I was like, that's real. That's who I am. In my real life, I'd be wearing a Soulgear shirt, talking about Soulgear, and doing whatever I could to make my business work.

My real life is Soulgear. Why wouldn't they want to film that? It's like I'm trying to have my passions fuel my passions. That's what I'm about.

It was Danny and Kelley who were the most bothered. They had issues with Melissa, too. What the? That girl is going to be a very big success with her art and her art is a big part of this season's story. And people are pissed off about that. Why not support us? I'd support them! I hate when people point fingers and critique what other people are doing.

Julie: Jamie was Soulgear all the time. He sees money as a tool for happiness. That's why he gave us all shares in the company. Jamie is a really loyal person, and he thinks money makes him happy.

We had this saying: "Drop the *Real World* bomb." That's something Jamie did all the time. He would use our *Real World* status to get us free stuff. We did get a lot of good opportunities. We met Anne Rice and went to Angola Prison because Jamie abused the situation. Sure, I went along with a lot of it, but I felt bad; I don't think taking advantage of our celebrity status is "real." The producer was constantly telling us not to do that stuff.

I don't blame Jamie for his self-promotion. He wanted a bit of Soulgear on TV. I guess I would have been honest in casting and told them my exact intention.

Since the show ended, Jamie has offered me a job at Soulgear. One day I was really feeling down and the phone rang. It was Jamie. He was like, "I knew there was a lot of crap with school, and I wanted to offer you a job." It made me relieved and happy. Jamie is the most loyal person ever. Once you make friends with Jamie, you're friends for life.

David: We all show up to the Belfort with our talents. If Jamie put his heart and soul into his company, then that's who he is. I feel the same way about my music career—it's me. So, yeah, I think Jamie should go ahead with his bad self.

Melissa: Kelley said she didn't want to be a pawn in Jamie's game. She thought his sole purpose was to use MTV and *The Real World* as promotional vehicles for Soulgear.com. She may have been upset that he wasn't there to change the world like the rest of us, right? (Yes, I'm being sarcastic!)

Well, pawn or no pawn, funny how he gave everyone shares, lots and lots of shares of his company (which will succeed) and no one declined. I repeat: no one declined. See what I'm getting at? Jamie is my boy. End of story.

Exhibitionism
Cameras and Ego in the Belfort

MELISSA: I'm sure my roommates will accuse me of turning it on when the cameras were there. But that's how I am all the time. I'm as crazy on camera as I am off. The whole stand-up comedy thing is really me. They thought I was an actress when I walked through the doors, but I kept it up the whole time. I'm really that silly.

I believe you have to be somewhat egotistical to turn in a tape to *The Real World*, to think you can be on a really popular TV show. It's like we all have egos, we all sent in tapes, we all talked about ourselves for hours and hours. Deflate your ego at the door of the Belfort or just don't bother.

If you want to be on *The Real World*, clearly you want the world to see who you are. I don't know why I'm the one who's labeled an attention whore. Yes, it's true: I was a drama queen. I am a drama queen. And I don't think it's altogether bad. I know I'm going to get a lot of hype from my roommates about "Oh, Melissa's a drama queen," but no one will be telling me stuff I don't know. Calling me that is not going to hurt my feelings.

I've been a hyper-exaggerating person my whole life. In the house, I was dramatic about important things. I know Matt was walking around the house calling me a drama queen. He should have been honest. He never once said that to my face.

It's not like I'm the only person who changed in front of the cameras. I don't think Julie ever acted for the cameras, but she did ask us to stop talking about her family when the cameras showed up. And Jamie would try not to have serious interactions on camera.

Danny asked me to recall stories to make him laugh all the time. Every time he was just sitting around or with company, he'd be like, "Tell me the story about this. Tell me the story about that." I was performing on request. Now he accuses me of seeking attention. What?

I'm not exclusively a firecracker. I'm so tired of that. Firecracker this. Firecracker that. I have a normal energy level. I can totally sit down and have an intellectual conversation. I can be regular.

I feel like I'm paying for my honesty. I thought the premise of the show was to talk about issues and be honest. I did that.

Kelley: Sometimes when she was going overboard, I'd tell Melissa to get a grip. So much of her torment was for attention.

I've heard Melissa's comedy routines like fifty times. I really didn't egg her on as much as the rest of the house did. Yes, Melissa's comedy is always funny. But, say you're out to dinner with ten people and it's a social situation; well, if Melissa's there, forget about conversing with anyone else. It always becomes Melissa's show. No one else gets to talk. I think there were people in the house I didn't get to know because I spent so much time listening to Melissa's jokes.

Matt: Melissa acknowledges that during the first half of the season, she wasn't the most likable person. As a result, we were like two ships passing through the night. I found Melissa's center-stage antics melodramatic. It was like, is she being real or is she trying to secure episodes five through eleven? Since she's such a hard-core fan of *The Real World*, you can't help but wonder if she was being melodramatic on purpose. She's gotten

into the lives of every single past cast member, and you can't help but wonder whether that affects every one of her actions.

She talked about other people on _The Real World_ all the time, and it made it hard to live life normally. She'd be like, "I'm not going to pull a Kaia." Or she'd look into the camera and send a message to the editors by going: "Don't put Jewel over that." She was always cognizant of the documentary process.

Melissa will never deny she craves attention. But to sit around and talk about her getting attention gives her attention. If conflict is necessary, then so be it, but I don't like drama for the sake of drama. Sometimes, she would make such big things out of nothing that it was embarrassing. I realized she was just trying to make a story.

I don't know if viewers will realize how extensive the need for camera time was. At her birthday party, Melissa danced on the table for forty-five minutes. Forty-five minutes! It was a really long time. I'm sure it won't look that way on the show. But, I was thinking the whole time: "Damn, who can dance for that long?" She wanted to make sure those cameras got her from every angle.

Of all the roommates, we probably talked behind Melissa's back the least. That's because when she was around, she talked so much about herself. There was nothing left to say.

Jamie: Matt had issues with Melissa because he was used to being the Funny Guy, and in the house she was the Funny Girl. It's just how Julie had issues with Matt being the punk Web design guy, when that's what she thought she was. People want to be projected in a certain way, and not overshadowed, but you can't be mad at people for being who they are.

I think if anyone altered how they behaved for the cameras, it was Dave. We got a really small slice of Dave for this project, the woo-woo musician guy. In regular life he doesn't let people in. On national TV, there was no way he would.

David: Melissa has to have the spotlight. When the camera isn't there, she's quiet.

It's like there she is in the kitchen, eating ramen. Then the camera shows up, and boo-ya, she's out there with the jokes. It also happens in the opposite way. Instead of being really happy or popping jokes for Ikegami {the camera}, she'll act incredibly sad. It's all about attention.

I never called her out on that. If you want the limelight and you want to work so hard to get it, go get it. The better person will come out in the end. Melodrama's great but it distracts people from the focus. She's the melodrama and I'm the person who walks around not getting noticed. I didn't have time to call her out.

Am I the only person in the house who found her annoying? To my understanding, yeah. Everybody I hang out with back home would find her completely annoying and probably kick her out.

Melissa will succeed in life when she falls into a circle of people who will not tolerate how annoying she is. She needs to learn to be the passenger. She thrives on having people around. It would do her good to sit back and be a follower and not the center.

Danny: My biggest regret is not calling people out when I felt like they were acting for the cameras. I felt I encouraged Melissa by getting her to tell jokes and stuff.

Julie: I walked out of the Belfort feeling frustrated that I knew everything there was to know about the six people I lived with, but they didn't know half of my story. I spent a lot of time unraveling their stories; maybe I was

forcing stuff too much, pulling stuff out from them, making them nuts when they just wanted to be booze hounds or whatever. But, I don't feel like they asked me as much about me as I asked about them.

An Interview with Melissa's parents, Shorty and Mercy

Shorty: I thought *The Real World* would be a good experience for Melissa. I thought she'd have what you call a growth as far as being a person. She's more confident than she was before she did the show. To me, when she was in front of the cameras, I thought she did pretty good. She didn't seem to notice the cameras. Me too—when I came to visit, I was relaxed. In front of the cameras, I just acted normal, like my crazy self. I liked all of the roommates. I was kinda impressed by all of them. Did I like the house? Not really. The house to me was kind of out of order. No feng shui. I guess with teenagers, there wouldn't be order. There was some nice art, but it seemed out of sync. It looked good on TV, but not in person. The first thing I said when I walked in the door: "This house got potential."

Mercy: I'm scared for Melissa. She's going to be famous, and there are a lot of crazy people out there. I saw *The Real World-Hawaii* with Ruthie taking off her clothes. I said to Melissa, "You better not take off your clothes." She told me she stripped for the camera. I said, "I hope it's not too bad." Yup, I liked the house, except for the cameras. I liked the roommates. I liked all the guys. I even went to church with them.

Confronting David
Race and Ego in the Belfort

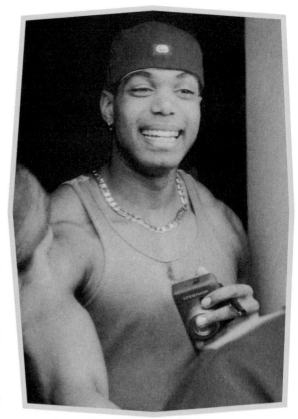

DAVID: When my roommates called that meeting, I wouldn't say it was a confrontation. I don't know what I'd call it. Whether it helped them understand me, I don't know. Those that got something out of it were those who were there to listen, who were genuinely concerned.

My roommates didn't want me to look like I was doing *The Real World* to become a star. Well, I don't care if I "look" that way. I've always wanted to be a star. That's real for me. I rocked the mike in Chicago and I'm going to rock the mike in New Orleans.

I don't know how to measure the success of other *Real World*-ers against what's going to happen to me. But, let me just say I'm about to be the most successful *Real World*-er ever. EVER. I've got the voice. I've got the flow. I've got the physicality. I'm covering all grounds. I'm going to *blowuptuate*.

I don't know who in the house most resented me for my talent. Maybe Julie. That's because she's got talent too, but lacks confidence. Or maybe Matt. Matt and I had conversations about how he should have worked out more. I was instrumental in getting him (and all of my roommates) to work out.

My roommates wouldn't say that stuff to my face. If they'd stepped up to me wrong, it would have been bad. It would have gotten nasty. I have no qualms about making sure I'm not disrespected. So, yeah, my roommates did tiptoe around me. Good.

Basically, it's like this. Black males are built on survival. It has to be that way. We still have to fight very, very hard. I was the only black person in the house. (No, Melissa does not count.) It's not like I *tried* to keep the

> I may get myself in trouble, but I'm going to say it again: I'm gonna be the most successful *Real World*-er ever. Put that under my picture. I'm like Muhammad Ali talking crap, but I can back it up—just like he did.

angry-black-male stereotype, it's just that I had to fight harder than anyone else.

To my roommates, I say, I'm not angry, but don't get in my way.

Melissa: I don't know what happened to David. The camera turned on and he turned angry. David is totally funny, so smart; he's got a 4.0 average; he's fun and loving and cool. But when the cameras started rolling, he became this angry manipulator who couldn't deal with the house. I wish to God I'd seen his audition tape before the show so I could ask him why he wasn't acting like he did in the tape—funny and enjoyable. I don't want anyone to think I wasn't cognizant of his behavior

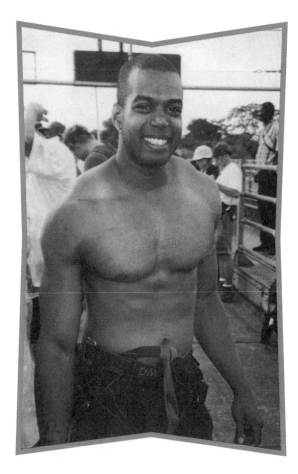

It was totally true. But I wasn't angry, and I was very accepting of the fact that she was a product of her environment. That was difficult for me. And as far as the "n****r bird" remark went; well, what was I supposed to do? If I hadn't said anything, I would have been accused of not standing up for myself. There was really no way to win.

Julie: I don't know if confronting David helped him. I hope so, but I doubt it. He's just got this very singular focus. Kelley, she does tarot cards. And she read David's and they said he was going to fail in his musical career and that he was going to find success, but not in his musical life. Humility is a big thing David's going to have to learn in his life. He got a taste of it in Africa when he was beaten in wrestling by Laterrian *{Road Rules Maximum Velocity Tour}*. He's got this supercharged ego that he's using to cover up insecurities.

Jamie: I didn't think that after we confronted David, we'd cure everything, get this newly emerged David. I think that conversation we had with David planted a seed in him that will somehow grow in the future. He will start shedding his mega-ego, this survivor ego that he has. But he has an uphill battle ahead of him. People revert to their bad ways. I'd like to think that David's going to get into the music business, but he still has the motive of "I have to survive and pay the bills." It's tough. You want someone to start designing their life and not living paycheck to paycheck.

Matt: It's very possible that David will come out of this thing looking like a conceited selfish bastard. There were people who didn't want him go down like that, most specifically me. Jamie, too. He was the one who initiated the meeting. Kelley, Melissa, Danny, they all gave up on him really early—that's only my opinion, of course. As I saw it, Kelley was masked with indifference. That's how she allowed herself to be distant. I admire David for his focus, but I can't help thinking that while getting a record contract will be great for him, it's a minute achievement compared to learning vital lessons in life. David will make things happen, because he's focused. But he's going to step on people in the process.

and its negative ramifications. It was very painful to watch "his story" unfold. I do think that because of David, some viewers are going to think that all black men are promiscuous players.

I hated when people were tiptoeing around David. Matt would come up to me and be like, "How can I deal with David? I don't want to be the white guy who doesn't like the black guy." I felt his pain. I was the only person not afraid of looking racist; I think that's why I confronted him the most. Being afraid of looking racist was a big fear in this house.

I know it's going to look like I'm some female Johnnie Cochran, always playing the race card. But I'm really not racially fixated. I didn't want to sit around and talk about that crap every day. I was forced into it. I was thrown into an environment where people used the word *colored*. Yeah, I told Julie she lived in an insular world.

Danny: David came in here with this bad rap image, totally hard-core, and we were all like, "Please, we see through that BS. Drop the act." After the talk when he cried, he became more of a person. It didn't do anything to his ego, which is still as big as ever, but it changed him as a person. Too bad his change took place only in the last two weeks. We finally saw the softer, real side to him. David needs to keep stuff inside. He wants to be seen as somebody who's in complete control and nothing bothers him.

Being Biracial

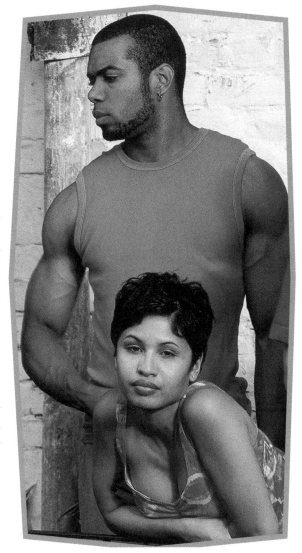

David: I'm a full-fledged black man and what I represent for Melissa is the gateway into the black race. If she could start getting along with me, she could use it as a blueprint for some other black guy. I don't think I represent every black man, but I *am* a black man so I *can* represent.

Melissa's got a lot of dilemmas because she's half black and half Filipino, but she listens to Green Day. It's as if she's culturally confused. She nitpicks. She chooses what she wants from each race. But, it's like, don't expect black girls to appreciate you if you don't appreciate hip-hop. If you don't respect their culture, you're not going to get respect back. She's wondering why she can't hang with black people! Well, she can't even begin to understand fifty percent of who she is.

Melissa: First of all, I don't listen to Green Day. OK, I listened to them back in the day. But, whatever. David needs a lesson in diversity. I was raised in an all-white neighborhood. I happen to like things that aren't stereotypically black, thank you very much. I'm a good example of a diverse person. David implies that cultural confusion is equal to being biracial? Does he buy into the stereotype that all black people have to like the same things?

He's buying into the lie that all black people are alike. That's ridiculous. Everybody has options. But imagine me trying to get that through his stupid head.

As a 23-year-old adult, I have faced a good three-fourths of my life with this doubtful sense of self. Being biracial in an all-white community constantly threw me. People would make comments like, "I knew you were black because of your lips" or "You can't possibly be black, the way you talk." And swallowing these kinds of statements as a 10-year-old or a 15-year-old was very hard! I had to somehow, someway, on my own, come up with some convictions about who I was racially, who I was as a complete person. At 10, that is impossible. At 15, you can do it, but you will regress. And can you imagine discussing this with my parents? They were supportive, but sometimes grew impatient with the questions. Besides, as nonmixed individuals, how could

they possibly really put themselves in my little shoes?

So, somewhere toward my adulthood, I got out of these inquisitive, sometimes cruel nondiverse situations and became grounded in both of my races, never surrounding myself with people who were concerned with that bulls**t. I shunned racist remarks made toward both of my races, and accepted the notion that I can eat rice everyday and never betray my blackness. I could listen to punk and feel black as can be. I could have white, black, Trinidadian, Korean friends and none of them would care about my choices, and they would never make my choices seem racially bound.

So people will call me racially fixated. Well, I am almost positive that if their race was questioned in long stares and quiet whispers, they, too, would become fixated. It's so infuriating! So Kelley can call me angry, I think I have a right to be at this point. David can call me culturally confused, and I will lump him with the people whom I call ignorant.

SHAKA-ZULU

Jamie: I am not racist. During casting, that girl Kameelah was annoying me the whole time. I said that thing about the Nelson Mandela poster that I wake up to. To them it sounded tokeny. Well, as a kid, I was really interested in African and black authors. That doesn't mean I know what it's like to be black. But it does mean that my concerns in life go beyond the North Shore, my BMW, and the next episode of *90210*. Kameelah has this aversion to white men. She was completely judging me. She holds immense bias. She has reverse racism. I felt like I was being judged on the way I looked. I'm a grateful kid. No matter how many times I said that, she was up in my grill. I was thinking, "I came to L.A. for this? I'm not going to be on the show after this." The Shaka-Zulu joke was not racist. It was about how militant she was. People don't understand the roots of my humor.

I talked to Kameelah and this other girl, Piggy, off camera. They let *The Real World* get to their heads. I came into casting as a nobody, one guy out of thousands, and they just had this air about them, this "Oh, you're not part of the club" air. I'd never watched the show. I didn't even recognize them, and I think that shocked them. I think that's why they wanted my ego deflated.

Melissa: After *The Real World* ended, Jamie and I were doing a radio interview in San Francisco. Well, that's where Kameelah lives! She called the radio station when she heard us. Actually, Kameelah only heard me. She didn't realize that Jamie was in the booth. So, when one of the deejays asked her what she thought of Jamie, she flat-out said: "I think he's an ass****." Then the deejay busts out with: "Well, he's sitting right here." Jamie asked her what her problem with him was, and Kameelah said: "I just want you to know you have a privileged life." She also said she was pissed at him for calling her Shaka-Zulu. She said she gave him a hard time in casting to see how he might behave when on the defensive. The phone lines were lit up for hours! Kameelah and I actually had lunch after. That's when I realized that—like Jamie—she was also going on *The Challenge!* Isn't that funny?

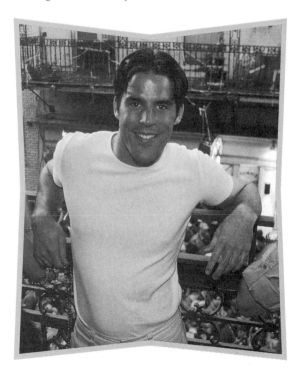

JULIE

Even flying to Los Angeles for the semi-finals casting interview was liberating for me. In fact, that trip was life-changing. I was all alone for the first time. My parents didn't know where I was. I was so wide-eyed. To be somewhere that wasn't Wisconsin or Utah! If one little trip to L.A. made me feel that way, imagine how I'd feel if I got on the show?

CASTING
Kelley

FIRST AND MIDDLE NAME: Kelley Marie
AGE: 22
BIRTHDATE: October 14, 1976
PRESENTLY LIVING IN: Fayetteville, Arkansas
PARENTS: Elaine and Fred
SIBLINGS (NAMES AND AGES): Jason, 25
WHAT IS YOUR ETHNIC BACKGROUND? Caucasian
NAME OF HIGH SCHOOL? Fayetteville High School
NAME OF COLLEGE (YEARS COMPLETED AND MAJORS): University of Kansas 3 Years, Communications; University of Arkansas, 1 Year Communications.
OTHER EDUCATION: No!

WHERE DO YOU WORK? DESCRIBE YOUR JOB HISTORY? Bordino's Italian Restaurant. I've been waiting tables for five years, while I've been in school and traveling.
WHAT IS YOUR ULTIMATE CAREER GOAL? Motivational Speaker/Broadcasting
WHAT KIND OF PRESSURE DO YOU FEEL ABOUT MAKING DECISIONS ABOUT YOUR FUTURE? WHO'S PUTTING THAT PRESSURE ON YOU? I definitely feel pressure, although I don't feel I am on a time line. I want nothing more than to be successful, but I am determined to have fun in the process. What is the point in living if you are always running and you never take time to appreciate the moment?
WHAT ARTISTIC TALENTS DO YOU HAVE (MUSIC, ART, DANCE, PERFORMANCE, FILM/VIDEO MAKING, WRITING, ETC.)? HOW SKILLED ARE YOU?? Artistic...hmmmm! My writing is my most artistic talent. But I can make these really cute spiral chocolate things to put on top of ice cream. I dance in the shower. I sing in the car. I perform in life and I write about it all.
WHAT ABOUT YOU WILL MAKE YOU AN INTERESTING ROOMMATE? As my favorite quote says, "I am the hand up your skirt when you least expect it." That's me! I am an extremely diverse person who looks like a sorority girl. It tends to throw people off. Although, the best is, I really am interested in people and therefore I will be extremely involved with my roommates.
HOW WOULD SOMEONE WHO REALLY KNOWS YOU DESCRIBE YOUR BEST TRAITS? Always present. Gives great advice and truly cares about others. Fun, funny, spontaneous, and intelligent.
HOW WOULD SOMEONE WHO REALLY KNOWS YOU DESCRIBE YOUR WORST TRAITS? I'm always digging into people's personal lives. Sometimes it just isn't my business.
DO YOU HAVE A BOYFRIEND OR GIRLFRIEND? HOW LONG HAVE YOU BEEN TOGETHER? WHERE DO YOU SEE THE RELATIONSHIP GOING? WHAT DRIVES YOU CRAZY ABOUT THE OTHER PERSON? WHAT'S THE BEST THING ABOUT THE OTHER PERSON? Yes and no, how typical! I met the most wonderful man while I was living in England. He has come to visit twice since I left in January, but it is impossible to be twenty-two and maintain a monogamous relationship. We've made an agreement to always be friends but not tell of our other endeavors. I love him, but I am in no way ready to be married. What drives me crazy is not getting laid by my

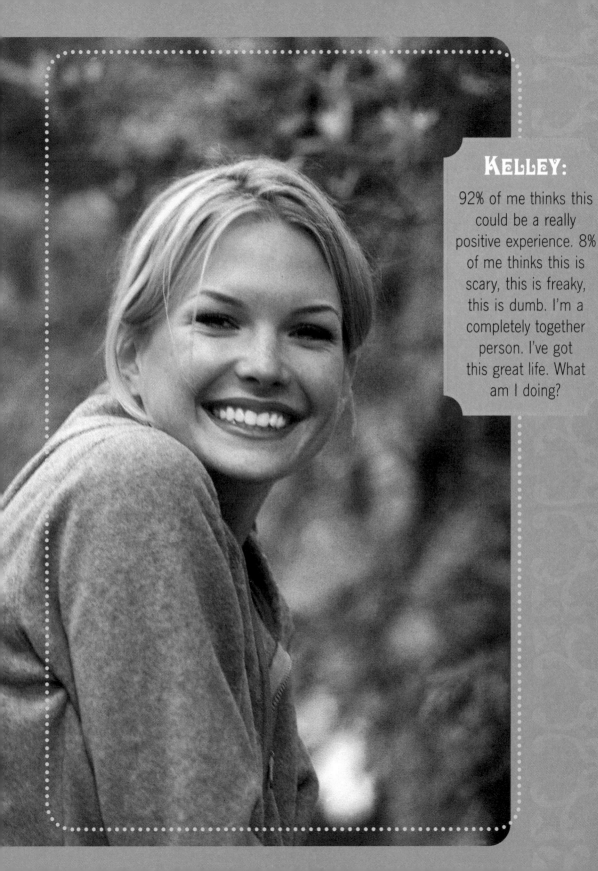

KELLEY:

92% of me thinks this could be a really positive experience. 8% of me thinks this is scary, this is freaky, this is dumb. I'm a completely together person. I've got this great life. What am I doing?

Kelley's RANDOM THOUGHTS...

Everybody forgets what it means to date. If I'm dating you, I'm not your girlfriend. I'm dating you, so to me, I think that I can go out to dinner with you one night, and someone else the next. **If I'm not sleeping with all of them, then who cares? I want to go on dates.** I always date bartenders. Why is that? Because they're the last ones there? In a guy, I like somebody who doesn't just go to Abercrombie and give me the mannequin thing. Mix it up: that works best. I guess my favorite look is worn-out Levi's that look good, and maybe a button-down or something that's kind of open and rolled-up and a little bit breezy and then some flip-flops or sandals or something.

boyfriend because he is always across an ocean. The best thing about him is his tremendous kindness. He is the best friend anyone could ever have and it doesn't hurt that he is the sexiest man alive. Yum!

WHAT QUALITIES DO YOU SEEK IN A MATE? Uninhibited, spontaneous, kind, honest, someone whose intelligence can challenge me, someone who keeps their eyes open when they make love, diverse, present.

HOW IMPORTANT IS SEX TO YOU? DO YOU HAVE IT ONLY WHEN YOU'RE IN A RELATIONSHIP OR DO YOU SEEK IT OUT AT OTHER TIMES? HOW DID IT COME ABOUT ON THE LAST OCCASION? I love the love of sex. I am over having casual drunk sex. Although I would sleep with an old flame if the lines were clear and there was still respect between us. When I am in a relationship, I think sex is the ultimate celebration of your love for each other, and I will take it to its height every time. The last time I had sex was with Darren when he was visiting from England. Once again...yum!

DESCRIBE YOUR FANTASY DATE: My fantasy date would take place in a cabin with no TV or phone. We would cook a fabulous meal, drink fabulous wine, have an intense challenging conversation and (maybe) make love in front of a fire on a bearskin rug and let a Van Morrison record play while I fell asleep!

WHAT DO YOU DO FOR FUN? Everything! I try to always have fun. As my father says, the worst insult is to be called boring. But to answer directly: movies, camping, traveling, eating, drinking with friends, Frisbee, cooking.

WHAT ARE YOUR FAVORITE MUSICAL GROUPS/ARTISTS? Ben Harper, Dave Matthews, Indigo Girls, Ani DeFranco, Miles Davis, Bob Dylan, Paul Simon, Carlos Jin, Ali Farka Toure, Wilco, Grateful Dead....

DESCRIBE A TYPICAL FRIDAY OR SATURDAY NIGHT: Go out to dinner with friends and drink wine, then usually check out a good band in town. Probably an after-hours (if available) then home.

OTHER THAN A BOYFRIEND OR GIRLFRIEND, WHO IS THE MOST IMPORTANT PERSON IN YOUR LIFE RIGHT NOW? TELL ME ABOUT HIM OR HER: Renée Angel. She is my best friend and soul mate. She lives in Denver now but we met in college at KU. Her middle name describes her best...angel!! She has been my savior, mentor, and best friend for a while and hopefully forever. I don't have a sister, but she definitely comes close.

WHAT ARE SOME WAYS YOU HAVE TREATED SOMEONE WHO HAS BEEN IMPORTANT TO YOU THAT YOU ARE PROUD OF? I would bend over backwards for anyone worth their grain. I have always stuck my neck out to make others heard and if I can't change the world, I sure will listen well.

WHAT ARE SOME OF THE WAYS YOU HAVE TREATED SOMEONE WHO HAS BEEN IMPORTANT TO YOU THAT YOU ARE EMBARRASSED BY, OR WISH YOU HADN'T DONE? I can be abrupt at times and I have said things to friends that were hurtful because I figured it was better to tell them than not. I always say what I think and sometimes people don't need to know.

DESCRIBE YOUR MOTHER: My mother is the best teacher I have ever had. She has so many different faces, all beautiful, all perfect. She inspires me to breathe life in and never settle for less than what I deserve.

DESCRIBE YOUR FATHER: My father is also my best friend. He is as intelligent and caring as they come. He has maintained an open forum for me my whole life. He is the smartest human being I have ever met. Basically, he is a stud! Gotta love him.

IF YOU HAVE ANY BROTHERS OR SISTERS, ARE YOU CLOSE? HOW WOULD YOU DESCRIBE YOUR RELATIONSHIP WITH THEM? I have one brother. We are not very close, but we are getting there. He is much more introverted than I am so we don't have a lot in common.

WHAT IS THE MOST IMPORTANT ISSUE OR PROBLEM FACING YOU TODAY? My future. I am in transition as to my path. I need to experience more in order to determine where I want my life to go.

DO YOU BELIEVE IN GOD? ARE YOU RELIGIOUS OR SPIRITUAL? I believe in a higher power, but not just one God. All this had to come from somewhere. I would say I am a spiritual person. I leave my life to fate when I can't control the outcome.

WHAT ARE YOUR THOUGHTS ON PEOPLE WHO HAVE A DIFFERENT SEXUAL ORIENTATION FROM YOU? The more diversity, the better. I can only learn from difference.

DO YOU HAVE ANY HABITS WE SHOULD KNOW ABOUT? You mean besides my constant urge to have people "pull my finger?" Hmmm...no, I can't think of any.

WHAT BOTHERS YOU MOST ABOUT OTHER PEOPLE? Dishonesty. I wish everyone would just lay it on the table. I don't understand the point of letting things fester and build. I hate feeling betrayed.

HOW DO YOU HANDLE CONFLICTS? DO YOU FEEL THAT THIS APPROACH IS EFFECTIVE? I listen. Yes, it is very effective. Most of the time people just want to be validated.

IF YOU COULD CHANGE ANY ONE THING ABOUT THE WAY YOU LOOK, WHAT WOULD THAT BE? My hair. It's much too thin. But screw it, there are bigger things to worry about.

IF YOU COULD CHANGE ANY ONE THING ABOUT YOUR PERSONALITY, WHAT WOULD THAT BE? I would like to care less. I take everything to heart. I feel everything to the highest degree. I should take it down a notch.

IF YOU HAD ALADDIN'S LAMP AND THREE WISHES, WHAT WOULD THEY BE? No more violence. The intelligence of Socrates. A whole bunch of cash.

Casting Preferences File

ACTIVITY	COMMENT
Read Books	✓ Semi-frequent
Sleep 8 Hours	✓ Yes, but it varies
Watch Television Daily	✓ Oprah always
Shop	✓ OK, I confess
Go Out/Party	✓ Yep. Once or twice a week
Spend Time with Friends	✓ Every day
Spend Time Alone	✓ Every day
Balance Work/Study	✓ Still working on that one
Talk on Phone	✓ I get to the point quickly
Cook	✓ Every day
Clean	✓ Unfortunately every day
Write/E-mail	✓ Too much
Read Newspapers	✓ 1 to 2 times a week
Play with Animals	✓ Every day
State Opinions	✓ Lots
Ask Opinions	✓ More
Confide in Your Parents	✓ In excess
Volunteer	✓ Whenever I can—really!
Procrastinate	✓ Whenever I can—really!
Eat	✓ Constantly
Get Drunk	✓ I drink some
Diet	✓ Never
Vote	✓ I was getting to that
Cry	✓ When needed
Laugh	✓ More than all the rest
Instigate	✓ EXCESSIVELY
Cinema	✓ I LOVE MOVIES
Theater	✓ I LOVE THEATER
Concerts	✓ Depends
Clubs	✓ Not really
Parties	✓ Absolutely
Surf the Web	✓ I like people better

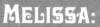

MELISSA:

I told my dad about applying for the show. I was like, "Dad, you know I sent my tape to *The Real World*." He was like, "Don't get your hopes up." And I told my mother. She didn't understand at all. She was like, "Oooh, MTV give free music. You think I get a Julio Iglesias CD?"

FIRST AND MIDDLE NAME: Melissa D.

AGE: 22

BIRTHDATE: February 12, 1977

PRESENTLY LIVING IN: Tampa, Florida

PARENTS: Narcisa and Maurice

SIBLINGS (NAMES AND AGES): Michael, 19; and Marlene, 27

WHAT IS YOUR ETHNIC BACKGROUND? Half Black, half Filipino

NAME OF HIGH SCHOOL? Brandon Senior High; three years completed.

NAME OF COLLEGE (YEARS COMPLETED AND MAJORS): University of South Florida, four years completed, Mass Communications

OTHER EDUCATION: No!

WHERE DO YOU WORK? DESCRIBE YOUR JOB HISTORY? I work at a law firm.

WHAT IS YOUR ULTIMATE CAREER GOAL? To entertain myself. To entertain others. To be happy at work for once.

WHAT KIND OF PRESSURE DO YOU FEEL ABOUT MAKING DECISIONS ABOUT YOUR FUTURE? WHO'S PUTTING THAT PRESSURE ON YOU? I have high anxiety over being successful or even just being good at everything I attempt. I have always brought this pressure onto myself because my parents or my friends do not push or pry into my decisions. Right now, I am working on being ultimately happy and not just comfortable or complacent. I don't know how, but I'm working on it.

WHAT ARTISTIC TALENTS DO YOU HAVE (MUSIC, ART, DANCE, PERFORMANCE, FILM/VIDEO MAKING, WRITING, ETC.)? HOW SKILLED ARE YOU? I graduated with a degree in journalism. I believe I write extremely well, except I am ashamed because I am not a writer. Maybe I don't believe I can write well. No, I do. I just don't have the guts to take $6 an hour to write obituaries just to get my foot in a BROKEN door. Oh, I can dance. Dance Wars. It's all about me. Don't make me point you out.

WHAT ABOUT YOU WILL MAKE YOU AN INTERESTING ROOMMATE? I am totally silly! Just retarded sometimes. I adapt well to adverse situations. I can make people laugh—even if we were at a funeral. I don't ever think I am a "comedian." How nerdy is that? But if I had just two cents for every time I was urged to be one or go to an amateur night, I'd be mad rich. I'm also...never mind.

HOW WOULD SOMEONE WHO REALLY KNOWS YOU DESCRIBE YOUR BEST TRAITS? They would say, "Melissa...holy s**t, she is *so* funny!" Definitely. Ask someone. I think they'll say, "She's funny as hell" almost immediately. Naturally silly. Just plain retarded.

HOW WOULD SOMEONE WHO REALLY KNOWS YOU DESCRIBE YOUR WORST TRAITS? They would say, "Melissa...ooh, but don't make her mad...." POOR ANGER MANAGEMENT SKILLS AT TIMES. I think they'd say I can get a little irate and irrational. I have to get my point across though. All parties involved must listen thoroughly...sometimes I get a bout of Tourette's. F**k. F**k. F**k. It's a bad thing when I'm fired up. Doesn't happen often. "And she can HOLD A GRUDGE."

DO YOU HAVE A BOYFRIEND OR GIRLFRIEND? HOW LONG HAVE YOU BEEN TOGETHER? WHERE DO YOU SEE THE RELATIONSHIP GOING? WHAT DRIVES YOU CRAZY ABOUT THE OTHER PERSON? WHAT'S THE BEST THING ABOUT THE OTHER PERSON? No. Just broke up this year. Three long sexless years. He is so serious. All day-trading and globally volunteering. We are friends now.

WHAT QUALITIES DO YOU SEEK IN A MATE? Must have all fingers and toes intact. Must be silly! Must laugh all the time, has to

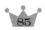

Casting Preferences File

ACTIVITY	COMMENT
Read Books	✔ cool
Sleep 8 Hours	✔ yes, yes, yes
Watch Television Daily	✔ not daily. Love Dateline
Shop	✔ good
Go Out/Party	✔ good
Spend Time with Friends	✔ good
Spend Time Alone	✔ not really
Balance Work/Study	n/a
Talk on Phone	✔ alright
Cook	✔ no
Clean	✔ yes
Write/E-mail	✔ yes
Read Newspapers	✔ BayLife, Florida Metro
Play with Animals	✔ NO NO NO
State Opinions	✔ yes
Ask Opinions	✔ sometimes
Confide in Your Parents	✔ dad
Volunteer	✔ no
Procrastinate	✔ yes yes
Eat	✔ yes
Get Drunk	✔ not really
Diet	✔ NEVER
Vote	✔ yes
Cry	✔ not really
Laugh	✔ ALWAYS
Instigate	✔ not really
Cinema	✔ sometimes
Theater	✔ sometimes
Concerts	✔ lots
Clubs	✔ not really
Parties	✔ no
Surf the Web	✔ not often

be infatuated with me on the same level, must love eating candy. I'm pretty low-maintenance.

HOW IMPORTANT IS SEX TO YOU? DO YOU HAVE IT ONLY WHEN YOU'RE IN A RELATIONSHIP OR DO YOU SEEK IT OUT AT OTHER TIMES? HOW DID IT COME ABOUT ON THE LAST OCCASION? Sex is really important when you're having it. Since this is not the case, I am over it for now. My last boyfriend helped destroy my sex life. I had two—oh my God—two one-time sex encounters recently. Both ended in my broken-down hurt feelings. I unfortunately had sex with two weirdos. I'm raggedy on the sex trip right now, dry as a cat's yawn. Creaks like a broken cabinet door. I think my own hand hates sex. It won't let me masturbate!

DESCRIBE YOUR FANTASY DATE: For the boy to come pick me up! I always get these LOSERS. Maybe it's me? Only janitors, lawn mowers, maintenance men, and really gross toothless OLD men are attracted to me. A cute boy picking me up on time...PERFECT! Let's French-kiss!

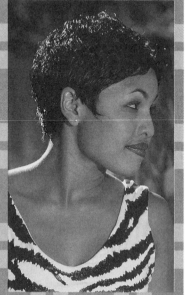

WHAT DO YOU DO FOR FUN? I look at people. I shop for shoes and unfortunately barrettes. I go to this place called New World and socialize. I go to shows. I chill with my daddy. Eat candy. Listen to CDs. (Music therapy is the best!)

WHAT ARE YOUR FAVORITE MUSICAL GROUPS/ARTISTS? Right now: Jets to Brazil, Erykah Badu, Mineral, The Gloria Record, Christie Front, Drive, Outkast, and of course Goodie Mob, sometimes Promise Ring.

DESCRIBE A TYPICAL FRIDAY OR SATURDAY NIGHT: Typical? Saturday go to New World at 2:00 A.M., right before last call. Have either one beer or no beers. Talk, laugh, talk, laugh. Figure out what to do Sunday.

OTHER THAN A BOYFRIEND OR GIRLFRIEND, WHO IS THE MOST IMPORTANT PERSON IN YOUR LIFE RIGHT NOW? TELL ME ABOUT HIM OR HER: Most important? Damn. Ummm. Anisa is my star. I love her and need her. She's a great great asset to the company. She understands me and breaks me down before I can. She laughs with me. She cries with me. (Not often—rare.) She is my star, really. We have an unspoken unbreakable attachment. We are retarded over each other.

WHAT ARE SOME WAYS YOU HAVE TREATED SOMEONE WHO HAS BEEN IMPORTANT TO YOU THAT YOU ARE PROUD OF? I am proud that I can make Anisa laugh in the middle of crying. I mean CRYING. She cries way more than me. I can make her laugh about syphilis, not that she ever had it. She didn't. She never has! Anyway, I can make her smile.

WHAT ARE SOME OF THE WAYS YOU HAVE TREATED SOMEONE WHO HAS BEEN IMPORTANT TO YOU THAT YOU ARE EMBARRASSED BY, OR WISH YOU HADN'T DONE? I cannot keep a secret.

DESCRIBE YOUR MOTHER: My mother is selfless and sacrificing. She gives up everything, goes without water for her kids. At the same time, she can be silent and angry. She resents being so selfless and will maintain an internal anger with her kids because she thinks we don't appreciate her.

DESCRIBE YOUR FATHER: He's George Jefferson. He slams doors, talks about ti**ies and honkies, says, "What's up, blood?" Still! Hilarious! He can be a jerk in good and bad ways. He can hurt my mom's feelings and has trouble expressing love. Sorta like me.

IF YOU HAVE ANY BROTHERS OR SISTERS, ARE YOU CLOSE? HOW WOULD YOU DESCRIBE YOUR RELATIONSHIP WITH THEM? My sister and I were close until she got married and he took her away. YES, I was insanely jealous. She married at a young age. She's Christian. My brother and I are starting to get along better. He's super-irresponsible and it makes me angry because he's smart. We have arguments about race often. Good ones.

WHAT IS THE MOST IMPORTANT ISSUE OR PROBLEM FACING YOU TODAY? Me personally? Stop trying to love these wack-a** boys who give me no attention! These two-week relationships are painful.

DO YOU BELIEVE IN GOD? ARE YOU RELIGIOUS OR SPIRITUAL? No. I refuse. Sometimes I ask myself, "What would Jesus do?" (Please note: sarcasm.)

WHAT ARE YOUR THOUGHTS ON PEOPLE WHO HAVE A DIFFERENT SEXUAL ORIENTATION FROM YOU? Don't care. Pretty indifferent.

DO YOU HAVE ANY HABITS WE SHOULD KNOW ABOUT? I twirl my hair when I'm nervous. Nothing horrible. I don't have convulsions or shoot up heroin. Just a normal kid, I guess.

WHAT BOTHERS YOU MOST ABOUT OTHER PEOPLE? Other people...just kidding. Sometimes people with staring problems. Never seen a brown person before? I can't stand self-righteousness and downright vanity. I can't stand ego. I can't stand Christianity. I can't. I just prefer to avoid that topic with believers of God.

HOW DO YOU HANDLE CONFLICTS? DO YOU FEEL THAT THIS APPROACH IS EFFECTIVE? I win. Even if I don't win. I won. I can't lose. I can't stand it.

IF YOU COULD CHANGE ANY ONE THING ABOUT THE WAY YOU LOOK, WHAT WOULD THAT BE? Only one! I have two. I would fix my smile. I have an overbite. Buck toof smile! Sometimes I like it. But I really hate my kneecaps.

IF YOU COULD CHANGE ANY ONE THING ABOUT YOUR PERSONALITY, WHAT WOULD THAT BE? I can be, now I just said CAN BE, quick to judge. I can be excessively angry about someone's clear stupidity. But that is rare. I usually make it funny and laugh out loud.

IF YOU HAD ALADDIN'S LAMP AND THREE WISHES, WHAT WOULD THEY BE? Let my mom see her family in Manila. Be able to tell my sister that I love her. Mo' money, mo' money, mo' money. Ka-ching!

Melissa's RANDOM THOUGHTS...

I'm really actually sort of nerdy. I have a hard time matching all my clothes. Sometimes they just don't match but it looks nice. The other day I went on a date and I had this camouflage cargo miniskirt and a red tank top and two days later the guy I was on a date with was like, "You looked really crazy." And I thought I looked so cute! **I do like to shop, though. I have a shoe problem really bad.** It must be a Filipino thing, like Imelda Marcos must be my cousin or something.

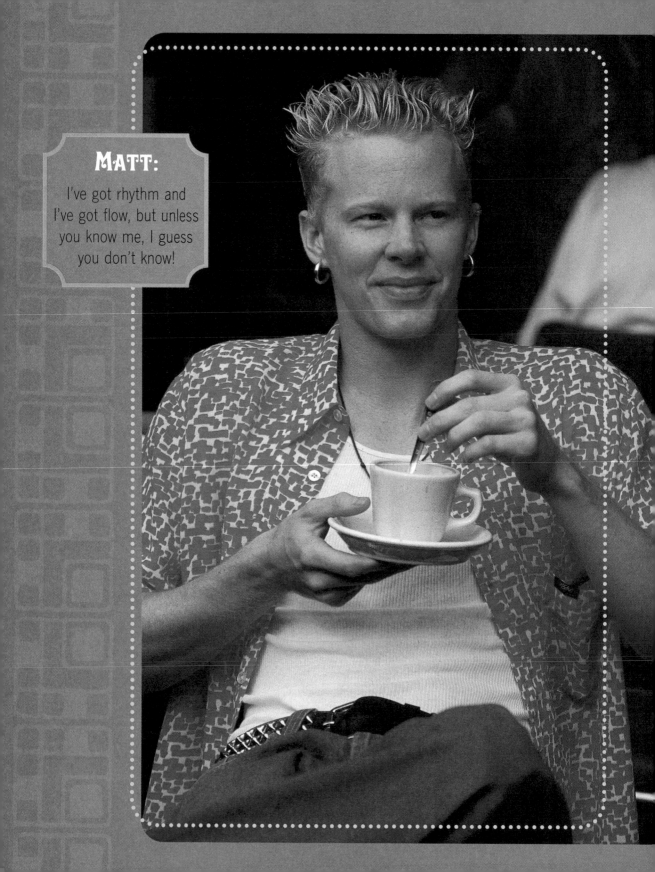

MATT:

I've got rhythm and
I've got flow, but unless
you know me, I guess
you don't know!

APPLICATION
EXCERPTS

Matt

FIRST AND MIDDLE NAME: Matthew Stephen

AGE: 20

BIRTHDATE: November 30, 1978

PRESENTLY LIVING IN: Atlanta, Georgia

PARENTS: Mary and Stephen

SIBLINGS (NAMES AND AGES): Katie, 25; Kristen, 23; Peter, 18; Paul, 15; Andrew, 13

WHAT IS YOUR ETHNIC BACKGROUND? Whitey. Just one white mutt.

NAME OF HIGH SCHOOL? Town Country High School. Four years completed.

NAME OF COLLEGE (YEARS COMPLETED AND MAJORS): Young Harris College 1996-97, Visual Arts; Georgia Tech 1997-present, Industrial Design.

OTHER EDUCATION: None

WHERE DO YOU WORK? DESCRIBE YOUR JOB HISTORY? I do Web design. I'm also a peer adviser. I've worked at an Italian restaurant as a server. I was a photo and fashion editor for *YOU!* magazine in Los Angeles. I was a bag boy at Dills Food City, a golf cart attendant at a resort, and a waiter at a seafood restaurant. I am also a VJ on GT Cable Network.

WHAT IS YOUR ULTIMATE CAREER GOAL? It would be nice to have my own design company with different design houses. We would work on the top floor of a tall building in a big city with a trampoline in our office. And lots of candy and music playing really loud all the time. Maybe a half pipe to skate on when we are on breaks.

WHAT KIND OF PRESSURE DO YOU FEEL ABOUT MAKING DECISIONS ABOUT YOUR FUTURE? WHO'S PUTTING THAT PRESSURE ON YOU? Most kids in college feel pressure from their parents, but my parents have always trusted my decisions ever since I have been in high school. They keep an eye on me to make sure I don't do anything stupid, but they understand it is my life and they know I will make them proud, and myself happy. I feel pressure from my peers at Georgia Tech, but I blow them off. I put pressure on myself to do well. I set high goals. I want to be the best at what I do.

WHAT ARTISTIC TALENTS DO YOU HAVE (MUSIC, ART, DANCE, PERFORMANCE, FILM/VIDEO MAKING, WRITING, ETC.)? HOW SKILLED ARE YOU? I enjoy painting with acrylics and spray paint. I have an exceptional ability to draw what I see, be it a still life or a figure drawing or something in my head. My graphic and Web design skills are pretty dope, too.

WHAT ABOUT YOU WILL MAKE YOU AN INTERESTING ROOMMATE? Quite simply, I am interested in a variety of things: hip-hop culture, fashion design, poetry, religion, cultures, psychology, breakdancing, etc....

HOW WOULD SOMEONE WHO REALLY KNOWS YOU DESCRIBE YOUR

BEST TRAITS? Funny. Outgoing. Creative. Loving. Fun.

HOW WOULD SOMEONE WHO REALLY KNOWS YOU DESCRIBE YOUR WORST TRAITS? Overzealous. Forgetful. Sometimes spacey. Too helping. (Sometimes people don't want to be helped.)

DO YOU HAVE A BOYFRIEND OR GIRLFRIEND? HOW LONG HAVE YOU BEEN TOGETHER? WHERE DO YOU SEE THE RELATIONSHIP GOING? WHAT DRIVES YOU CRAZY ABOUT THE OTHER PERSON? WHAT'S THE BEST THING ABOUT THE OTHER PERSON? I do not have a girlfriend now. I did have one for ten months a couple of years ago. She rocked! She was so funny and outgoing and enthusiastic about everything. She was so cute and lovable. Everyone loved her. The best thing about her was she was so upbeat. The worst

thing about her was she became consumed by uncertainty in her life and she could not care for anyone beyond herself in that uncertainty. She is still rad though.

WHAT QUALITIES DO YOU SEEK IN A MATE? She has to love God. She has to love me unconditionally. She has to be passionate, creative, and fun. Selfless...and sensitive...She needs to be a little bit weird, too. And definitely outgoing.

HOW IMPORTANT IS SEX TO YOU? DO YOU HAVE IT ONLY WHEN YOU'RE IN A RELATIONSHIP OR DO YOU SEEK IT OUT AT OTHER TIMES? HOW DID IT COME ABOUT ON THE LAST OCCASION? Sex is really important to me, that's why I don't do it. I am a virgin and I will stay that way

Matt's RANDOM THOUGHTS...

The summer after my freshman year, for some weird reason I just started being drawn to children. I don't know if it's fatherly instincts kicking in or something, but every time I saw a baby in a grocery store I'd be so drawn to hold the baby.

I was jealous of women because they got to experience motherhood.

I don't know if this sounds weird, but they get to feel a baby growing inside of them. They get to develop that bond with a child. I know I'll never be able to experience that.

until I meet a girl that is rad enough to spend the rest of my life with. I take a lot of pride in myself and I will not share something so intimate with just anyone. That is the relationship aspect to my chastity. Other than that, I can focus my energy elsewhere. I am not always seeking to get laid. Sex can wait.

DESCRIBE YOUR FANTASY DATE: I would dress like JJ from *Good Times*. I would pick up my girl (b-girl, DJ, graffiti, artist, poet, model) in my Woody. We would go to the beach and she would watch me try to surf. Then we would watch the sunset and sing Monster Ballads to each other. Then we would go break spray and read poetry that we wrote for each other. (Cheeseball? Yes.) No, now that I think about it, I would rather be Columbo.

WHAT DO YOU DO FOR FUN? Since my life is so busy and always on the go, I usually sit and draw for fun. I will listen to Bach and draw or paint myself into oblivion. But if I feel like I deserve some excitement, I will break with my friends, or go to see a concert or a movie. Or I take my hot-rod Honda out and see what trouble I can get into. Oh yeah! I love thrift store shopping...four stores in one afternoon is the only way to do it.

WHAT ARE YOUR FAVORITE MUSICAL GROUPS/ARTISTS? Payable on Death, Project 86, Rabbit in the Moon, any jungle DJs, Grits, DJ Swamp, Poor Old Lu, Tony Bennett, Bach, Dick Dale, MxPx.

DESCRIBE A TYPICAL FRIDAY OR SATURDAY NIGHT: I can't describe a typical Friday or Saturday because I never know what I will run into. I enjoy going out with friends. Or maybe going on a road trip for a couple of days. If there is an art exhibit opening I will go. If a band or DJ is in town that I like, then I will definitely go to that. Or I will go to a friend's place to hang out.

OTHER THAN A BOYFRIEND OR GIRLFRIEND, WHO IS THE MOST IMPORTANT PERSON IN YOUR LIFE RIGHT NOW? TELL ME ABOUT HIM OR HER: The most important person in my life right now is God. Our relationship is just like any other—you have to put time and energy into it, or it isn't going to happen. God is more real to me now than ever and it is a beautiful thing. He has really helped me out when my life has been really tough.

WHAT ARE SOME WAYS YOU HAVE TREATED SOMEONE WHO HAS BEEN IMPORTANT TO YOU THAT YOU ARE PROUD OF? My girlfriend was being rather tough to love. She was being selfish, inconsiderate, and impatient. But I knew she needed me in the midst of all her troubles and her actions were because of her troubles. I stuck by her when most others would have left.

WHAT ARE SOME OF THE WAYS YOU HAVE TREATED SOMEONE WHO HAS BEEN IMPORTANT TO YOU THAT YOU ARE EMBARRASSED BY, OR WISH YOU HADN'T DONE? I've said some stupid things in relationships and to people. My emotions get hold of me sometimes and I say stupid stuff. And I hate when I am selfish in a relationship. I feel like such a fool. No one likes selfish people, so it is important that I don't be one.

DESCRIBE YOUR MOTHER: Mom is Mother and Wife. She loves us so much and did so much for us. She was always there for us when we were kids. Yet she still had enough to be a wife, too. She had to give her all into being a wife...to loving my dad even if he was hard to love. And it is phenomenal that she could maintain both roles. She kicks ass. I love her so much.

DESCRIBE YOUR FATHER: My dad is a perfectionist and is very good at what he does. He will do his job the absolute best he can. He put in long hours and went the extra mile to make sure he did his job. Then the other side was the Father for us. He came home and played with us, watched *The A-Team* and *MacGyver* with us all. He planned huge road trips all up the East Coast for us. He, just like my mom, had to find the balance between his two roles. I admire him a lot.

IF YOU HAVE ANY BROTHERS OR SISTERS, ARE YOU CLOSE? HOW WOULD YOU DESCRIBE YOUR RELATIONSHIP WITH THEM? I am very close to my family. My sister Katie lives in Atlanta and we see each other all the time socially. My sister Kristen is a real good comforter so she usually

helps me with my struggles. Peter and I hang out when he comes to Atlanta. Paul is growing up and turning out to be a pretty rad little kid. Then there is little Andrew. He has such a giving temperament. I love my family.

WHAT IS THE MOST IMPORTANT ISSUE OR PROBLEM FACING YOU TODAY? The biggest challenge I am facing today is school. But I am doing awesome, so that is not a problem. Really, it is that my life is so set. I mean, I am riding the whole college-to-job train right now. It is like there is no room for adventure. I don't want to be some schmuck sitting in my Navigator in rush hour traffic. I don't want to be like that. My life is an adventure because it always takes big turns. And I haven't had one in a while and that concerns me.

DO YOU BELIEVE IN GOD? ARE YOU RELIGIOUS OR SPIRITUAL? Yes. I am religious and spiritual. It is through religion that I become more spiritual. I go to Mass all the time.

WHAT ARE YOUR THOUGHTS ON PEOPLE WHO HAVE A DIFFERENT SEXUAL ORIENTATION FROM YOU? I am not homophobic. All people must be loved unconditionally.

DO YOU HAVE ANY HABITS WE SHOULD KNOW ABOUT? No.

WHAT BOTHERS YOU MOST ABOUT OTHER PEOPLE? Selfishness. This seems to be a recurring theme in my responses. It just sucks when all people care about is themselves. All their time, money, energy goes into themselves. That and closed-mindedness...like Mother Teresa said, "If you judge someone, you have no time to love them."

HOW DO YOU HANDLE CONFLICTS? DO YOU FEEL THAT THIS APPROACH IS EFFECTIVE? I have been through a lot of training for conflict mediation through my job with Housing at Tech. So I deal with conflicts all the time. We talk things out in a mature manner. You always have to put yourself in their shoes in order to see where they are coming from. My approach is very effective.

IF YOU COULD CHANGE ANY ONE THING ABOUT THE WAY YOU LOOK, WHAT WOULD THAT BE? I used to be really sensitive about how thin I am but now I really like it. I suppose I would drop a little bit of pigment in the complexion...just so I wouldn't get hounded about getting a tan every time I take off my shirt. But hey, they can't hate me because of the color of my skin.

IF YOU COULD CHANGE ANY ONE THING ABOUT YOUR PERSONALITY, WHAT WOULD THAT BE? Nothing. I like who I am. I have a lot of fun with my life and my personality. I don't want to change a thing.

IF YOU HAD ALADDIN'S LAMP AND THREE WISHES, WHAT WOULD THEY BE?

1) I want an afro. It would be nice to be able to stick a pick in there.
2) Stop pollution...make people recycle. 3) I would ask for wisdom.

Casting Preferences File

ACTIVITY	COMMENT
Read Books	✔ I would like to read more
Sleep 8 Hours	✔ Usually seven
Watch Television Daily	✔ No, I don't own a TV
Shop	✔ Thrift stores
Go Out/Party	✔ Go out when I can
Spend Time with Friends	✔ Often
Spend Time Alone	✔ I work alone, so often
Balance Work/Study	✔ Very well
Talk on Phone	✔ 15 minutes a day
Cook	✔ No
Clean	✔ My room is very clean
Write/E-mail	✔ 1/2 hr-1 hr a day
Read Newspapers	✔ 20 minutes a week. Auto, living
Play with Animals	✔ None
State Opinions	✔ Often
Ask Opinions	✔ Often
Confide in Your Parents	✔ All the time
Volunteer	✔ Often. 4-6 hours a week
Procrastinate	✔ Only when I have to
Eat	✔ 3x a day
Get Drunk	✔ Never
Diet	✔ No fatty foods
Vote	✔ Next election
Cry	✔ Maybe once a month
Laugh	✔ All day
Instigate	✔ ??
Cinema	✔ One movie every few weeks
Theater	✔ Sometimes
Concerts	✔ 1 every two weeks
Clubs	✔ Every few weeks
Parties	✔ 1 per weekend
Surf the Web	✔ 3 hours a week

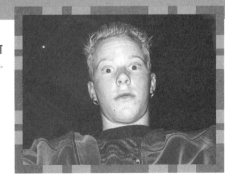

CASTING David

FIRST AND MIDDLE NAME: David Alan

AGE: 21

BIRTHDATE: October 19, 1977

PRESENTLY LIVING IN: Canton, Missouri

PARENTS: Vicki and Dennis

SIBLINGS (NAMES AND AGES): None that I know of!

WHAT IS YOUR ETHNIC BACKGROUND? Black; African American Naturally Nubian; Dark and Lovely or Eclipsed Sunshine, take your pick. They all mean the same thing.☺

NAME OF HIGH SCHOOL? Chicago Vocational High School (two years); Lincoln Park High School (two years).

NAME OF COLLEGE (YEARS COMPLETED AND MAJORS): Culver-Stockton College (three years completed). Double Major: Psychology and Criminal Justice.

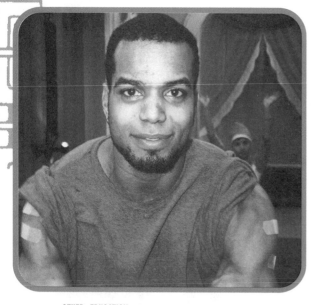

OTHER EDUCATION: Ghetto University School of Hard Knocks taught by Professor Jay Z. (Kidding ☺ No other education yet!)

WHERE DO YOU WORK? DESCRIBE YOUR JOB HISTORY? At college as a resident assistant. I've also been a manager at McDonald's (had to quit ☹), and was a production programmer for a radio station. (They fired me because I was too vocal with my opinions.)

WHAT IS YOUR ULTIMATE CAREER GOAL? Ultimately, when all's said and done, I will be the first Black President of the United States of America. I may need quite a bit more security than usual (i.e. armored limos with ballistic missiles and jet propulsion capabilities), but I'm willing to take the chance.

WHAT KIND OF PRESSURE DO YOU FEEL ABOUT MAKING DECISIONS ABOUT YOUR FUTURE? WHO'S PUTTING THAT PRESSURE ON YOU? I feel and place more pressure on myself than I could ever explain. This world, let alone the nation as a whole, is not ready for a Black president, but I can't sit around and wait until it is. I can either prepare and prove myself worthy now (through school and such) or watch the parade go by. I refuse to do the latter. I will not be a spectator to my own life!!! Can U dig it???

WHAT ARTISTIC TALENTS DO YOU HAVE (MUSIC, ART, DANCE, PERFORMANCE, FILM/VIDEO MAKING, WRITING, ETC.)? HOW SKILLED ARE YOU? I have been blessed with a gospel-rich voice like Fred Hammond and lyricist/piano skills like Tori Amos. Now that's a combo you can't get at Burger King. Feel me?

WHAT ABOUT YOU WILL MAKE YOU AN INTERESTING ROOMMATE? Remember Mork from *Mork and Mindy?* Remember how he always stood on his head to watch TV? Well, every night before I go to bed I have to stand on my head and sing at least one verse of the spiritual "Sometimes I Feel Like a Motherless Child." Otherwise, I swear I don't sleep as well. I know that sounds strange, but ever since I was thirteen I've done this. Hey, don't knock tradition! ☺ Point is, I'm a little weird. ☺

HOW WOULD SOMEONE WHO REALLY KNOWS YOU DESCRIBE YOUR BEST TRAITS? They would say: "He is extremely opinionated, but equally intelligent and knowledgeable to back his statements. He will never back down—even against overwhelming odds. As a matter of fact, he prefers the odds to be stacked. He spares nothing when it comes to friends, and will use everything against an enemy. He's the type of person you either love for who he is or despise his very existence."

HOW WOULD SOMEONE WHO REALLY KNOWS YOU DESCRIBE YOUR WORST TRAITS? They would say: "He is so anal about health and working out that he is sometimes very difficult to be around. His moods are a direct reflection of how he feels and looks physically for a given day. When he doesn't have a good workout, or he is altogether prevented from working out, it is best to leave him alone until *he* feels he can overcome the bad day.

DO YOU HAVE A BOYFRIEND OR GIRLFRIEND? HOW LONG HAVE YOU

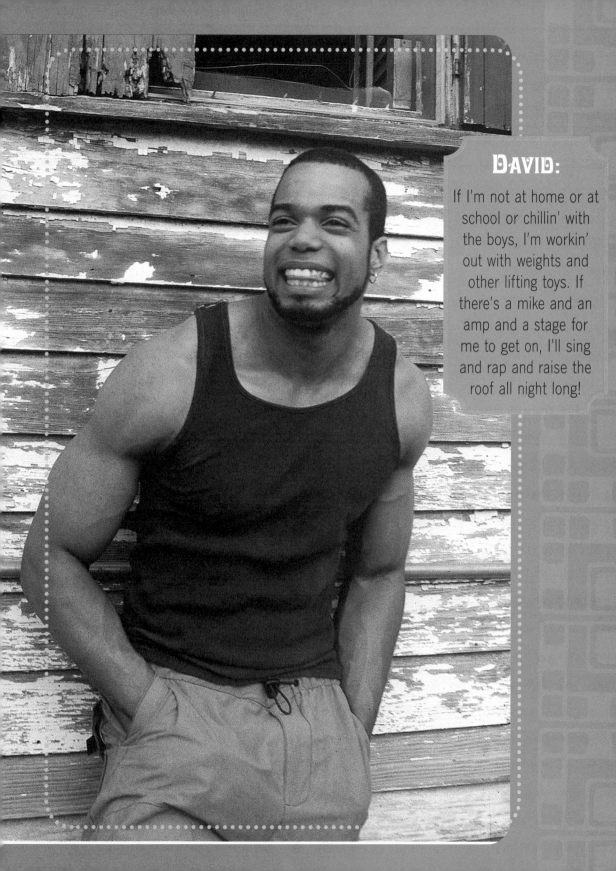

DAVID:

If I'm not at home or at school or chillin' with the boys, I'm workin' out with weights and other lifting toys. If there's a mike and an amp and a stage for me to get on, I'll sing and rap and raise the roof all night long!

David's RANDOM THOUGHTS...

People don't seem to understand why I'm obsessed with working out like I am. People don't understand why I want to be 285 pounds, why I want to be all massive.

All the women that I talk to think it's disgusting. They don't like veins.

They don't like big men. That's cool. Why do I want to be like this? It's the ultimate challenge. The dedication, the hard work, the desire, the will, the guts to get to the gym every day, to add more weight, to push yourself to the absolute limit. I'm 175 pounds. I want to be 285...110 to go. I'm only 22. When I'm 26 or 27, I'll be huge. I'll be very big. I want to have a problem walking through double doors, that's how it's going to be.

BEEN TOGETHER? WHERE DO YOU SEE THE RELATIONSHIP GOING? WHAT DRIVES YOU CRAZY ABOUT THE OTHER PERSON? WHAT'S THE BEST THING ABOUT THE OTHER PERSON? Very tricky question. If fantasies, desires and happy-go-lucky wishes count, then of course I have a girlfriend, Janeane Garofalo. However, if I were talking reality of what actually is, then the answer is a resounding no!! I think intelligence, work ethic, and a disciplined attitude are not what girls my age want right now. (Not to mention their lack of readiness for a man like that.) Therefore, I am single. I'm always looking, though. Miracles happen every day, so I have faith someone will come along. If not, it only takes one (me) to live my life.

WHAT QUALITIES DO YOU SEEK IN A MATE? They say beauty is in the eye of the beholder, and since it's my eye we're talking about here, my mate better render me blind.

HOW IMPORTANT IS SEX TO YOU? DO YOU HAVE IT ONLY WHEN YOU'RE IN A RELATIONSHIP OR DO YOU SEEK IT OUT AT OTHER TIMES? HOW DID IT COME ABOUT ON THE LAST OCCASION? This may sound strange, but I have sex a lot—not only because I'm single and there's no other feeling like it but also because if done right for a long time, it becomes the "greatest" workout you wouldn't mind "doing" every day, especially if done to music. You never know, it could be the next big thing! Can you imagine "The Sex Cardio Workout?" Sexin' to the oldies, baby!

DESCRIBE YOUR FANTASY DATE: A moonlit, breezy summer night with Janeane Garofalo, eating a bowl of strawberry Jell-O, two bottles of sparkling grape juice and a guy with an unpronounceable French name to play the violin in the background.

WHAT DO YOU DO FOR FUN? I'm a club hoppin', disco jivin', freakazoid-type guy that'll dance as if life and humanity depended on it. As a matter of fact, if I were a superhero, that would be my power. I'd dance my enemies and all supervillains into submission.

WHAT ARE YOUR FAVORITE MUSICAL GROUPS/ARTISTS? Fred Hammond, Hezikiah Walker, Kirk Franklin, Tori Amos, Björk, various DJs and mix albums, and last but definitely not least, the old-school jams: the Ohio Players, Marvin Gaye, Barry White, et al.

DESCRIBE A TYPICAL FRIDAY OR SATURDAY NIGHT: At school, I study. Back home in Chicago, I go to the barber, hook up my 'fro, slide on the old-school linens, get up in the club, and shake my booty until it's sure red and sweatin'. After that, get something to eat from Denny's, talk to my friends, mac on the waitress, and call it a night.

OTHER THAN A BOYFRIEND OR GIRLFRIEND, WHO IS THE MOST IMPORTANT PERSON IN YOUR LIFE RIGHT NOW? TELL ME ABOUT HIM OR HER: The most important person in my life right now is not even "in" my life. Regardless of the fact that Grace is no longer with me and I don't even know where she is for that matter, I am still living as if she can see my every move. Because of her presence in my mind, I have no other option but to force myself to succeed *all the time*.

WHAT ARE SOME WAYS YOU HAVE TREATED SOMEONE WHO HAS BEEN IMPORTANT TO YOU THAT YOU ARE PROUD OF? My little cousin wanted to go to the circus one day, but we couldn't afford it. She cried all day long because she just wanted to see the clowns. So instead of going to the circus, I dressed up as a clown, nose and all, and brought the circus to her room.

DESCRIBE YOUR MOTHER: My mother is like water and time. She's like water because she exemplifies the very essence of life every day. She's like time because no matter what you do or try, she can never be stopped.

DESCRIBE YOUR FATHER: My dad is like an eagle and a valley. He's like an eagle because he is forever trying to reach the heights of heaven to better understand God. He's like a valley because he knows at the same time that nothing can be above God, therefore being humble is in order.

IF YOU HAVE ANY BROTHERS OR SISTERS, ARE YOU CLOSE? HOW WOULD YOU DESCRIBE YOUR RELATIONSHIP WITH THEM? No brothers/sisters, just cats.

WHAT IS THE MOST IMPORTANT ISSUE OR PROBLEM FACING YOU TODAY? I have this feeling my mother is very sick, but she's too proud to tell me the truth about it. If I got a phone call at school or anywhere saying she has passed away, I'd freak!

DO YOU BELIEVE IN GOD? ARE YOU RELIGIOUS OR SPIRITUAL? Yes, I believe in God. I do not believe, however, that God was pimpin' a beard and long beautiful flowing hair like the pictures depict. But I do believe! I feel God is a woman!

WHAT ARE YOUR THOUGHTS ON PEOPLE WHO HAVE A DIFFERENT SEXUAL ORIENTATION FROM YOU? Do what you wanna do!

DO YOU HAVE ANY HABITS WE SHOULD KNOW ABOUT? I sing really loud in the shower. Instead of using a towel to dry myself after a bath or shower, I air-dry. (Not butt naked, the bottom half is covered!)

WHAT BOTHERS YOU MOST ABOUT OTHER PEOPLE? I can't deal with people who won't stand up tall for what they believe. Just raising your hand in a world that gives no acknowledgment will not do. You either rise up to be counted and heard clearly or stay dat a** at home. I got no love for the silent type!!

HOW DO YOU HANDLE CONFLICTS? DO YOU FEEL THAT THIS APPROACH IS EFFECTIVE? I'll talk *to* you, I'll talk *at* you, and I'll definitely argue you to the ground. However, as soon as you get physical, I *walk* away and so does my respect for you. This is very effective because if I wanted to and I was that type of person I'd kick dat a** and people know it, but I don't.

IF YOU COULD CHANGE ANY ONE THING ABOUT THE WAY YOU LOOK, WHAT WOULD THAT BE? I would change my a**! Don't get me wrong, I have a nice firm well-rounded a** now, but I want a little more plumpness. Kinda like what happens to a hot dog. But I don't want to have to put my a** on a grill! ☺

IF YOU COULD CHANGE ANY ONE THING ABOUT YOUR PERSONALITY, WHAT WOULD THAT BE? I would change my pimp daddy skills from normal to hellified!! Dig it? See, at this point in my life, I'm a mac! I've got more mac than Velveeta got cheese! Don't hate the playa, hate the game! Let that marinate for the sauce that it is!

IF YOU HAD ALADDIN'S LAMP AND THREE WISHES, WHAT WOULD THEY BE? 1. I don't want to be human. Humans are too limited. I wish to have mutant-type intellect, size, and strength. 2. The ability to talk to and see God. I'm sure she's beautiful. 3. Would be a gift to my firstborn son or daughter.

Casting Preferences File

ACTIVITY	COMMENT
Read Books	✔ Almost as much as I breathe
Sleep 8 Hours	✔ Yeah right! 8 hrs a week!
Watch Television Daily	✔ For sure!
Shop	✔ w/o $$, it's called shoplifting
Go Out/Party	✔ Enough to get my swerve on
Spend Time with Friends	✔ Not enough!
Spend Time Alone	✔ People won't let me
Balance Work/Study	✔ Balance? That's all there is
Talk on Phone	✔ If you call and pay the bill!
Cook	✔ Like a chef on steroids!
Clean	✔ My body, yes. Room, no
Write/E-mail	✔ Need practice!
Read Newspapers	✔ All about arts and money!
Play with Animals	✔ Cuz they're cute like that
State Opinions	✔ Up your a** if need be
Ask Opinions	✔ Always willing to learn
Confide in Your Parents	✔ Mom, yes. Dad, think not
Volunteer	✔ Whatever I can share
Procrastinate	✔ Tell you later
Eat	✔ 6x a day
Get Drunk	✔ Never have
Diet	✔ Have no choice
Vote	✔ For even the smallest thing
Cry	✔ On the inside
Laugh	✔ Like a hyena on laughing gas
Instigate	✔ I don't start things. Just finish
Cinema	✔ I sneak in bags of food!
Theater	✔ All about fine arts!
Concerts	✔ Up front and jammin'
Clubs	✔ Make way, please! Comin' thru!
Parties	✔ Of which I am the life!
Surf the Web	✔ Like I was from Hawaii!

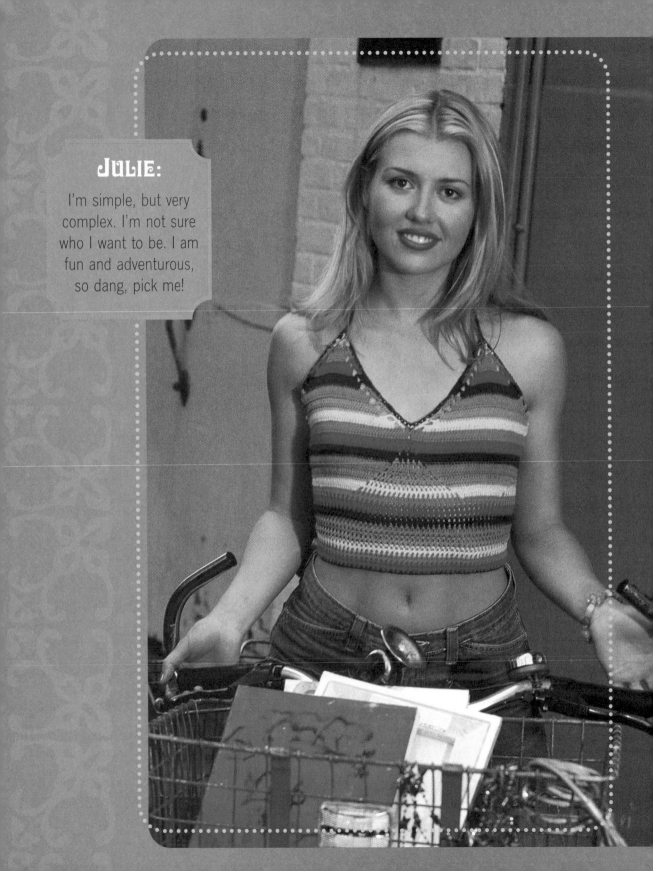

JULIE:

I'm simple, but very complex. I'm not sure who I want to be. I am fun and adventurous, so dang, pick me!

Julie

FIRST AND MIDDLE NAME: Julie

AGE: 20

BIRTHDATE: July 11, 1979

PRESENTLY LIVING IN: Provo, Utah

PARENTS: Janet and James

SIBLINGS (NAMES AND AGES): Alan, 18; Jonathan, 17; Lisa, 14; Susan, 8

WHAT IS YOUR ETHNIC BACKGROUND? White

NAME OF HIGH SCHOOL? Kettle Moraine High School. I graduated. (4 years.)

NAME OF COLLEGE (YEARS COMPLETED AND MAJORS): I'm a junior at Brigham Young University. I'm a business major.

OTHER EDUCATION: I worked at a salon where I learned to do nails. My dad once taught me to juggle.

WHERE DO YOU WORK? DESCRIBE YOUR JOB HISTORY? I worked at that salon. I've also worked at Wal-Mart Pharmacy and telemarketing. Last summer I was a youth counselor. That was fun. Right now I work for myself cleaning guys' smelly apartments. During summers I manage my parents' restaurant at home.

WHAT IS YOUR ULTIMATE CAREER GOAL? Marry money. Just kidding. I'd love to own my own business.

WHAT KIND OF PRESSURE DO YOU FEEL ABOUT MAKING DECISIONS ABOUT YOUR FUTURE? WHO'S PUTTING THAT PRESSURE ON YOU? I believe you make your own decisions. Sure, my parents have tried to influence my choices and they've succeeded to some extent, but basically I run my life. I'm happy with where my life is now. I have some big decisions coming up, but I know things will work out how I need them to.

WHAT ARTISTIC TALENTS DO YOU HAVE (MUSIC, ART, DANCE, PERFORMANCE, FILM/VIDEO MAKING, WRITING, ETC.)? HOW SKILLED ARE YOU? I love life and trying new things. So, my talents are kind of diverse. I *love* to play guitar. I sing and am kinda getting into Latin dance. I also dive, run, play volleyball, write poetry, speed (only five tickets, however), and camp, and I like poetry. I'm big into skiing and plan to become a ski bum if I don't get on MTV. Other skills include unwrapping a Starburst with my tongue, spending money and debate. (I can argue just about any point, if I believe it).

WHAT ABOUT YOU WILL MAKE YOU AN INTERESTING ROOMMATE? I love to have fun. I'm also very passionate and animated. Life is too short to be boring. I tend to be spontaneous. I like to listen and help people sort things out. I've also never lived with guys before. I'm looking VERY much forward to it. ☺

HOW WOULD SOMEONE WHO REALLY KNOWS YOU DESCRIBE YOUR BEST TRAITS? I'm independent. I'm pretty low-maintenance. High return as far as relationships go. Probably why I've been screwed over. Regardless, I'm not hard to live with. I'm fun. I've also been told that I care a lot about people's feelings unless something I really believe in is at stake. Then I fight to the death. I guess that makes me loyal. I had a boyfriend tell me I am a sexy spaz once. Compliment? You tell me.

HOW WOULD SOMEONE WHO REALLY KNOWS YOU DESCRIBE YOUR WORST TRAITS? I'm independent. I tend to bury my problems so as to not involve others. I'm not too touchy-feely. I look at things logically. I'm somewhat indecisive. Sometimes I get overly excited at the wrong times and can make a scene. I have a hard time committing to things, even if it's what brand of toilet paper to buy. My mom tells me I start arguments intentionally although I don't know if I believe it. Maybe I just talk too much.

DO YOU HAVE A BOYFRIEND OR GIRLFRIEND? HOW LONG HAVE YOU BEEN TOGETHER? WHERE DO YOU SEE THE RELATIONSHIP GOING? WHAT DRIVES YOU CRAZY ABOUT THE OTHER PERSON? WHAT'S THE BEST THING ABOUT THE OTHER PERSON? Okay, welcome to my so-called-life. See I tend to stop liking guys when I find out they like me. This causes problems. This past summer was my best relationship. I started seeing my brother's best friend. He was so sweet to me and would actually call me his girlfriend (step up from past relationships). We were kinda star-crossed, though, because he was only seventeen and I was twenty. Plus, he's my brother's best friend AND to make it worse he worked at the restaurant I managed, making me his boss. Anyway, he wanted to keep things secret so I agreed. It was awful. I mean,

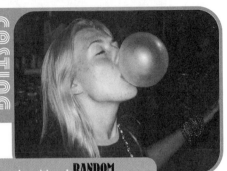

Julie's RANDOM THOUGHTS...

I like mustard a lot. I seriously love mustard. I'll drink it from the bottle, like a baby or something. I'm obsessed with mustard and pickles. And I love vinegar. Maybe Mom made a lot of vinegar when she was pregnant with me. I don't have a lot of phobias per se. I used to be scared of heights, but now I'm just kind of like fascinated by it. I would love to go bungee jumping. I'd like to do anything. **Seriously, I've done nothing in my life. I feel so out of it.** So that would be so cool if I could go to New Orleans and see some things and go to Mardi Gras and Bourbon Street. What do you do at Mardi Gras? It's gonna be pretty fun when all the roommates are sloppy drunk and I'm gonna be like, "Another Mountain Dew, please."

at first all the sneaking around was romantic, but soon he started dating other people just so "people wouldn't talk." Jon's one of those guys that makes you feel like a princess when you're with him, but when you're not you wonder if he even knows you're alive. I can't tell you the countless hours I've spent thinking about him, crying about him, wondering if any of the things he told me were sincere. I haven't heard from him since I left for college, but like an idiot, I still write him and I still check my e-mail every day just in case. I love Jon because he's so gentle. (He's never hit me.) He's also totally fun. I feel very safe and content around him. Jon drives me crazy because I don't think he loves me like I love him, despite what he says. How do you just stop loving someone?

WHAT QUALITIES DO YOU SEEK IN A MATE? I need someone who makes me happy. Someone who loves me like I love him.

HOW IMPORTANT IS SEX TO YOU? DO YOU HAVE IT ONLY WHEN YOU'RE IN A RELATIONSHIP OR DO YOU SEEK IT OUT AT OTHER TIMES? HOW DID IT COME ABOUT ON THE LAST OCCASION? Sex is very important to me. That's why I'm a virgin. I won't have sex until I'm married. I have a strict clothes-on policy when it comes to relationships.

DESCRIBE YOUR FANTASY DATE: Romeo sneaks in my room at about 4:30 A.M., wakes me up and we fly on his unicorn (you said fantasy, right?) to an overlook where we eat Cheerios and watch the sun rise. Then we spend the rest of forever together. (Sorry, I'm a hopeless romantic.)

WHAT DO YOU DO FOR FUN? I try to make everything I do fun. (Yes, even laundry.) I like to get out and do things: camp, skinny-dip (no! Not on MTV!), roll down hills, go to movies, make out, dance (although the clubs in Provo are seriously lacking), drive, play guitar—you know.

WHAT ARE YOUR FAVORITE MUSICAL GROUPS/ARTISTS? I love Blink 182 and Lit a lot right now. Collective Soul converted me from country, although I still appreciate some country. Latin is fun. Ska and Christian rock are awesome. Jewel is probably my biggest musical influence.

DESCRIBE A TYPICAL FRIDAY OR SATURDAY NIGHT: Watch TV or do homework until my friends get home. Then we jump in my Subaru and drive around to parties. Sometimes we go up in the mountains and play or just do something dumb and crazy!

OTHER THAN A BOYFRIEND OR GIRLFRIEND, WHO IS THE MOST IMPORTANT PERSON IN YOUR LIFE RIGHT NOW? TELL ME ABOUT HIM OR HER: My brother Alan is probably the most important person in my life right now. He's so supportive and caring for me. We never got along until I left for college, but now he's my best friend. He's funny, considerate, talented, all-around a great guy. I have more fun with him than anyone I can think of.

WHAT ARE SOME WAYS YOU HAVE TREATED SOMEONE WHO HAS BEEN IMPORTANT TO YOU THAT YOU ARE PROUD OF? I do just about anything for someone I care about. They are top priority. Alan has gotten himself into trouble A LOT and I have covered for him, whether it be work, with our parents, or with friends. I'd stop, drop, and roll for that kid.

DESCRIBE YOUR MOTHER: My mother is half puma and half kitten. She is strong, sharp, bright, convincing, and beautiful. She's the only person who always beats me in an argument. She can do anything she wants. But at the same time, my mom is so caring. She'll do whatever she can to make you happy. She's always there for me. She can be very playful, sweet, and vulnerable.

DESCRIBE YOUR FATHER: My dad is a genius. He can do anything. He's so talented, I used to sit and watch him play guitar and beg him to teach me. He's loyal and strong and brave. He works hard. While my dad works hard, sometimes I feel that where our family is concerned he is so lazy. He doesn't take much interest in us kids.

IF YOU HAVE ANY BROTHERS OR SISTERS, ARE YOU CLOSE? HOW WOULD YOU DESCRIBE YOUR RELATIONSHIP WITH THEM? I am closest to my eighteen-year-old brother, Alan. I love him and respect him so much.

I will marry someone just like him. Alan was always a little wigged that I was dating his best friend this past summer, but he never freaked out. Then one day I found out that Jon was out with some other girl. I was crying in my room. Alan came in and asked me what was up, so I told him. I'll never forget his face. He didn't say anything. He just got in his car, drove to Jon's house, and sat in his driveway for three hours waiting for him to get home. That's the kind of guy Alan is. You know you're tight when your brother will beat up his best friend for you.

WHAT IS THE MOST IMPORTANT ISSUE OR PROBLEM FACING YOU TODAY? Having grown up with low self-esteem, I have seen how much damage insecurity can cause. I think it's very important to have a good self-image. Confidence in yourself helps keep you from abusive relationships and facilitates success and happiness. I wish that more people would love, appreciate and have faith in themselves.

DO YOU BELIEVE IN GOD? ARE YOU RELIGIOUS OR SPIRITUAL? I believe in God with all my heart. I know He lives and I'd be lost without Him. I'm Mormon and I attend the Church of Jesus Christ of Latter-Day Saints EVERY Sunday I can.

WHAT ARE YOUR THOUGHTS ON PEOPLE WHO HAVE A DIFFERENT SEXUAL ORIENTATION FROM YOU? While I do not approve of homo- or bisexuality, I understand it exists and try hard to not let my bias affect my judgment of people who choose such lifestyles.

DO YOU HAVE ANY HABITS WE SHOULD KNOW ABOUT? I talk in my sleep. It gets me into trouble sometimes. I'm also addicted to pickles.

WHAT BOTHERS YOU MOST ABOUT OTHER PEOPLE? Nose picking, people who try too hard, people who act like hard-a**es...also unibrows kinda bug me.

HOW DO YOU HANDLE CONFLICTS? DO YOU FEEL THAT THIS APPROACH IS EFFECTIVE? I usually stay very calm and very strong in conflict. I only back down if I feel the issue isn't important enough for the risk involved. I've been known to yell.

IF YOU COULD CHANGE ANY ONE THING ABOUT THE WAY YOU LOOK, WHAT WOULD THAT BE? I can honestly say that I like my body. In high school I hated my flat chest. My friends and boyfriend were forever teasing me. I got to the point where I actually researched and started saving for implants. Then I looked in the mirror one day and realized how stupid I was being and that I had a beautiful body. I dumped my boyfriend and never thought about it again. No girl should have to feel unpretty.

IF YOU COULD CHANGE ANY ONE THING ABOUT YOUR PERSONALITY, WHAT WOULD THAT BE? There are a lot of traits I wish I had. A big one involves compassion. I wish I were less judgmental.

IF YOU HAD ALADDIN'S LAMP AND THREE WISHES, WHAT WOULD THEY BE? I wish everyone could pick an age and stay that age until they die. I think it would make for some great parties. I wish everyone could find happiness. Oh, and I wish Taco Bell Mexi-Melts grew on trees.

Casting Preferences File

ACTIVITY	COMMENT
Read Books	✔ When I have time
Sleep 8 Hours	✔ It makes you brighter!
Watch Television Daily	✔ Simpsons!
Shop	✔ No money!
Go Out/Party	✔ I like to "party" sometimes
Spend Time with Friends	✔ A lot!
Spend Time Alone	✔ I like myself
Balance Work/Study	✔ I try...
Talk on Phone	✔ Mostly to family...
Cook	✔ Only when I have to
Clean	✔ Only when I have to
Write/E-mail	✔ Lots
Read Newspapers	✔ Mostly to family
Play with Animals	✔ They're OK
State Opinions	✔ Frequently
Ask Opinions	✔ Frequently
Confide in Your Parents	✔ Sometimes
Volunteer	✔ Whenever I'm needed
Procrastinate	✔ That's my middle name
Eat	✔ Daily
Get Drunk	✔ Never
Diet	✔ Always
Vote	✔ Not yet
Cry	✔ It's healthy
Laugh	✔ All the time. At myself
Instigate	✔ My other middle name
Cinema	✔ I like to escape reality
Theater	✔ Guys take me. I love it
Concerts	✔ Too much
Clubs	✔ Sometimes
Parties	✔ Lots
Surf the Web	✔ Sometimes

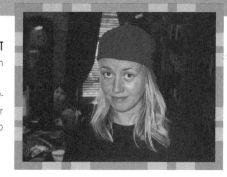

CASTING

Jamie

FIRST AND MIDDLE NAME: James C.

AGE: 21

BIRTHDATE: October 27, 1977

PRESENTLY LIVING IN: Ithaca, New York

PARENTS: Sandra and James

SIBLINGS (NAMES AND AGES): Caroline, 24

WHAT IS YOUR ETHNIC BACKGROUND? Caucasian, Irish/Italian

NAME OF HIGH SCHOOL? New Trier Township High School (Go Trevians!), 4 years

NAME OF COLLEGE (YEARS COMPLETED AND MAJORS): Cornell University School of Hotel Administration, 3.5 years

OTHER EDUCATION: City University, London, England; Chinese University of Hong Kong, Special Admin. Region of the PRC

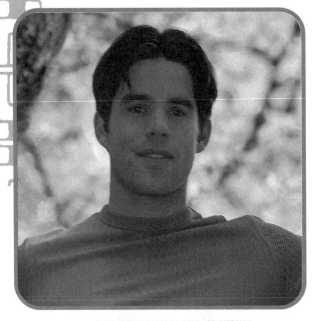

WHERE DO YOU WORK? DESCRIBE YOUR JOB HISTORY? Founder and CEO of an online extreme-sports outfitter; women's self-defense instructor at North Shore Martial Arts Academy; Windsurfing/sailing instructor at Northwestern University; Clerk/runner at the Chicago Board of Trade

WHAT IS YOUR ULTIMATE CAREER GOAL? I would like to have a career similar to Richard Branson, the founder of Virgin Records, Virgin Atlantic, etc. He is a man I admire and a man who has created a cool multinational corporation out of nothing. I would like to be a creator of jobs and dreams similar to Mr. Branson.

WHAT KIND OF PRESSURE DO YOU FEEL ABOUT MAKING DECISIONS ABOUT YOUR FUTURE? WHO'S PUTTING THAT PRESSURE ON YOU? I have very lofty goals for my future. These "Sky's the limit" goals put pressure on me to perform. I embrace this pressure as a motivator to take action. My parents are two of the most supportive individuals I have ever met. They would love me if I was a surf bum in Indonesia or a Wall Street tycoon. One major pressure I feel relates to having enough time for my friends, family, health, travel, and business. That's a challenge.

WHAT ARTISTIC TALENTS DO YOU HAVE (MUSIC, ART, DANCE, PERFORMANCE, FILM/VIDEO MAKING, WRITING, ETC.)? HOW SKILLED ARE YOU? Since I have been a little shorty, grown people have told me my vocal talent is something I should pursue. I can sing certain parts of operas like *The Barber of Seville, La Boheme,* and musicals like *Les Mis.* One of my dreams is to be in the London cast of *Les Mis.*

WHAT ABOUT YOU WILL MAKE YOU AN INTERESTING ROOMMATE? I am a very active person who has been known to give my roommates early morning wake-up visits regardless of their hungover states. These wake-up calls are either done with a serenade or a WWF body slam. ☺ In addition to this, my musical taste is across the spectrum from Dave Matthews to Metallica or Garth Brooks to Tupac!

HOW WOULD SOMEONE WHO REALLY KNOWS YOU DESCRIBE YOUR BEST TRAITS? I am great friends with a forty-five-year-old woman who is a mentor to me and a friend. My family and friends joke and say she is some "Mrs. Robinson" woman who wants to shag me. This is not true. She once said to me: "You *can* and *will* achieve your monumental end goals. Dreams are meant to be realized and yours are on the way to that state of fulfillment!" I am positive, proactive, and visionary. This woman sees that in me.

HOW WOULD SOMEONE WHO REALLY KNOWS YOU DESCRIBE YOUR WORST TRAITS? My mother can be critical at times and the traits that she says I need to work on are as follows: My opinions are law. I do not consider the other side. I am random for the sake of being random. I have trouble with long-term commitments with women.

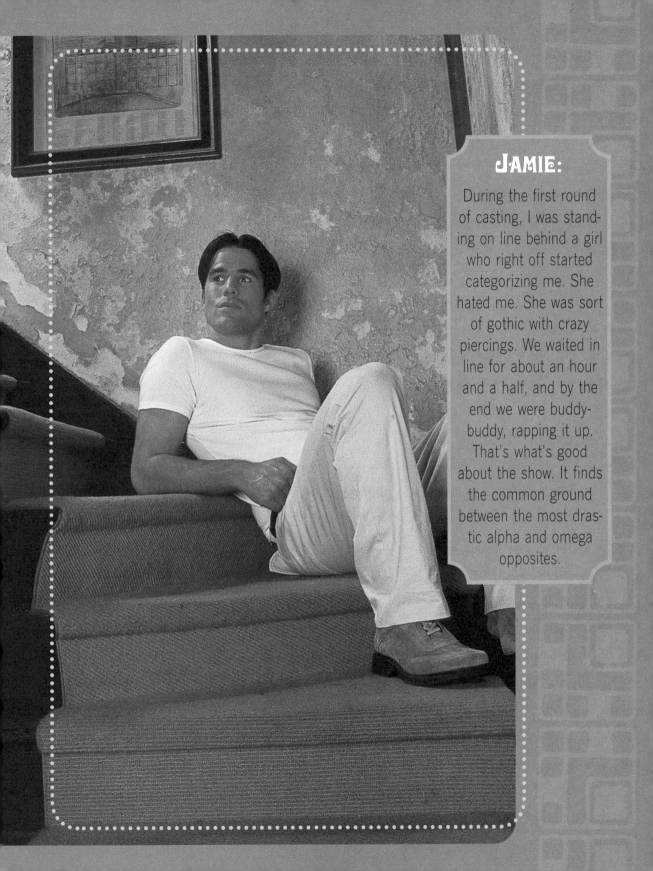

JAMIE:

During the first round of casting, I was standing on line behind a girl who right off started categorizing me. She hated me. She was sort of gothic with crazy piercings. We waited in line for about an hour and a half, and by the end we were buddy-buddy, rapping it up. That's what's good about the show. It finds the common ground between the most drastic alpha and omega opposites.

CASTING

Jamie's RANDOM THOUGHTS...

It bothers me when people don't like me, because I think I'm a nice guy. I never would go out to hurt somebody. I'm not a militant kid. I would never pick a fight with someone at a bar unless he was seriously disrespecting my family and friends. I generally think I'm open to everybody.

I think that the President of the United States and the janitor are the same person.

People may put me in a pigeonhole. They see one facet and they think they know me. I'm this guy-frat boy-Mr. WASP-white man. But I'm a person who has a lot of different facets going on.

DO YOU HAVE A BOYFRIEND OR GIRLFRIEND? HOW LONG HAVE YOU BEEN TOGETHER? WHERE DO YOU SEE THE RELATIONSHIP GOING? WHAT DRIVES YOU CRAZY ABOUT THE OTHER PERSON? WHAT'S THE BEST THING ABOUT THE OTHER PERSON? I do not have a significant other. I am not yet blessed with the woman who will rock my world. I am, however, forever hopeful.

WHAT QUALITIES DO YOU SEEK IN A MATE? I want a woman who can climb mountains, seal million-dollar deals, debate about the conflict in the Balkans...and at night look good and make love like an expert.

HOW IMPORTANT IS SEX TO YOU? DO YOU HAVE IT ONLY WHEN YOU'RE IN A RELATIONSHIP OR DO YOU SEEK IT OUT AT OTHER TIMES? HOW DID IT COME ABOUT ON THE LAST OCCASION? I thoroughly enjoy sex. I have had five partners and I am friends with all of them to this day. This may sound weird but I believe masturbation is like sleeping, eating, exercising, and socializing. It should be a daily part of one's routine. Therefore I am very relaxed sexually. I am not like Mt. Fuji ready to erupt. The last time I had sex was in Santa Barbara, California, with a great girl whom I used to long-board with.

DESCRIBE YOUR FANTASY DATE: I would love to drive in a convertible on Highway 1 south from San Francisco to Big Sur, stopping in Carmel for lunch and then Monterey for a surfing session. I would then get a room at a resort and dine at sundown on the cliffs overlooking the breaking waves of the Pacific.

WHAT DO YOU DO FOR FUN? In high school, my friends and I would do crazy crap like surf Lake Michigan in January or bungee-jump off of Chicago bridges. I have toned down my outdoor pursuits and I love to go trail running, windsurfing, and skateboarding. Skateboarding sounds juvenile; however, on the hills of Ithaca it can get very hairy and intense. I also love consuming beverages with my friends and entertaining at my casa.

WHAT ARE YOUR FAVORITE MUSICAL GROUPS/ARTISTS? Peter Tosh, Robert Nesta Marley O.M., Pink Floyd, Barenaked Ladies, Toby Keith, Toots and the Maytals, Bruce Springsteen, Vivaldi, Garth Brooks, Tupac

DESCRIBE A TYPICAL FRIDAY OR SATURDAY NIGHT: I'll explain a typical weekend night on the North Shore of Chicago. All of my good friends meet up at one of our many houses. We booze in a manner similar to high school days and then take the EL (subway) into the city and either go to a bar or club.

OTHER THAN A BOYFRIEND OR GIRLFRIEND, WHO IS THE MOST IMPORTANT PERSON IN YOUR LIFE RIGHT NOW? TELL ME ABOUT HIM OR HER: Jeff is my business partner and best friend and without a doubt the most important person in my life. We own a company that owns an extreme-sports e-commerce superstore. Jeff is the coolest kid: a savvy businessman and ladies' man whom I met in Hong Kong and who speaks Mandarin Chinese. He goes to Brown and will be cash money someday. We are tied together by friendship or debt.

WHAT ARE SOME WAYS YOU HAVE TREATED SOMEONE WHO HAS BEEN IMPORTANT TO YOU THAT YOU ARE PROUD OF? I *love* my sister very much and am unbelievably proud of the professional powerful woman she's become. I have made it a priority in my life to call her once a week and listen to the events of her life.

DESCRIBE YOUR MOTHER: A woman with powerful convictions and opinions on everything from racial strife in South Africa to the color of tulips at our country club. A completely dedicated mother. I respect my mother so much for quitting her law firm and raising my sister. The hand that rocks the cradle is the hand that rules the world.

DESCRIBE YOUR FATHER: A completely loving father. My dad has such a deep love for my sister and me that I am worried what would happen to him if anything happened to us. He lives vicariously through us and works so we can have all the things we want. He's also a worried man. My dad was at one time very depressed and would worry about everything.

IF YOU HAVE ANY BROTHERS OR SISTERS, ARE YOU CLOSE? HOW WOULD YOU DESCRIBE YOUR RELATIONSHIP WITH THEM? My sister Caroline and I have gotten a lot closer over the years. She lives in a trendy area of Chicago and is a physical therapist. I respect so many facets of her character and take to heart her opinions of how I should treat women.

WHAT IS THE MOST IMPORTANT ISSUE OR PROBLEM FACING YOU TODAY? I own a company that is in hot pursuit of venture capital. My partner and I work very hard in developing a solid company and attracting Silicon Valley venture capital. It is sometimes hard to focus on school when you are talking with guys about mega-financing.

DO YOU BELIEVE IN GOD? ARE YOU RELIGIOUS OR SPIRITUAL? Yes, I believe in a higher power. I was born and raised Catholic but do not call myself Catholic or Christian. I am a proponent of finding one's personal way to spiritual enlightenment. I am a very spiritual person.

WHAT ARE YOUR THOUGHTS ON PEOPLE WHO HAVE A DIFFERENT SEXUAL ORIENTATION FROM YOU? Whatever floats your boat! ☺ Different strokes for different folks.

DO YOU HAVE ANY HABITS WE SHOULD KNOW ABOUT? Nothing out of the ordinary. I don't rub Jell-O all over myself during a full moon or anything.

WHAT BOTHERS YOU MOST ABOUT OTHER PEOPLE? I do not like when people do not realize how great they have it in the grand scheme of things. When people bitch about the weather, their friends, where they live, I want to take them to Calcutta, India, during monsoon season to see the impoverished AIDS victims dying in the streets. We are all incredibly lucky. I don't like people who don't realize that.

HOW DO YOU HANDLE CONFLICTS? DO YOU FEEL THAT THIS APPROACH IS EFFECTIVE? I deal with people with a clear head and focus on resolution. I never yell for the sake of yelling and attempt to avoid conflict in most situations. Most things are not worth raising your blood pressure.

IF YOU COULD CHANGE ANY ONE THING ABOUT THE WAY YOU LOOK, WHAT WOULD THAT BE? I would get rid of my love handles. Too much Milwaukee beer and burritos.

IF YOU COULD CHANGE ANY ONE THING ABOUT YOUR PERSONALITY, WHAT WOULD THAT BE? I feel that I am a very compassionate person yet I wish I could be more understanding of people's habits and core beliefs that differ from mine.

IF YOU HAD ALADDIN'S LAMP AND THREE WISHES, WHAT WOULD THEY BE? 1) Unlimited financial wealth. 2) Unlimited personal health. 3) Unlimited creativity

Casting Preferences File

ACTIVITY	COMMENT
Read Books	✔ Hell, ya. Atlas Shrugged—epic
Sleep 8 Hours	✔ Try to
Watch Television Daily	✔ CNN, TLC, and oh, MTV
Shop	✔ When I need to
Go Out/Party	✔ Thursday, Friday, Saturday
Spend Time with Friends	✔ Sacred and necessary
Spend Time Alone	✔ Not really
Balance Work/Study	✔ Work hard, play hard
Talk on Phone	✔ For business. Cell phone bill!
Cook	✔ Love it
Clean	✔ It's therapeutic
Write/E-mail	✔ Keep up with high-school homies
Read Newspapers	✔ Rarely
Play with Animals	✔ I love my cat Scooter
State Opinions	✔ Standard
Ask Opinions	✔ Yes, from people I respect
Confide in Your Parents	✔ We have an open relationship
Volunteer	✔ I was an Eagle Scout
Procrastinate	✔ Try not to
Eat	✔ Love it
Get Drunk	✔ When the time calls
Diet	✔ No
Vote	✔ Yes
Cry	✔ Rarely
Laugh	✔ Every day! Can't help it
Instigate	✔ I am a motivator, a revolutionary
Cinema	✔ I love movies
Theater	✔ London West End!!!
Concerts	✔ Small ones are enjoyable
Clubs	✔ Not my bag
Parties	✔ Best if I'm throwing them!
Surf the Web	✔ Hang ten, bro!

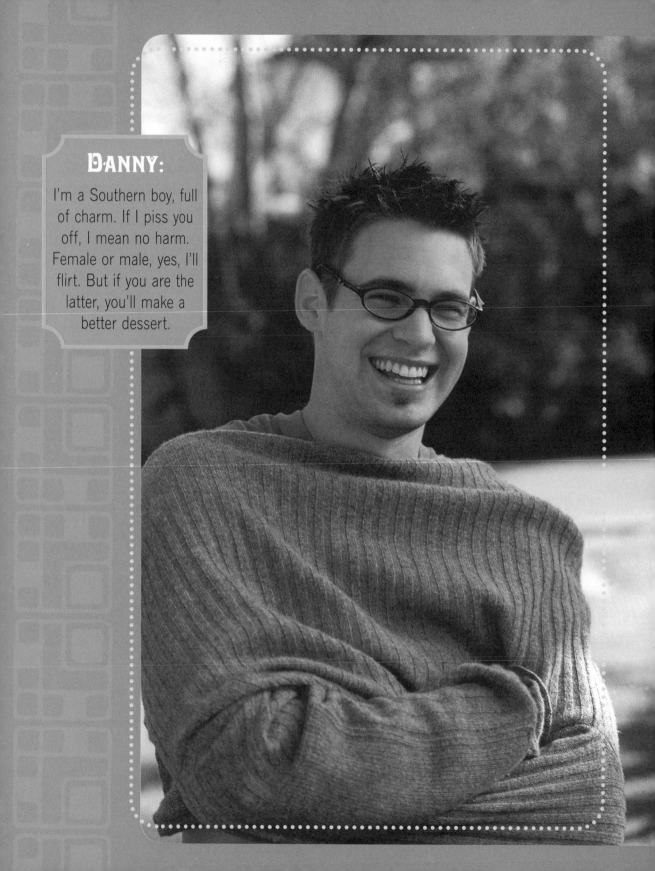

DANNY:

I'm a Southern boy, full of charm. If I piss you off, I mean no harm. Female or male, yes, I'll flirt. But if you are the latter, you'll make a better dessert.

FIRST AND MIDDLE NAME: Danny

AGE: 22

BIRTHDATE: July 19, 1977

PRESENTLY LIVING IN: Atlanta, Georgia

PARENTS: Freida and Steve

SIBLINGS (NAMES AND AGES): Josh, 19; Drew, 13

WHAT IS YOUR ETHNIC BACKGROUND? Euro-American

NAME OF HIGH SCHOOL? Rockmart Comprehensive High School—four years

NAME OF COLLEGE (YEARS COMPLETED AND MAJORS): The University of Georgia—four years/graduated summer '99

OTHER EDUCATION: None

WHERE DO YOU WORK? DESCRIBE YOUR JOB HISTORY? I currently work in an insurance office but my job history mostly consists of jobs in restaurant settings as a server or bartender. I've also worked as a cook in a catering shop.

WHAT IS YOUR ULTIMATE CAREER GOAL? I would like to teach at some point, because I feel it would be a great contribution to society and young people. This is not, however, my lifetime goal. I think maybe someday I would like to own my own business or work for the Environmental Protection Agency.

WHAT KIND OF PRESSURE DO YOU FEEL ABOUT MAKING DECISIONS ABOUT YOUR FUTURE? WHO'S PUTTING THAT PRESSURE ON YOU? My current problem is that I feel no pressure from anyone to go in any direction. As a post-college graduate I am somewhat lost as to where I want to take my life. All I know is that I want to make a positive contribution to the world around me and it is up to me to find my own calling.

WHAT ARTISTIC TALENTS DO YOU HAVE (MUSIC, ART, DANCE, PERFORMANCE, FILM/VIDEO MAKING, WRITING, ETC.)? HOW SKILLED ARE YOU? I am a very creative person in all ways—my imagination is incredible and I often use it. I like to play around with drawing and water colors. I am also a fairly good creative writer, which began when I was in the eighth grade when I would write weekly stories on my own time and read them to my class when my teacher would let me. I also did a lot of writing in French during college.

WHAT ABOUT YOU WILL MAKE YOU AN INTERESTING ROOMMATE? 1. I'm from a small town in the South so I have an interesting background. 2. I'm gay. 3. I have many different interests, thus I tend to attract and hang around people of all different backgrounds and interests.

HOW WOULD SOMEONE WHO REALLY KNOWS YOU DESCRIBE YOUR BEST TRAITS? I'm very intelligent and intuitive. I see past bulls**t that most people exude. I appreciate small things yet aim high in my goals. I love nature. I am open-minded and give most people I meet a chance. I'm a good kisser!

HOW WOULD SOMEONE WHO REALLY KNOWS YOU DESCRIBE YOUR WORST TRAITS? Without a doubt, many of my close friends, no, most of my close friends, would say that I'm stubborn and think that I'm a know-it-all at times. Also, I can be brutally cynical.

DO YOU HAVE A BOYFRIEND OR GIRLFRIEND? HOW LONG HAVE YOU BEEN TOGETHER? WHERE DO YOU SEE THE RELATIONSHIP GOING? WHAT DRIVES YOU CRAZY ABOUT THE OTHER PERSON? WHAT'S THE

BEST THING ABOUT THE OTHER PERSON? No, I recently came out of a relationship and am currently single. I'm actively dating, but just haven't met many that interest me.

WHAT QUALITIES DO YOU SEEK IN A MATE? Intelligent/intellectual, out-doorsy, down to earth, nonmaterialistic, cultured, creative, fit, mainly someone who stimulates my mind.

HOW IMPORTANT IS SEX TO YOU? DO YOU HAVE IT ONLY WHEN YOU'RE IN A RELATIONSHIP OR DO YOU SEEK IT OUT AT OTHER

Casting Preferences File

ACTIVITY	COMMENT
Read Books	✔ Not enough
Sleep 8 Hours	✔ The greatest pleasure
Watch Television Daily	✔ Only news
Shop	✔ Window shop. Don't buy
Go Out/Party	✔ 3x a week
Spend Time with Friends	✔ Ranks with sleep. Great!
Spend Time Alone	✔ Good for the soul
Balance Work/Study	✔ Perfected it in college
Talk on Phone	✔ Detest
Cook	✔ All the time
Clean	✔ Hate it but do it
Write/E-mail	✔ Don't care
Read Newspapers	✔ Travel section, local and global
Play with Animals	✔ No, but with myself!
State Opinions	✔ Should keep mouth shut more
Ask Opinions	✔ Really need to work on this
Confide in Your Parents	✔ Not good at this, but trying
Volunteer	✔ Used to. Planning to
Procrastinate	✔ Have perfected this
Eat	✔ Love to eat as much as sex
Get Drunk	✔ Don't. For health reasons
Diet	✔ Never
Vote	✔ Vote Democratic always!
Cry	✔ Once in a blue moon
Laugh	✔ Constantly
Instigate	✔ Not really
Cinema	✔ Love it
Theater	✔ Rare occasion
Concerts	✔ Outdoor
Clubs	✔ Every weekend
Parties	✔ Not so much
Surf the Web	✔ Rarely

TIMES? HOW DID IT COME ABOUT ON THE LAST OCCASION? I feel that sex is a very important part of a relationship because it's the main thing that sets a lover apart from a friend. Being sexual is a big part of being close to someone you love and is the best way to enjoy that person. I feel that sex should only happen with those you care about, though I have had one-night stands in the past. The last time I had sex was with my last boyfriend a couple of months ago.

DESCRIBE YOUR FANTASY DATE: A sexy guy would take me to his favorite spot outdoors; we would hike to a secluded river or lake; skinny-dipping; and then lay in the sun all day kissing and talking about whatever came to mind.

WHAT DO YOU DO FOR FUN? I love going dancing and house parties are always a plus. I also enjoy going to coffee shops and people-watching. Anytime that I can get out of the city to go hiking or camping is always a plus as well.

WHAT ARE YOUR FAVORITE MUSICAL GROUPS/ARTISTS? Tori Amos, Garbage, Björk, most trance, Bob Dylan, the Cure, U2, Madonna, Led Zeppelin.

DESCRIBE A TYPICAL FRIDAY OR SATURDAY NIGHT: A round of four or five bars and then a last stop at a club for an hour or two of dancing. It really depends on whom I go out with, though.

OTHER THAN A BOYFRIEND OR GIRLFRIEND, WHO IS THE MOST IMPORTANT PERSON IN YOUR LIFE RIGHT NOW? TELL ME ABOUT HIM OR HER: My friend Jen means the most to me because I have the most in common with her. We confide in each other about everything. We spend a lot of time together and help each other through a lot. She's an awesome, sincere girl and we talk about maybe having kids together one day.

WHAT ARE SOME WAYS YOU HAVE TREATED SOMEONE WHO HAS BEEN IMPORTANT TO YOU THAT YOU ARE PROUD OF? I try to do things for my thirteen-year-old little brother because he looks up to me and I try to be a positive role model for him—my parents are pretty busy so I do take him camping with me, take him to movies, let him hang out with me and my buds, etc. He loves spending time with me and I love giving him my time.

DESCRIBE YOUR MOTHER: There are two parts of my mom which are easily described. First, there is the dedicated hard-worker side that never

stops to rest. Then there is the other side of my mom who enjoys the simple things in life such as taking a hike with me or teaching her Sunday school class.

DESCRIBE YOUR FATHER: My father is a little more difficult to describe. As far as I go, I guess I would say that there is the part who respects me and what I've done in life and then there is the other part who always argues with me and disagrees with me. It makes staying on good terms with him difficult—he's very stubborn. I've learned to overlook this and deal with him in a mature way when he's being stubborn.

IF YOU HAVE ANY BROTHERS OR SISTERS, ARE YOU CLOSE? HOW WOULD YOU DESCRIBE YOUR RELATIONSHIP WITH THEM? I have two younger brothers. I'm pretty close to both of them. My brother is very

different from me, but we still manage to get along and party together sometimes. He's in boot camp (Marines) right now, so I've been supporting him through letters often. My youngest brother looks and acts exactly like I did when I was his age. He worships me and often emulates me. I think he's a very intelligent kid with initiative.

WHAT IS THE MOST IMPORTANT ISSUE OR PROBLEM FACING YOU TODAY? Choosing to be openly gay is a huge issue in my life. I have tackled this issue for years and am only now becoming comfortable with it. It is a huge choice in my life to make because it will alter my life's course forever. Coming out to my parents is a huge thing I must tackle at some point soon.

DO YOU BELIEVE IN GOD? ARE YOU RELIGIOUS OR SPIRITUAL? I definitely believe in God and a higher spiritual level but I also believe that organized religion is bulls**t. It takes what is so personal about religion and being spiritual and creates a sociopolitical machine out of it. To me, religion is a sacred personal belief that does not have to involve going to church in order to be close to God.

WHAT ARE YOUR THOUGHTS ON PEOPLE WHO HAVE A DIFFERENT SEXUAL ORIENTATION FROM YOU? Straight people are great! Most of my friends are straight.

DO YOU HAVE ANY HABITS WE SHOULD KNOW ABOUT? Nope.

WHAT BOTHERS YOU MOST ABOUT OTHER PEOPLE? People who are materialistic and extremely concerned with their image annoy the hell out of me. I wish I could meet more cool down-to-earth people who aren't this way.

HOW DO YOU HANDLE CONFLICTS? DO YOU FEEL THAT THIS APPROACH IS EFFECTIVE? I often overlook conflicts and problems until they build up and explode. I know this method is wrong and causes many problems with my friends, so I'm trying to be more up-front with people when things are bothering me.

IF YOU COULD CHANGE ANY ONE THING ABOUT THE WAY YOU LOOK, WHAT WOULD THAT BE? I would have more of an a**! Mine's flat!

IF YOU COULD CHANGE ANY ONE THING ABOUT YOUR PERSONALITY, WHAT WOULD THAT BE? I would be more spontaneous and stop worrying so much about the future. I would really like to live more for the day.

IF YOU HAD ALADDIN'S LAMP AND THREE WISHES, WHAT WOULD THEY BE? 1. Eternal happiness. 2. The love of my life. 3. All the wisdom in the world.

Danny's RANDOM THOUGHTS...

In a small town there's nothing to do. It's like school and that's it. And there are just hicks everywhere. And the teachers, so many of them were just so freaking stupid. I mean, they're burnt out. **There was no party scene. People would just get in their cars and drive around.** That was what people did on weekends. Just drove around. And then there was this one cabin that all the kids would go to get messed up. That was life in a small town. Half of the people I grew up with are already married with kids. No life, no careers. I don't want any part of that.

What They Don't Know Won't Hurt Them?

Julie doesn't know this but...

Jamie: In the hotel in Africa, Matt and I were watching TV, and we saw her showering through a glass brick wall. I turned to Matt and was like, "Dude, do you see what I'm seeing?" He nodded. He tried to stop himself, but he was looking.

Matt: Sometimes I thought I might just slightly like her.

Kelley: I don't think she needs to be as hard on herself as she is.

Melissa: I think she French-kisses way too many guys! I'm actually glad she's doesn't sleep with them. That would be borderline promiscuity. That girl French-kisses everyone she meets!

Danny: I think she masturbates in the shower. That girl takes damn long showers, and then comes out saying she feels refreshed. She's practically whistling after!

David: I think she could do better with her clothes!

Jamie doesn't know this but...

Matt: I wish I had a third sister so I could hook him up.

Julie: My feelings for Matt don't run as deep as he thinks they do.

Danny: I knew he was creeping around, and that he wasn't as in love with Elizabeth as he said.

Melissa: I had a dream I went to a reunion and I was holding Baby Jamie Junior in my arms. You know you think about a person way too much when you dream about bearing his children!

Kelley: I'm really NOT attracted to him. Get over yourself!

David: I knew he peed on the plants after his bike rides. I thought that was the funniest thing. Gross but funny.

Danny doesn't know this but...

Melissa: I didn't enjoy listening to him and Paul make out. I wish he would have told me to go into another room to sleep.

Julie: I didn't do drugs at all when I was there. He really thinks I did!

Kelley: I think he flirts because he needs the ego rubs.

David: I would like to be friends with him.

Jamie: I think he needs to go to PDAA {Public Displays of Affection Anonymous}, because he and Paul are all over each other all the time.

Matt: I suspect he probably had a mullet {haircut with a tail} at one time.

108

Matt doesn't know this but...

David: I knew he wore makeup.

Kelley: I think he should hook up with somebody already!

Jamie: I think he's too compulsive about his flat-top haircut. He draws barbers a diagram of how he wants his hair to look. He's the customer from hell.

Melissa: During the middle of the season I started to think he was really really cute even though he has that gelled hair. I used to think that he was baby cute, but now I think he's *cute* cute.

Danny: I think he's got weird issues with females. I don't get what he wants from girls.

Julie: I've kissed more people in New Orleans than in my whole life. He'd be shocked!

David doesn't know this but...

Kelley: I really believed in him the entire time, whereas a lot of people did not.

Melissa: Sometimes I actually liked him.

Danny: There's nothing I think or know that David doesn't know. When the house confronted him, I told him everything.

Julie: I found all these pairs of underwear belonging to girlfriends of his!

Jamie: I think he stank up our room!

Matt: I know he really likes pop music! Not just rap!

Melissa doesn't know this but...

Kelley: I never really had that big of a problem with her.

Danny: I could relate to the issues she had with her family.

Julie: I made out with Jamie.

Jamie: I knew she liked me way before she told me.

Matt: I think she does her eyebrows entirely wrong. She needs to leave some brow so it doesn't look like she has skidmarks above her eyes.

David: I believe she had sex with Jamie.

Kelley doesn't know this but...

Julie: I think she wore really ugly shoes.

Danny: When she confessed to me how much she enjoys and needs attention from men, I already knew. I think she'd be shocked to know this.

Melissa: I think it takes her entirely too long to put her makeup on. She'll take forever to put that makeup on like she's going to a ball, and then throws on jeans and a tank top. I don't get it.

Matt: I thought she had a crush on Danny the whole time.

David: I think she's gorgeous. Well, maybe she already knows that.

Jamie: I think she could do better with her shoe selection. Out of all the cool women's shoes out there, she's picking wrong.

The Belfort
The Making of a Mansion

Andrew Hoegl

Tracy Chaplin, Director {left}: When we walked into the Belfort, we just *knew* it was a *Real World* house. The columns, the size, the location. We'd looked at all these places—beautiful houses that were already renovated and in pristine condition, loft spaces, even a bed-and-breakfast—but none of them seemed as right as this one. Initially, the Belfort was an apartment building. When we found it, it had been gutted, in the process of being converted into a single-family primary residence. The owner agreed to rent it to us for seven months, contingent that we returned the house as we got it. We did a huge build-out to create the kind of space we needed, and will do a huge demolition to return it to the state it was in. My first build-out was the Seattle house. It's heartbreaking to take down what you created, but what can you do!

The Belfort was the most utilized house by any cast. We wanted to avoid what happened in Boston when the cast used the second floor almost exclusively. (They were almost never in the living room.) This year the cast used almost every space.

Were there any unexpected problems? Well, not really, though it was termite season in New Orleans. The termites swarmed in the house at night. They were attracted to the lights. There were a lot of dead termite bodies floating around.

This was also the house most accessible to the public. People would drive by and scream *"The Real World!* I love you!" The Boston house was equally accessible, but the show wasn't half as big at the time. The Hawaii season changed everything. These days it's hard *not* to know about *The Real World*. We used to lie and say we were making a student documentary or a mayonnaise commercial. We really can't do that anymore.

Jonathan Singer, Coordinating Producer {right}: The Belfort began as raw space. We started from scratch. As with Seattle, we could design it specifically for our needs. In Hawaii, we didn't find a house that we could totally reconstruct. As a result, we had some problems—not big ones, but certainly we had trouble shooting in certain bathrooms and from particular angles. The Hawaii house was great because of the location. But this year we wanted a space we could completely control. We had a vision, and we wanted to design it. We had three months to renovate the place before the cast moved in. Technically, we had a lot of work to do. There's a camera in

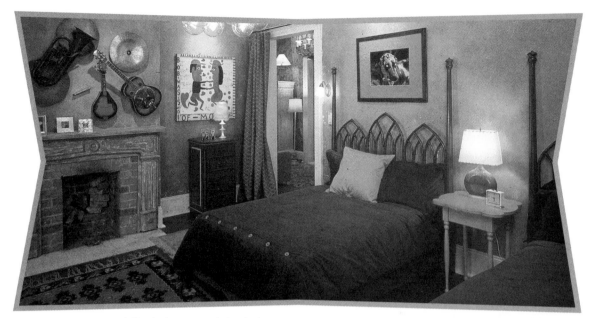

every room except the bedrooms and the bathroom stalls. There's one perched above the hot tub and one on the front door. There are two on the front steps looking into the streets and two in the courtyard.

There's a formula for *Real World* houses that works. We wanted a double bedroom and a triple bedroom. And we wanted another communal bathroom, as we'd done in Seattle. There's a logic to everything. You'll notice that the color scheme is similar to that of houses past. We shoot color tests, setting five different skin tones against the painted walls, seeing which colors are overall the most flattering. Greens, blues, pinks, and purples are good. You'll never see a white or yellow wall in a *Real World* house.

In general, with all houses, we try to embrace the culture of the city. We wanted to capture the flavor of New Orleans in the design of the house. Each bedroom has a different theme. We have the Mardi Gras room, which is the purple room. We have the Blues room, which is the green room, and the voodoo room, which is the orange room.

When the cast flies home, we have a huge toast with all the crew. We toast the season and the work we've done. We have three days until the house's interior is demolished. For me, a lot of the glory has to do with the house. When I see the show for the first time, I think, "There's the house. That's my baby on the screen!"

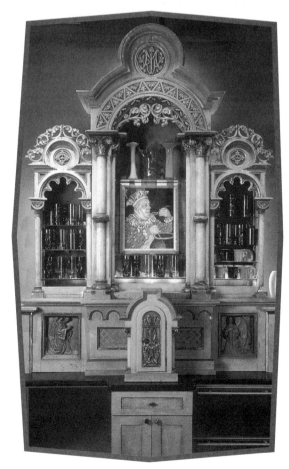

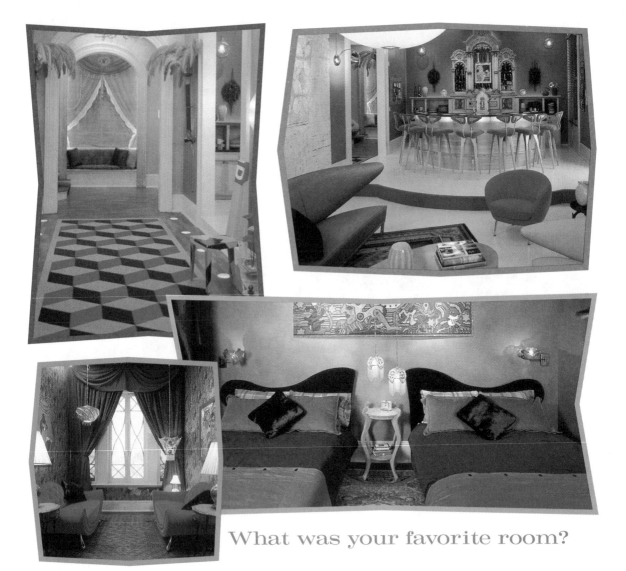

What was your favorite room?

Matt: The computer room, because that's where you got to talk to your friends at home and check your e-mail, experience those little securities from the outside world. Sitting at that desk meant you were having a positive experience. As far as design, the kitchen looked the coolest. It was a masterpiece.

David: That's a toss-up between the corner of the living room where my keyboard was or my bedroom when I was making "music" in the bed.

Melissa: My bedroom was the absolute coolest room! We called it the sweet suite. I'd eat candy before bed. The voodoo room was too dark and melancholy. The Mardi Gras room (otherwise known as the "white girl room") was way too bright, way too happy. That turquoise and yellow sickened me! Oh God, I hope some white girl doesn't freak out that I used that term. It's just that I talk about races across the board. OK, let's call it the *"blonde girl* room"!

Kelley: The jazz room, where Melissa and Danny slept.

Julie: The confessional. I liked spilling my guts. I'm an emotional roller coaster. And that room helped me.

Jamie: I liked the front porch where our rocking chairs were. I liked watching St. Charles roll by.

The Real World

REUNION

Album

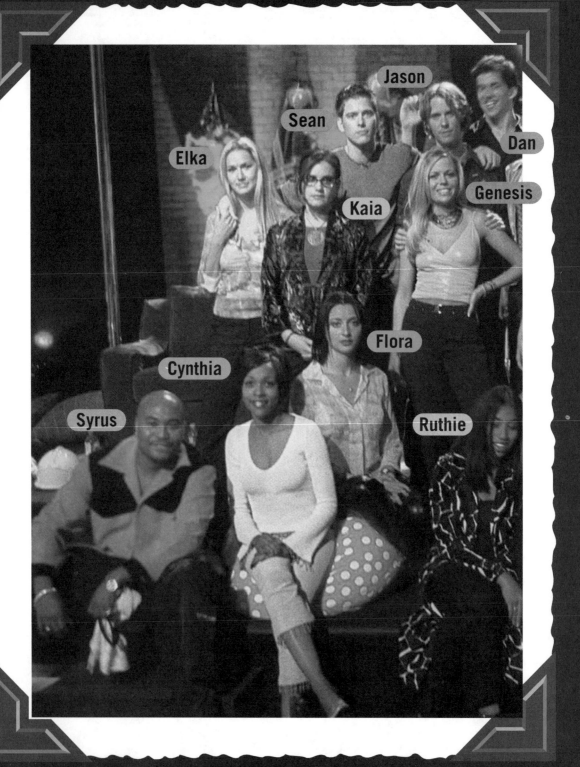

The Real World Reunion

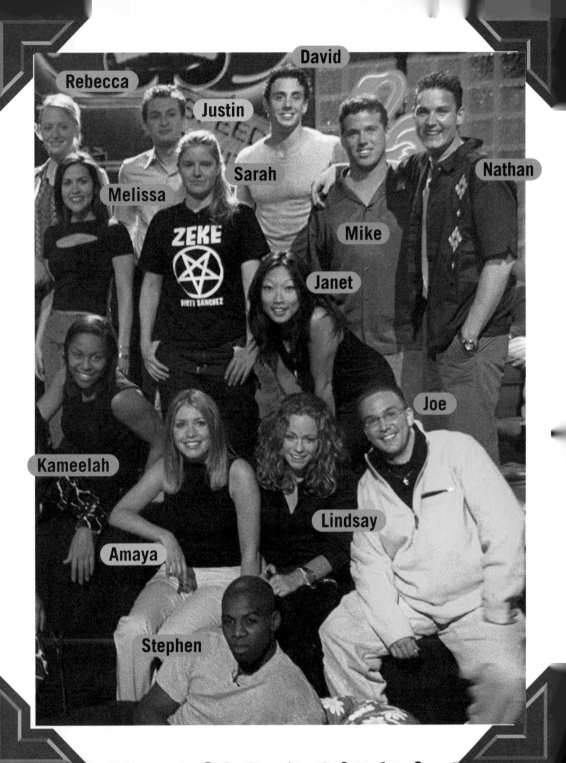

Rebecca · David · Justin · Sarah · Melissa · Nathan · Mike · Janet · Joe · Kameelah · Amaya · Lindsay · Stephen

Las Vegas, 2000

Ruthie

My Reunion Diary

TUESDAY 10:30 AM Get on plane. Feel very nervous. The plane lands, and I think, "Okay, here we go. Viva Las Vegas!" I've only been to Vegas once before—and that's when I was nine! Coming back to the **Reunion,** I think I look a little different from how I did in **Hawaii.** I've got to wonder if the crew is going to recognize me. First of all, my hair is straightened. Second of all, I'm wearing color—a baby-blue tank top and beige pants. I never wore color on the show, just black, black, and more black. I've got reds now—and even blues and yellows.

The camera crew is waiting for me outside the gate. When I see them, I just start laughing. Here we go again...

Oh, and I can't believe there are slot machines at the airport!

2:45 PM Arrive at the Hard Rock. There are slot machines here, too! Run into **Syrus** (Boston). He's going to be my suitemate, meaning that he's sharing a room with **Nathan** (Seattle) and their room adjoins mine and **Janet's** (Seattle). I'm psyched to be rooming with **Janet,** because she's, like, my favorite. I love talking to her and feel like she understands me. Even though we had different experiences on **The Real World,** we can relate. She thinks a lot, and I like that. Also, she knows I'm crazy and doesn't care. A good thing, since I might end up doing some crazy stuff in the room...

4:30 PM **Syrus** and I go shopping with some non-**Real World** friends who are in town. I still don't know what I'm going to wear to the reunion, so I buy a hot-pink skirt and a tank top. See, I told you, I'm into color now.

As soon as we come back, guess who we see in the lobby: **Genesis** (Boston). All I can think is: **"Genesis** is hot with a capital HOT." She looks so sophisticated, even **Syrus** doesn't recognize her. Oh, and her wife, **Paige,** is so hot, I nearly tripped over myself. **Genesis** looks like a rich girl now, like some girl who drinks only Evian. There's not a hint of tomboyishness to her. Oh, and these girls are both awesomely nice.

10:00 PM We decide to go out again. Someone hooks us up with a party bus limo, so what choice do we have? It's **Nathan, Syrus, Janet, Jason** (Boston), **David** (Seattle), and I. First, we go to Studio 54 where we party like rock stars. There's this total energy when we're all together. It's just like, "Let's go let's go!" We're dancing on speakers, all over the place! Oh yeah, **Rebecca** (Seattle) is also with us. She's so much fun! Let's see what else happens? Well, **David** gets into a fight with some random guy, but that's no big thing. Oh, we bump into **Corey Feldman!** Weird!

2:00 AM Head to a strip club. I love strip clubs. I love to be in that element, surrounded by women. I meet this one girl, and she's so pretty. I don't think I've ever kissed somebody for so long. I got lost kissing her...in a really wonderful way. Before, I know it, hours have passed...

7:00 AM When I get out of the strip club, it's bright out. When I'm with all the other **Real World**ers, I don't even watch the clock. I have so much fun with them. I go back to my room and get into bed. **Janet** is already asleep and so is **Syrus. Nathan** is up, but he seems to be occupied! ☺

WEDNESDAY 10:00 AM I only get a couple of hours of sleep. I wake up, and the phone rings. It's **Kaia** (Hawaii). I'm surprised. **Kaia** seems like she's a different person now. She's just really serious. Anyway, **Kaia** wants to know if I want to have breakfast. I say yeah, but then she decides she doesn't want to if it's at the Hard Rock Cafe. She doesn't want to deal with a crowd of people. Whatever.

On the way to the Cafe, I meet up with **Sean** (Boston), **Rachel** (San Francisco), and their baby, **Evita.** They're cool as hell. The baby is so tiny and so cute. We make a plan to meet up at the pool later. **Sean** seems different from how he

was on the show—calmed down and a lot more grounded. They definitely match as a couple.

For breakfast, I eat chicken soup—I love chicken!—and quesadillas. **The Reunion's** tonight and I still don't know what I'm going to wear.

11:30 AM Leave the restaurant. Run into **Flora** and **Melissa** (Miami). I'm like: "Hey, what's up?" **Melissa** is all smiley and **Flora** is just...**Flora.** At first I think she doesn't like me, but then I realize I shouldn't take it personally.

12:00 PM Go to hang out by the pool. **Mike** and **Dan** (Miami) are there, along with **Rachel, Sean,** and **Evita. Evita** looks so cute in her bathing suit! We're just relaxing, but I'm beginning to stress about tonight's reunion. It's like, what am I going to say? I want to talk about balancing school and career and all the traveling I'm doing...

P.S. That **Dan** is so white, he's blinding. It's like "Damn, you need a tan."

I decide to take a nap, but it's impossi-
out of the room. The phone's ringing off
art going through outfits. **Syrus** tries on
inally picks this red outfit that none of
re.
on) comes in, and it starts to feel like a
dress, but end up taking it off and put-
oat. I don't have much time! I have to
ck up **Justin** (Hawaii)!
(Hawaii). She looks good! Her hair is
of hair that I want to have! I haven't
st summer. We're not close or anything,
er.

It's just the **Seattle** and **Hawaii** c
room. We don't talk about anything exc
about to go onstage. All I can think is t
hungry. I'm craving sushi!

Meet **Stephen** (Seattle) in the gree
hurt his feelings, but he seems a little c
impression.

9:00 PM (Not sure what tim
onstage. Walking onstage is overwhelmi
crowd. The minute I sit down with my ca
don't want to be here. All of a sudden, I'
and uncomfortable, like I've got stage fr

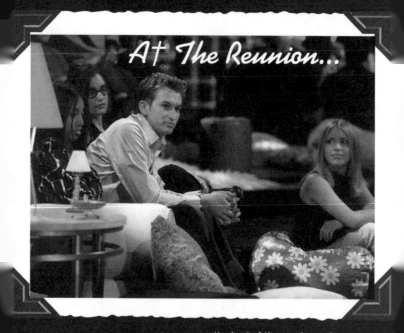

At The Reunion...

lustin arrives. Of course, he's the last
plane. He doesn't have dyed hair any-
hair! I laugh when I see he's wearing
see him, and we're just talking and

We go directly to the green room. We are
ing our makeup done. **Miami** is already
is about to go on. I watch the show from
ems like those casts are having a lot of

the host of the reunion, asks me a quest
want to say just—poof!—leaves me. I g
asks me what I'm doing, and I can't rem
wanted to say. All I say is I'm going to gr
This has never happened to me before! I
jump off the stage and run away!

I'm glad for our cast that **Teck** (Haw
ly entertaining. But I have to say our cas
hesive of all the casts. At least that's hov
it's that we just finished our season, but
have anything interesting to say. Plus, pe

11:00 PM (Again, not really sure what time it is!): The minute we break, I'm so mad at myself. I just run backstage and start crying. I don't know why I'm so emotional. I'm just so disappointed in my performance. Why did I get that way? I wanted to tell the world everything that was going on, and I just panicked. I give myself five minutes to just cry. I end up skipping the after-party, which turns out to be a mistake—there was food there.

LATE I feel better, and we all go out. It's practically everybody. **Genesis**, her wife **Paige**, **Kameelah**...there are a ton of us. **Genesis** puts her arm around me and asks, "So are you really a lesbian?" We start talking, which feels good. We even hold hands—**Genesis**, **Paige**, **Kameelah**, and I all hold hands.

We end up back at the circle bar at the Hard Rock. **Flora** is there for a little bit. **Justin** is around for a minute or so. All the girls are all over **David!**

It's a late night again. I've decided it's illegal to sleep in Vegas.

THURSDAY 7:30 AM **Janet** wakes us up, because we're supposed to film a Coke commercial. **Nathan** won't get up. He bitches **Janet** out. He's such a little boy!

Before the commercial, we have breakfast. **Kaia** is talking to **Jason** the whole time. They look like they're in a deep

Gorgeous!

conversation about something deep. Ha ha.

After the commercial, **Jason** and I go out to eat sushi together. Finally, I get my sushi!

10:00 PM That night, we all go out again. The party animals hit the town! We go to Baby's, this club in the Hard Rock. Some of the **Miami** cast are also there. **Sarah** is awesome. She gives great hugs, too!

Say good-bye to most everyone. When I said good-bye to **Kaia**, I ask her why she seemed so pensive the whole reunion. She says she doesn't have an answer.

11:00 AM Sleep for like three hours again. Wake up to find **Elka** (Boston) sitting on my bed. She's like, "You and I are going out to breakfast." I was happy to talk to her, because I'd never really talked to her before. I'm so happy she's still with **Walter.**

2:00 PM Get on the flight back. It's sad to think that we'll never be together again. Being with other **Real World**-ers feels like being with family. It's so good for us to see each other, because we're the only ones who know what it's like to go through this...Anyway, enough babbling, time to sleep! Finally

Makeup!

David

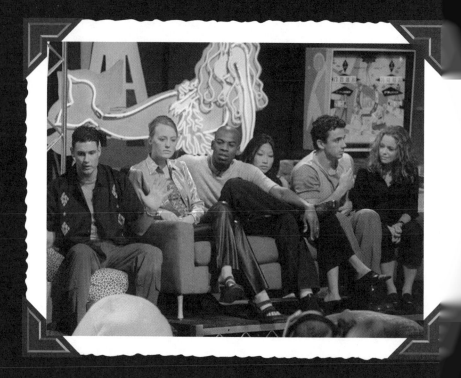

I was walking off the plane from Boston. I asked the stewardess: "Hey, did yo[u]
the plane yet? Did you see any cameras waiting?" She was like, "Yeah." I as[ked]
captain if we could switch clothes, just so I could mess with the crew, but he [wouldn't]
go for it. I did elude the camera crew for a few minutes by running off to the [place I]
got off the flight. But they caught me.

Over those three or four days, I didn't get to talk to too many people. I had a tight crew around me...**Nate** and **Syrus,** and **Mike,** who was my roommate. What did the cameras not see at the **Reunion?** Everyone getting their groove on. We were out until daybreak. We had stretch Hummers and limos taking us around. We were picking up stragglers from casinos. I was in a strip club at nine in the morning watching **Ruthie** give a lapdance. **Nate, Syrus, Ruthie,** we were the real hard-core partiers.

I was interested in seeing **Rebecca** and **Stephen,** I haven't seen them in ages. I just wanted to say, "Hi. How you doing."

open, outgoing. Seeing **Stephen** was brief. I t[hink]
were up. I can't blame him. You get off the pla[ne and]
a camera in your face. It's weird getting back [into]
Challenge, so I got used to the cameras agai[n with]
Stephen. He was a little abrasive, screamin[g across the]
room to **Ruthie,** "I feel you. I like you." Poor [Ruthie was]
really startled. Even onstage, he was giving N[ate something]
had to really bite his tongue.

Lindsay looks totally different. I was like, [I didn't]
even get to say good-bye to her. She was in a[nd out. That's]
the thing with **Linds,** she doesn't stick aroun[d]

It's been a couple of years since I was in Seattle, and here I was back for a reunion. I felt like one of the Partridge Family. I'm totally overexposed. With the Challenge, the Casting Special, and the Reunion, it's like I'm on TV every day. Whatever I try to do in life, I'll always be remembered for being on this show. That's too Danny Partridge for me. But I hold myself accountable. I'm the one who keeps coming back for more.

hot, hot, hot!

Party!

I watched a bunch of audience members dig into **Amaya**. She got shark-attacked, man. Some kid asked the **Hawaii** cast how it was to deal with **Amaya**. I told him to shut the hell up. I was whaling on him. I guess they probably cut that out. I don't know how **Amaya** takes it. Then they showed the video of her getting dissed by this 19-year-old kid, **Colin**. I really felt for the girl. When they were grilling her, I wanted to get off the stage. I just couldn't stand being there. I don't know how she takes it. I know she's resilient, but I feel like I'm waiting for her to crack.

The **Hawaii** cast, there are only four of them. I felt for them. They were stone-faced. **Teck Money**, they put him on the satellite, he was so funny. He'll say something off-color, and then say he's just playing; that's his get-out-of-jail-free card. The kids in the other casts didn't know who he was, but I was laughing like crazy. I love him.

What do I think about those two guys not showing to the Reunion? Not much. I don't know who **Matt** and **Colin** are. Just a couple of kids to me. If they couldn't make it, they couldn't make it. If you don't want to be on TV again, that's fine with me.

Genesis was there with her wife and they were both hotties. Those two blondes were walking around. I was talking

dirty to them all weekend, I couldn't help myself. They were like, "Meow." That girl **Elka** was FINE, just totally gorgeous.

Cynthia (Miami) was off-the-charts fine. I was so attracted to her. Write that. I want her to read that. Write that I thought she was hot, hot, hot. She's pretty. Plus, I always like my girl to be a little ghetto-ized. It's a big turn-on for me.

The best thing about our cast was that we flirt with each other, really just me, **Lindsay, Janet,** and **Nathan.** I was antagonizing **Lindsay** when we were about to go onstage. I was like, "Come on, can we French-kiss?" It was before we were going on. Also, we flirt with each other all the time...the four of us always flirt all the time. It's always been like that, it's pretty neat. The four of us we have each other's backs.

What was the difference between our cast and other casts? We are actually friends. We stay in touch pretty much. We get along pretty well. There's nothing to fight about. It's BS. I think we were probably the best cast. We're all fairly educated good kids. We're normal, you know. The only one who could have flown off the handle was **Stephen**. And the fact that **Dave Holmes** was referring to the incident with **Irene** as the "slap heard around the world"... that can't have made it easier.

The Challenge 2000 was overly competitive between us and the Road Rulers. It was terrible. We couldn't even speak to each other. We really were flipping out. I looked like I was being overcompetitive; really, everyone was like that. Road Rules was crying after missions they lost. People were taking a month out of their lives to do this, and they were going to make it well worth their time.

The biggest trip was Veronica *(Road Rules-Semester at Sea)* and Amaya. They used to fight and I used to love it. It was such comedy. We had these two high-maintenance girls talking about makeup and calling each other bitches. We'd be sitting around the table, and Amaya would just go: "Veronica's a bitch. Hey, so, what will we be doing tonight?" Then Veronica would call Amaya names. Mike *(Real*

World-Miami), Teck, and I would cry laughing.

Mike, Teck, and I were out every night on the Challenge. We'd be in Podunk, Mississippi, backwoods North Carolina, and we'd still find places to rock the house. We'd be in redneck Georgia, drinking in pickups and partying. Thinking about it, I get nostalgic. It was the best time.

Everyone on my team got along so well. I bonded with Heather B. *(Real World-New York)* so well. She was so bossy, she'd kick the Road Rulers off our bus. When Veronica would get off the bus, Heather would make her empty her pockets to see if she'd stolen anything. She was just joking around with those guys, but they were so scared of her, they took it. She'd even make the directors take off their shoes if

they wanted to come on the bus. She's beauty. Her insight on life is profound. She has a lot of common sense, and she always sees the bottom line. I used to go get hugs all the time. She'd be like, "David, come over here, you're my baby." She'd cook my breakfast and make my dinner. Everyone was mad, they were like, "Heather babies David." I don't care. She was my boo.

The Road Rules team was nice, but they seemed young. Holly and Dan *(Road Rules-Latin America* and *Northern Trail)* were like ultra-all-American. Sport Lilly and Sport Dilly never met anyone who was that Midwestern! Of that whole team, Dan was my favorite. Dan is such a good person, he makes you feel like a demon. Holly, too. They are just such good people with such good intentions. They go about every-

thing in such a benevolent way. Dan would say he wished he was more like me. But, I'd be like, "Dan, you Jerry Maguire me! You make me want to be a better person!" Dan's not an imposing guy, but he's really handsome. Once the girls get to know him, they fall for him. That Holly had a huge crush on him. I mean, I cried over a girl on The Real World, and that was dumb. But this was more like a game show, and she was all worked up crying about her soul mate. But they do look like they work together. I could see them with two Jeep® Cherokees and a Volvo making eggs for each other.

What did I think about Los *(Road Rules One)?* You don't want to know. He's well-educated and pretty smart. Big brain, no social skills. He was trying to play Jedi mind tricks on peo-

I've been designated the hunk of the shows. They're always like, "Can you take your shirt off?" I'm like, "I do have a brain." They put me in the cheese arena. I feel like all I'm supposed to do is flex my pecs.

...ple. He really didn't talk to me that much. He would say hi and ...hat was it. **Piggy** *(Road Rules-Australia)* and he were a trip. I ...didn't bother to ask what was going on, to tell you the truth.

Of all the girls, **Veronica** was the hottest. But **Kat's** *(Real World-London)* beautiful. What people don't know is that I used ...o date her. I actually met her when I was doing **The Real World** in Seattle. She lived two blocks up from the piers. I met ...er at a bar. She didn't even know I was on the show, and I did- ...'t know she had been on it. We hit it off, but then she saw I ...ad a microphone on. She was like, "HOLD UP, you're on the ...RW." Then she said she had been too. We were freaking out. ...She was like, "Why do I finally meet someone I like and he's on ...he **RW**?" We waited until after the season to start dating. I'd ...ly to Seattle, it'd be fun. She's a very intelligent woman, sensi- ...ive and cool. When it started to get serious, we decided to stop ...t. I had to go to VMI and everything. But she's great. I love **Kat.** ...'m the only one she lets call her **Kathleen**.

As for **Amaya,** I love her to death, but she's not the most seasoned competitor. We really did give her as much grief as i... seems. But we gave her love, too. She and **Kat** would be danc... ing to the soundtrack to *Rent* in the back of the bus. I was embarrassed watching myself scream at **Amaya.** I wish that hadn't happened. Regardless of how noncompetitive she is, no... one deserves that. And then how horrible I was to **Kat**...that was a bad day. That all went down in about twenty minutes.

By the end of the trip, we were all banged up. And, I admit, it felt terrible to lose the handsome reward. We wante... those cars. Truthfully, we needed it more than the **Road Rules** team. But, whatever. We should have dominated. But ... think **Road Rules** kids will always win these things. They're used to the mission format, to the road. **The Real World**...we only know the good life.

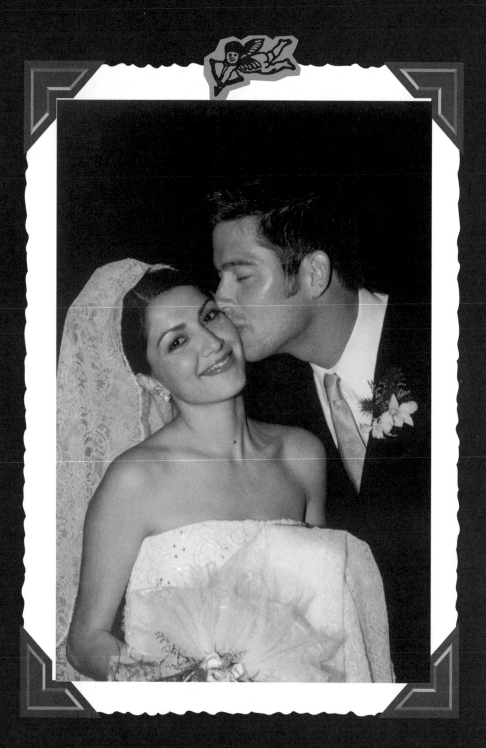

Rachel & Sean

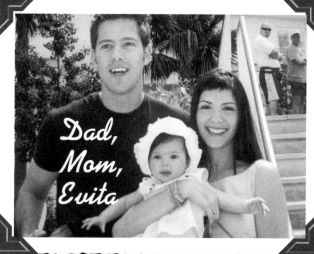

THE WEDDING

Rachel: Our wedding was amazing. It was a candlelight ceremony during a Latin Mass at our church. When we walked down the aisle, bells were going off and a bagpipe player preceded us. It was incredible. The reception was at my parents' house. It was a garden party with an outdoor bar. We had some rad Spanish hors d'oeuvres. There was a mariachi band at the reception, which is pretty traditional for Spanish weddings. It was festive, but it wasn't all "yeeha." It was very beautiful, I thought.

I wore a beautiful gown by **Donald Deal.** It was very Spanish-looking with a veil, strapless and hand-beaded, with a French Chantilly lace train. It was custom made. My ring was made by **Scott Kay,** a platinum jeweler. Oh my God, it is gorgeous.

Sean: Our wedding was small and intimate. The only people from **The Real World** who were there were **Syrus, Norm, Jacinda, Mike,** and **Cory. Montana** was invited to the wedding, but couldn't make it. It was kind of a bummer. I would have really liked her to be there.

I was very scared walking down the aisle. It was like a scene out of a movie. I had a ton of things going through my head, mainly "I can't do this, I can't do this." When you're about to get married, you see your whole single life passing before you. It's like, Oh no! But those thoughts faded once I was out there with **Rachel.**

WORK

Rachel: I was still auditioning for the ABC show *The View* when we got married. It was down to three candidates. I got pretty close, but didn't get the job. In the end, **Lisa Ling** got

something. I think all of those ladies on *The View* were wonderful. **Barbara Walters** is exceptionally elegant. She's everything you'd think she'd be. After *The View,* I got all these job offers. But I was pregnant, so I decided to take time off. went to Hayward. I was disappointed about *The View,* but **Sean** and I have etched out a nice little existence here. I don't know if it would have been as smooth in New York.

Sean: How is it to be a lawyer? It's great. I feel like I have the greatest job in the world. It's so amazing. I do criminal and family law. Emotionally speaking, they're pretty difficult.

HAVING A BABY

Rachel: Being pregnant was real easy. I only gained twenty-two pounds which is pretty good. I got really healthy. People are really into outdoors stuff here. I just worked on renovating our house and staying fit. Truthfully, I was relieved to not be dealing with work stuff. I delivered two weeks after the house was finished.

Sean: Rachel was the most fashionable pregnant person in Hayward. Actually, she's the most fashionable person Hayward, period. We found out after the fact that **Rachel's** fashion choices provoked some talk in town. I guess there were people here who thought she should be wearing a tent But I thought she was amazing. She was a sexy pregnant

New York, NY

LIVING IN WISCONSIN

Sean: Initially, it was strange to think of Rachel living in Hayward. We got married and didn't know where we were going to live. She was still auditioning to be on *The View*. But, when she didn't get *The View*, we knew it'd be Hayward. Truthfully, I didn't know how she'd be in a small town of three thousand people. But, she really has taken the positives from the area. It's quiet. It's peaceful. It's only two and half hours from Minneapolis. It's kind of a vacation lake spot and a tourist center in the summer.

Rachel: It's definitely weird here. Wisconsin is one of those states that never entered my consciousness. But I've traveled a lot, and this is one of the most beautiful places I've ever been. It's peaceful and natural with birds and lakes and clean air. Everything's clean. My friends were worried about how I'd adjust to it here. But I'm a military brat and I adjust to new places easily. I wasn't scared about living in Hayward. I knew I wouldn't get into a deep depression; I was just scared about not having access to shopping and stuff. There's not even a Wal-Mart here! We're not big enough for Wal-Mart! If I want anything—from a bra to home furnishings—I have to go to Minneapolis. I never understood the catalog thing until I moved here!

FAMILY LIFE

Rachel: I named the baby Eva Pilar, because Sean's grandmother's name is Eva and my mother's name is Pilar. I knew we'd call her Evita. I love all things related to Madonna.

How is being a mom? It's much more difficult and wonderful than I thought it could be. As for married life, it's very comfortable and cozy. My day is not very glamorous. Sean gets up first and hangs out with the baby, then he starts to get ready for work. Then the rest of my day is the baby. Sean's back for lunch. And then he's home for the day at 4:30. It's nice and relaxed, and during winter Sean can ski during lunch breaks.

Sean: The transition to living with each other was definitely difficult. Our first four months of marriage were hectic. Basically, in one year I graduated law school, passed the bar, got married, bought a house, and had a baby. People should stretch that over five years, shouldn't they?

Rachel is such an amazing mother. Her whole life is dedicated to this baby. She could have a fabulous career in entertainment, but she's opting for this. That shows a great dedication to her family and the baby. She far surpasses everything I thought.

Being a dad has obviously changed me. I've mellowed out so much. I'm so content to go to bed at 10:30 P.M. on a Friday night, and then wake up early and spend the day with Rachel and the baby. I'm completely enjoying it. It's family life. We even have a dog. Puck—Rachel is still friends with him—had a whole bunch of chihuahuas, and we got one

of his puppies. Incidentally, I have a completely different perspective of Puck from knowing him than seeing him on the show. No, I'm not jealous of Puck.

Do I recommend the family life? Oh, completely. It's a sweet change from the life of partying and bars and women. This is the most satisfying thing that's ever happened. I'm so loving where I'm at right now. I can sit back and say, "this is good."

Sean: It's amazing how everyone changes by the time of the **Reunion.** Everyone comes in to the project not so fashionable with no makeup. Now, a few years later, it's like a glamour show. **Genesis** was pretty done up. Everyone was drooling over her wife. Who cares? She's no **Rachel.** She had blond hair. I like dark hair.

Usually, people are really just focused on themselves, but with the baby everyone was so nice to both of us. We don't get a ton of breaks, and people just kept wanting to take the baby from us. **Flora** took **Evita** for a while and didn't want to give her back. Then **Ruthie** had her. When **Ruthie** gave her back, **Rachel** was like, "What's that on the baby's foot?" **Ruthie** had signed her name on our baby's foot! Little brat!

I wouldn't say I felt more mature than the other **Real World** cast members. I think everyone has their own things going on. I do think I'm more grounded in reality. A lot of the **Real World** people still want to be famous Mr. Actor and Ms. Actress. Me, I've got a mortgage and a family.

My impressions of other cast members? Well, as far as my own cast goes, I hadn't talked to **Jason** for eight months. Let's just say you notice **Jason's** style changed the most. He's Mr. Hip now. He tries so hard, it cracks me up. **Syrus** is the same ol' same ol'. He's my best friend from the show. **Kameelah** seems a little more levelheaded. And **Genesis** was off her rocker like she always was. **Elka** was good to see. **Montana** couldn't be there because of work. That was too bad.

As for the **Seattle** cast, I think **Janet** and **Lindsay** are a ball of fun. **Stephen,** he kind of bugs. **Rebecca,** I have no impression of. **Nathan,** either. **David** is nice.

I didn't spend that much time with the casts from **Miami** or **Hawaii.** During the **Reunion,** people were asking

Hayward, Wisconsin

Amaya difficult questions about her personality, and I thought she did an amazing job deflecting them. She impressed me. **Teck** was pretty funny. **Kaia** was weird as hell. I was like "Holy crap, are you strange." I didn't get to talk to **Justin.**

Initially, I would have said that I wouldn't let my daughter do **The Real World.** In hindsight, I take that back. The show was an amazing experience for me. I got to experience diverse cultures. And if **Eva's** going to grow up here in Wisconsin, that diversity would be good for her, too.

Rachel: In general, everybody from **The Real World** has been really cool. **Norm** (New York) has actually come to visit us. He's from near here, so he's familiar with the area. I guess it's pretty exciting. All the girls wanted to know all the gory pregnancy and birth details. **Puck** has actually been great. He calls quite a bit. I probably talk to him every month or month and a half. **Cory** loves babies. She's really into it.

It says a lot about **The Real World** that **Sean** and I are together. Without the show, we never would have met. **The Real World** can bring people together in a really positive way. Viewers are always wondering: Is it real? Well, it doesn't get more real than this!

Boston Cast!

Flora

Viva Las Vegas!

Our cast was the only cast that hung out the whole time. We were always together. It was really weird that everyone got along. We all had our differences in Miami when we were stuffed in a house. Six months isn't a long enough time to get to know somebody, so we fought. But, we've forgiven and forgotten and moved on.

Everybody's still the same, but more mature. Sarah's still got her crazy ways. Mike's still got his flirty ways. Cynthia, she was awesome. I don't remember how we ended the Miami season, but it was like bad stuff never happened.

I roomed with Melissa at the Reunion. We were our own little clique. We were pretty freaked out at first, I guess. But,

once we saw everybody, it was all good.

I'm probably the most negative person you'll ever meet. The weird thing is I have nothing negative to say about the Reunion. I've matured and grown up and moved on. In a weird, strange way, I was actually happy to see people. These people are always going to be a part of my life. There's always going to be something that links me to the people in Miami.

When they called me to do the Reunion, I was like, "Yes, definitely." Three years ago, I would have said no. The Hawaii people, they literally just finished. I think it took courage for them to come to the Reunion. I wouldn't have been able to do it. It's hard to come back.

I watched five or six episodes of my season. It was very painful to see the shows. I put all the tapes Bunim/Murray

F&M

Actually, we all look better now! That's because during the season, all of us, we blew up like balloons. I was a size four when I came on the show and a size nine when I left. I thought I was skinny at the time. But I look back at myself in shorts, and I'm like: "What was I thinking?" I had a huge ass. Now I'm a supermodel. I'm 118 pounds. That's not tiny, but I'll never be sickly thin. I've got boobs.

Aside from me and **Melissa**, who was the most attractive of all the cast members? Not **Amaya**. Everyone was going on about how beautiful she was. But you know who was so beautiful? **Genesis**. Oh my God, TV does not do her justice. Perfect body, perfect skin, just gorgeous. Now I sound like a lesbian, don't I? As for guys, I want to say **Dan,** but he's gay so...Well, so what? **Dan** is a very attractive guy. He has very distinct features.

After the **Reunion,** we didn't go to clubs. All the guys had all these Britney Spears wannabes all over them. Whatever! **Melissa** and I ordered room service, pigged out, and went to bed!

sent me in a bag and sent them to **Boston.** I prefer my memory of the **Reunion** when everyone was friends. I don't want the old flashbacks.

At the **Reunion,** I told the crowd I had joined the circus. That's not true. What I'm doing is slowly working on my acting career and working at a manufacturing company. My heart is to be an actress. I want to be a superstar. Hopefully, it'll turn out well. I don't want to say this and that and look like an idiot.

I think our whole cast is going to do well. If I had to predict what we'd all be doing in five years, I'd say: **Melissa** will for sure be a superstar. **Cynthia** will be married to a sports star. **Sarah** will still be into her comic-book stuff. **Dan** will still be yapping and into modeling stuff. **Joe** will be an Internet tycoon. And **Mike** will still be searching for the perfect woman.

I was the best dressed with the best hair! I have pitch-black hair at the **Reunion,** but now I have purple hair.

me with red hair...

Cindy-Lue, Yogi Bear & Me

He's hot!!!

GETTING MARRIED

My wedding was awesome. **Mitch** and I had been living in L.A. for two and a half years. After that, we decided to go to Vegas and just do it. We went to a little chapel, and then we went to a fabulous restaurant.

For me, there's nothing different between married life and regular life. **Mitch** and I have been together for four and a h[alf] years. We're still best friends who party and hang[]out. We have two doggies. We're thinking of havi[ng] kids in the near future. We do whatever we want. [We] just want to enjoy our lives for a while. And, yes, [we] have a better relationship than we used to. But w[hat] do you expect when you cross a Russian and a

Oh my God, Mitch
looks so much better now.
He's like half the
weight he
used to
be.

t's funny to look at *The Real World* after the experience, because you feel so different. At this point, all the irritation I felt in Hawaii has dissipated and I feel stronger than I did then. I'm a different person now, and it's weird to watch myself on the show looking so nervous and defenseless.

From watching the show, I learned how much people were talking s**t. I had no idea people were going to the confessional in the basement and talking as much crap as they were. I went down like once every two weeks and said *literally* nothing.

I never used that camera to my advantage or to others' disadvantage. People were just trashing. That was a dirty confessional in a dirty basement.

I'm not interested in any further media attention. It's too big a statement to say I'll never do something performance-oriented again. But my media fame obsession is gone. I thank the show for that. I feel like most people are in denial if they don't acknowledge they want to be famous, and I've had a taste of that.

Now I know I don't want it. I've been making my life what I want it to be. I've realized I probably want to be an academic and a writer and realize I'm probably more suited to that. That's all because of the show. And I'm truly grateful.

LOVE AFTER *THE REAL WORLD*

There was this guy Mark; he and I were really tight friends our first semester at this boarding school I went to, Simon's Rock. We were sixteen and at the time we were both closeted. He was one of the first people I was ever interested in, actually. Our friendship ended in this completely devastating way. I came on to him, and for whatever reason, he completely rejected me. Soon after that happened, we both enrolled in different colleges, and then went on to graduate school. I thought about him often over the years, wondered where he was, but I also continued to feel bad. Even after all that time, I felt shady and weird. I felt like I'd done something wrong. I never even knew if he'd come out—although I suspected he probably had.

So, the summer after *The Real World*, I was in Texas. I was going through my mail, and in between all these bills and loan-related correspondence was a personal letter addressed to me.

The letter was incredible. Mark told me that his brother had seen *The Real World*, and mentioned that someone from Simon's Rock was on the show. He says he knew automatically that it was me. The letter was so well-written and thoughtful and smart—even in Mark's sloppy handwriting. He didn't say he was gay, but I knew he was.

The next day I called him in Providence and we start-

I lost my breath when I saw the name above the return address. It was Mark's. I know this is going to sound crazy, but I knew even before I opened the letter that it was a love letter. And I'd never even received a love letter before!

ed chatting as if nothing had ever happened. We talked every day, and when I came to the East Coast, we started to hang out. At the end of December, we spent a week together, and it's been a relationship ever since then. Now we see each other four days a week.

We're boyfriends. We're in love. I've never been in love before, and now I am. And it was precipitated by *The Real World!* I don't consider that incidental.

If anything good was going to come out of being on

JUSTIN

television, that was it. I could never have gotten together with him without the show. Other people in the cast are trying to get a media career from being on the show. But, this is better. I'm proud of Mark and who he has become and I'm proud to know him. He's funny and self-deprecating and sweet and he has matured into this wonderful person. What we have is not fleeting. He's an actor who just graduated from a conservatory. Watching him has triggered this renewed interest in theater for me. I've realized through watching him act that it takes real training to do what he does. It kind of sheds some light on a lot of people whom I've met through *The Real World* who've been trying to act. Get real training!

FASHION BAD

There were so many. I'd stopped exercising, and I was on a tropical island and there was NO layering the truth. I was feeling fat and gross most of the time. I'm pretty modest, and there I was wearing only undershirts! You know those days you can't find any of the clothes you want to wear? Well, I had many. And sometimes I had those glasses on. Yuck!

FASHION GOOD

Honestly, I can't think of any!

SOMEBODY ELSE'S FASHION BAD

Mark calls Kaia the Duchess of Urban Outfitters after seeing that shot of her wearing bindis and amulets and crap on her head. There were definitely some times when her fashion was a little uh-oh.

CRINGE

I was always caught in bed with crusty eyes and slept-on hair, all groggy in an ugly position. Watching myself on TV, I was like, "For the love of God, wake up!"

Watching myself cry on television was not pleasant. I look like a gargoyle, like a pointy bleary-eyed reddish gargoyle! I don't cry in front of a mirror, so it's a rare thing to see yourself do that. I regret that I lost control, but I don't feel ashamed. There's no embarrassment. The crying was honest.

ON THE STREET

People don't recognize me as much as they used to. Maybe because I changed my hair color and because I've learned to walk fast.

FAVORITE MOMENT

The final montage when I left. I enjoyed that. Also, I liked the last episode that I wasn't in when they have their little show. That Matt and Kaia relationship was totally contrived (by them!). It was fun to see it. It was kind of a nice ending. I liked Amaya's song!

LEAST FAVORITE MOMENT

I grimaced when Amaya put out the vibe that I'd made speculations about why I was leaving. I mean, I knew my relatives were watching and there she was saying one of them might *not* be ill. She just used poor judgment by questioning me. She just looked insensitive. But I can't

blame my housemates for having reactions that were somewhat unsympathetic; I never told them what was going on.

As far as general story lines are concerned, I was bored by Teck and his women and the whole Colin and Amaya thing. I mean, we'd lived it. I didn't need to watch it again.

THE CUTTING-ROOM FLOOR

I guess it's good that this wasn't featured on the show. One night Amaya and I were drinking alone. That girl shouldn't drink. She climbed into the bunk with Colin, and he pushed her out. She fell off the bed. I felt bad for her and kinda responsible since I'd been the one who was drinking with her. Then she was like: "If I can't sleep with Colin, I can't sleep in this house." So she lay facedown on the treadmill with the sheet draped over her. I got obsessed with turning the treadmill on and seeing what would happen. But I stopped myself. Thank God. I was drunk.

KEEPING IN TOUCH

Who am I in touch with now? Everybody except Colin and Amaya, though I saw Amaya at the Reunion. Matt and I e-mail about once a month. I can't account for his not participating in the Reunion or the book. I don't know anything about who he is now, just what he tells me. I guess he's busy. I hope he finishes school at some

point. When I talk to him, he says he's got what he needs for his career and he's not going back to school. I don't want to lecture, but I think the real reasoning behind finishing college isn't about career prospects; it's about finishing something you've started, learning and growing. I hope he goes back to school. I don't know what Colin's doing, but to cut off ties to *The Real World*—it's a big sacrifice, so I assume he must have pretty good stuff going on.

THE REUNION

I think a lot of the previous casts were cooler than we were. I connected with them more. I don't know if it's because they've been out for longer or because they were older and more interesting. Jason, I like. I really dig Montana. Janet, I like a lot. David's funny. He's a big figure in that group of people. You can feel his phallic vibe! He's super-friendly.

I was glad to see Amaya at the Reunion. She seemed OK considering she got creamed on TV.

TO FUTURE *REAL WORLD*-ERS

Relax when the show hits TV. Maybe go incognito for a while. In a couple of months you'll be relieved and somewhat appreciative of the experience!

A fter Hawaii, I freaked out. This may sound crazy, but when I first got off the show, I couldn't speak to anyone. I didn't want to go outside or leave my house. I had this notion that everyone on the street knew me but didn't like me.

I mean, I was at a really unhealthy place. I would hear a loud noise and think the world was in synchronicity with my thoughts. It was nuts! I would analyze and break down every thought to the point of insanity. At such a young age, to have this much publicity messes you up; I didn't know how to deal with it. I felt like no one else could understand, because fame is something everyone wants, but doesn't truly understand.

I'm living in Brooklyn, New York, with my best friend from high school, Lauren. She's amazing. Without her, I wouldn't have gotten through the aftermath of being on the show. I was acting so strangely, Lauren told me she didn't recognize me. The minute I started talking to her about it, I felt better. We'd go to Martha's Vineyard for weekends, and just process. It was like having post-traumatic syndrome. I had no idea what was happening to me or that I was depressed.

The other thing that has saved my life is Shaolin kung fu, which is a style of martial arts. I've always been really into exercising. One day (during my particularly paranoid time), I was on a jog. On the wall of a building, I saw a picture of this young Asian-American guy in a fighting stance. The image was striking to me; it looked like there was energy emanating from this guy's hand. When I got back home, I called him. Now I attend his school. This school of martial arts has been around since the third century and involves a lot of breathing and meditation. It is extremely physical, extremely rigorous. I used to run miles a day, but that doesn't touch this.

In Hawaii, I knew I was a passionate person who was excited about life. But I couldn't channel my energy. I knew I wanted to paint, dance, act, but I lacked a central focus. Martial arts is that focus for me. In fact, exercise is the main portion of my day. I leave class and I'm happy with myself. The other thing about kung fu is that it's performance-based. You have to get up in front of people and do kicks. That helps me with all the other things I want to do—act, perform, do film production. *The Real World*, if you are a performer, is a great springboard. But the real performance world is all about technique and studying. Agencies say to me, "Well you obviously have an innate ability to act and perform, but we need more." So, I'm trying to train, to focus.

What does it mean to be in your early twenties and have this instant stardom? It changes you. What does our generation's hunger for glamour and fame mean? Even I'm tricked by the fame thing sometimes. But usually I realize it's illusory. Fame has nothing to do with real life.

I still feel like I have this problem relating my vision to people. I have all this knowledge, but I don't have the paper to back it up. My vision of the world is so large because of the traveling I've done and the people I've met. I don't break things down enough for people. But, it's like, I'm twenty-three. I don't have enough outlets for expressing myself. I'm working on a book, a memoir recounting a lot of the adventures I've had (including the experience of my father dying and my living in Africa). I'm also working on a body of poetry that I'm attempting to memorize so I can begin performing. It's not that easy for someone my age to express herself without a stage.

Kaia

FAVORITE MOMENT

It's so hard for me to remember exact moments. I would say I really liked watching the episode where I met Tre. I loved watching myself dive into the water. That was awesome and cool and a good time in my life. I was really relaxed. I still talk to him. He's become a good friend of mine.

LEAST FAVORITE MOMENT

Definitely at the end. There's this one confessional when I'm talking about going to see Matt in Los Angeles. I look so sweet and cute! It really bugs me! Not that I don't think it was good for me to show my sensitive side. It's just that it was too much.

Actually, I stopped watching the show, because I didn't want it to taint my memory of my time in Hawaii. For example, I don't like having this vision of an ambulance when I think about the first few days. I didn't even see that ambulance, and now that's what I think. It's an incredible thing. The medium of television is incredibly

powerful, and I feel powerless telling people, "Well, a lot of other things happened. It wasn't like that exactly." I just decided to let people experience it as a television show.

FASHION GOOD

I think I was pretty well-dressed the whole time. I can't think of anything that stands out in my mind as particularly good.

FASHION BAD

There are a couple of times when I had sparkly things on my face that I thought looked funny.

CRINGE

Honestly, there were no big cringes. If there's anything I don't like it's that I think I sound really authoritative sometimes, and it sounds really bad. I don't have all the answers, and I know it.

Does all the nudity make me cringe? Well, at first I was really gung-ho about having been naked on television. I thought my being comfortable naked must be doing something good for the world. But then, I felt really embarrassed. Maybe it was because it was winter in New York, and it was cold, and I was feeling so weird about everything. During the time I didn't leave my house, I didn't want anyone to see my skin or any part of my body. I thought I'd really degraded myself. I realized the whole world does not think it's a good thing to be naked.

THE REUNION

I was a little bit afraid, so I called Amaya before the Reunion. I knew I needed to talk to her, but I was very shaky and scared. I wanted her to know I didn't have ill feelings, but that I didn't want to rehash everything at the Reunion.

I told Amaya that if she had anything to say to me, she had to say it now.

The first thing she said was that she didn't want to think about the show or anything that happened on it. All she wanted to do was throw herself into her new life. That's not how I feel. I want to examine everything, feel the pain. But I wasn't going to preach to her. I think one

of the major ways I've changed is that I don't judge people quickly anymore.

Matt called me to tell me he wasn't going to the Reunion. At first I was adamant about not going too. I was just feeling: "I'm finally getting over it, and I'm going back?" But I'm glad I went.

Onstage, it was a pressure cooker of an atmosphere. I was just trying to get from one moment to the next.

But talking to people from other casts was amazing. Jason and Janet were both sweet. I felt like they were able to look into my eyes and know what was going on.

I roomed with Cynthia. She showed up and I was just sitting alone in the room, not feeling good. She immediately opened the blinds, let the sun in, and was just like: "No." She was really loud. She told me I was seeing everything all wrong. She said I just needed to let go. It was just what I needed to hear at the time. The other person who helped me—in a weird but definitely cool way—was Stephen from Seattle. He's highly religious, though I'm not sure what religion. I told him everything I was thinking, how I was in such an unhealthy place. He said he'd broken down too, but much later. He told me I was working through stuff at record speed. He made me feel great.

That was right at the height of my paranoid stage. Ruthie didn't know what was going on. She was acting normal and I wasn't.

Matt and I talk on the phone. He also went through a hard period during which he sheltered himself from the world. Colin I haven't talked to. Justin I have seen and talked to a little bit. We went and did Web Riot in L.A. We connected a little bit there, but he seemed really involved in his studies and not wanting to talk about the show. I told him to feel free to call me if he wanted to talk about stuff.

ON THE STREET

People say to me, "I really liked your performance." They tell me I was the only person who was together and not crazy in a bad way. They say, "Thanks for putting yourself on the line. Thanks for setting a good example." For people to acknowledge that, it's awesome. People do tend to ask gossipy questions. Like they want to know what I thought of Colin and Amaya. I'm like, "What did I think? Well, I just shut them out entirely." People also ask if Matt and I are together. They need to realize that life is ongoing and my life didn't end with *The Real World*.

KEEPING IN TOUCH

I've talked to Teck a few times, but we haven't really seen each other. I know some time we'll connect and it'll be right. I saw Ruthie at a speaking engagement once.

LOVE AFTER *THE REAL WORLD*

What is dating life like after *The Real World?* I wouldn't know, because I haven't dated anyone. I think I'm ready now. The thing is, just trusting anybody right now is a big deal for me. I'm not looking for it, but I think I'm open to it in a way I wasn't before. I'm young, and I don't see any reason why I should be single.

FAMILY AFFAIR

My family has watched the show. My grandparents are so proud of me. I'm like the shining light. Their whole retirement community watches it. My mom has been incredibly supportive. She's been the champion supporter of everything I've done. It's been hard for her dealing with me in the aftermath. One moment I'm happy I did it, then the next minute I hate it.

ife after *The Real World* has been everything I wanted it to be. When I first got off the show, it was no big deal. I went back to Peoria to my friends and family and my job at California Pizza Kitchen. I guess it was around Christmas that everything started cracking, just getting crazy. I couldn't walk through the mall without people noticing me! I got a manager through a friend, actually the same manager who represents Vivica A. Fox. I've been taking hella meetings. I've been auditioning for movies and TV. I had a callback for a Whoopi Goldberg movie. I got all the way to network on a show.

I'm doing what I want to do. I can't say exactly what's going to happen, but like I said at the Reunion, I'm going to blow up. I'm already famous. I can get into clubs I want to go to. I've been on the radio a ton. I did some rhyming on Atlanta radio. I've been riding in limos and town cars. I've been in *Vibe* magazine. I'm even in a Japanese magazine. Not that I'm not still down with my old crowd. I am. I'm taking them with me. They're only pissed off that I'm not already on to bigger and better things. They're rushing me to get a series or a movie or something.

The first time I saw myself on *The Real World*, I got chills. That opening shot of me on the surfboard, it was out of control.

I loved watching our season of *The Real World*, but I feel like the TECK $ story was not adequately repped. The fans always ask me where I was at. They tell me they got sick of the Colin and Amaya story. And I have to admit I agree with them. It was Colin and Amaya this, Colin and Amaya that. It was a broken record!

But whatever, I don't hold a grudge. And it's been all good from then. I love being on MTV. My first gig was for *Say What? Karaoke*. Then I did *Spring Break*. That was off the hook. Eminem saw me and was like: "What's up, Teck?" And I love Ananda. She's so cool.

With the exception of spring break, I've slowed down with women. Every good man's downfall is a woman: Kennedy, Clinton, Mike Tyson, all the way back to Adam.

I don't look for women anymore. I actually ran into Andrea, the girl who I'm with in the episode when my dad visits. (My favorite episode, by the way. Why? 'Cause it's about me!) I wanted to get back with her, but she was going out with someone else. Really, though, I've mel-

I've been trying to behave after *The Real World*, but I couldn't help being a wild young kid at spring break. Yeah, yeah, I got thrown out of the hotel for bringing girls up. It was an upscale hotel, so I had to get ghetto high class on them. I was like: "Do you know who I am?" In the end, I evicted myself. It's spring break—you gotta get a little action.

lowed. I want to work. I'm in a position to make some money now. The women will always be there. Let's just say that at present I'm in love with American currency.

ON THE STREET

Kids on the street think I'm the biggest player in the world. So many guys come up to me and go, "Yo, dawg, I want to be like you!" They tell me I'm the biggest pimp and player. And a lot of times people ask me if Amaya's t**s are really as big as they look. Then people ask me about Kaia. They ask, "What about the girl with no t***ies? She has a big a**!" Another thing people ask is,

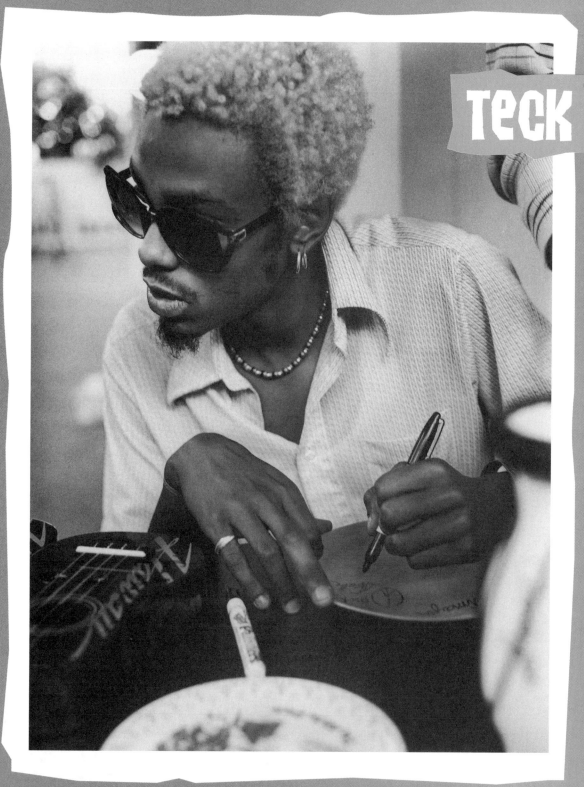

FAMILY AFFAIR

My family loved it. There was nothing that shocked them. They gave me no flak. My dad just laughs about stuff. Like when I jumped in the mud on the Challenge, he was like, "Boy, can you ever keep your clothes on?"

FASHION GOOD

When I'm wearing my Woodruff High School T-shirt.

FASHION BAD

When I've got my glasses on and I look like a total geek.

KEEPING IN TOUCH

I'm busy. It's like I see people when I see people. I rarely see Kaia. Matt and I did the American Comedy Awards, which was great. Colin and I have done speaking engagements. I saw Ruthie at Christmas. My people wanted to see her and she came and chilled with me. I actually talked to Malo, too. She's still all love for Teck, but I can only stand so much.

"Why did one of the two gay guys leave?" And I'm like, "Which other guy did you think was gay?" They say: "Matt." When I tell them he's straight, they're shocked!

FAVORITE MOMENT

My favorite moment would have to be during that first episode, when I come back late with the car and I look like I'm smirking. I love that. Actually, I take that back. My favorite moment is anytime I look like a G, like in the episode with Ruthie and Malo. That was funny personally to me.

LEAST FAVORITE MOMENT

The worst moment is when I was talking to Kaia on the couch. We're talking about how Malo ratted on me to Ruthie, and I'm saying "Damn, I'm slipping. I'm slipping." That moment is real.

CRINGE

When Matt is going on about some of Amaya's problems on the radio. All her business was out there. The damn disease crap made me cringe the most. I would not like that to be me. To me, that was worse than the alcohol stuff.

TO FUTURE *REAL WORLD*-ERS

Prepare for your life to change. You might get harassed. You might be liked. You might get love. You might get hate.

THE REUNION

I'm glad I participated. I think it's funny that Colin didn't, since he was the star of the show!

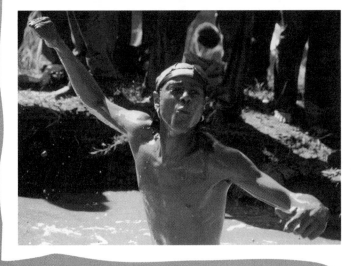

THE CHALLENGE 2000

What didn't you see on *The Challenge 2000?* The fact that we went out every night. I was always going off with townies. I never wanted to sleep with anyone on *The Challenge 2000.* Okay, well, I would have tore Veronica *(Road Rules-Semester at Sea)* up, but the cameras wouldn't have let us alone. She was the hottest girl on the trip.

So, the guys, we were always going out. Dave *(Real World-Seattle)* didn't go out as much as some of us. That's because he's the man of *The Real World.* I gotta give a shout out to Dave. He's a real player. He could have had Kat, Amaya, Piggy *(Road Rules-Australia)*, Holly *(Road Rules-Latin America)*, whomever he wanted. That's right, Holly. I know it seemed like she was only after Dan *(Road Rules-Northern Trail)*, but she was always jonesing after Dave, too. He hung out with the chicks all the time. He's the Italian Stallion.

Yes was my kickin'-it partner on the show, but he's a punk. Yes is not a closer. Once he gets a girl, he doesn't know what to do. It was almost to the point that he was messing up situations for me. I'd be like, "Wanna split up, you take one girl and I take the other?" He'd be like, "I just want to talk." What is that?

Heather B. *(Real World-New York)* was my road dog. She and I hung out the most. We could relate. It was so good to have a sister with me. That made a big difference. We grew up the same way. We had so much in common music-wise. She took it upon herself to school me in the business, to warn me about all the snakes I'd encounter out here in Hollywood. What do I think of Los *(Road Rules One)?* Well, Los is a strong person. The problem was that everyone wanted to be in his business. All you had to say to Los was "How you doin'?" If he said "fine," then just leave him alone.

I loved having Amaya there, but she harassed everyone. She always had her foot in her mouth. But, both being from Hawaii we stood up for each other. Like family.

THE CHALLENGE 2000

I was nervous at first to be back with the cameras, but I was happy to be on the road and not know what was happening next. It was two totally different experiences, *The Challenge 2000* and *The Real World-Hawaii*. I had more fun on *The Challenge 2000*. People were there to have fun. We listened to music and danced on the bus. It was a good time, although not exactly a healthy one: we ate crap and were always ill. Waking up in a compartment on a bus does not make you feel great. Our team got along so much better than it seemed. In fact, our team got along really really well. It was all around positive. I know it seemed like I was ganged-up on, but it was not as big a deal as it seemed. I loved each of my teammates.

Is it true that I got hurt on every mission? Absolutely. I'm the least in-shape person. Seriously, I wasn't posturing. Like on the football team, they wouldn't let me back in the game even when I wanted. They said I might have a fracture. And I had a concussion that last day after parachuting. I had to miss most of the wrap party because I was in the hospital getting X-rays. Here's something nobody knows. When the parachute flipped me over, I landed in a fire-ant hill. There were ants all over my legs, stinging me. I had hundreds and hundreds of welts all over my legs. I was in so much pain. People were pouring water all over me. Somebody

threw Citra {soda} on me. That didn't work out so well.

Another thing people can't tell from watching the show: It smelled really really bad on our bus. David stank and was always getting pizza on his face and throwing chicken at people. It would get really gross on the bus. That mud from the Red Neck Festival was all over us. It was dripping out of every orifice.

The pig knuckles were definitely the grossest thing. Imagine looking into that water: there were all these little toenails floating around. We'd already been barfing from the pie-eating contest, and then those pig knuckles! Kat was sick for the rest of the day.

The sausage incident was really horrible for me. I was getting prank calls at work for a month. Somebody got my number and would call constantly and just say, "sausage." It was terrible.

Another thing people don't know about *The Challenge 2000* is that we lost the smoking challenge in Tampa after we played football. David was our most adamant smoker, but he wasn't even the one who messed up. We were sitting at a table and Teck unknowingly puffed on a football player's cigar. We didn't realize cigars counted. He felt so terrible.

Regardless of anything that happened in Hawaii, I'm grateful for *The Challenge 2000*. I got to play for a month. You don't get that opportunity often.

AMaya

hen I left Hawaii, I was angry. I'm not angry anymore. No, I haven't been in therapy! I've just had a few revelations! I'm in a very different place now. I feel like I've aged eight years in the last one!

Watching the Hawaii season is like watching a bunch of seedlings.

We were all so young! We were on a launching pad for the rest of our lives, and all we could do was grow. Some of us grew in positive directions, and some of us in negative ones. I learned a lot in Hawaii. I learned to

be stronger; to be patient; to not take things for granted; to not let people take me for granted. I learned to trust my instincts more; I learned to be more constructively critical of myself; I learned that life is full of adventure, and you never know what can happen. Growing up, I was never the person who did anything incredibly spectacular, so just having the opportunity to be in that position—for me, it changed everything.

I'm living in Los Angeles now. Actually, Lindsay *(The Real World–Seattle)* lived next door for a while, and Nathan *(The Real World–Seattle)* lives across the street.

I still hang out with my old friends. We kind of ignore people when they recognize me.

I've started to not really pay attention if people are looking at me, and I feel bad that my fame (or whatever you want to call it) affects my friends in any way. The whole thing is embarrassing. I'm a shy person. I'm not a mingler. At parties, I'm always the quiet person.

A lot of girls come up to me and tell me they identify with me and the insecurities I exposed on the show. I guess if I could send a message to them, I'd say, "As you grow older, the little things that bother you will get easier. Just don't take anything too seriously. Take risks." I took a big risk by going to Hawaii. And for all the pain, it was worth it.

FAVORITE MOMENT

Any time that it showed us in our lighter sides. That's how I liked it the best. When we were silly.

LEAST FAVORITE MOMENT

Anything that was a downer. I don't like watching me fighting with Kaia, but I don't hold anything against her. It takes too much energy.

A relationship is not a priority for me right now. I'm enjoying having my freedom and getting to know myself and my friends on a more adult level. The early twenties are the time in your life when you realize who your true friends are. These are the people who are going to be with you through your life.

ON THE STREET

It's hard to remain anonymous with the stupid name I have. If I go to Jamba Juice, I use a different name. It's a weird phenomenon having people think they know who you are, people yelling your name all the time. It's so ridiculous. I'm like, "What did I do?" I was on a TV show for a minute, and this is what it's like for me! I have a newfound respect for people who have fame. God, it must suck to not be able to go to the supermarket. I know only vaguely what it's like.

People on the street are unanimously positive. People relate to me, which is funny because I don't really relate to the person I was on the show—a person who lost her identity and let her lack of self-esteem take con-

trol. People always ask me about Teck and Ruthie. Teck says people are asking about my boobs. Doesn't that give you a warm and fuzzy feeling inside? Yuck!

When people ask me about Colin, it's like answering questions about the boy you went out with in junior high. I'm caught up in my own thing.

Colin's doing his own thing right now. He's acting, which is funny considering he always said he didn't want to act. But, whatever. He's an ex ex ex ex ex. Let it be.

FAMILY AFFAIR

My family gets annoyed by watching me on *The Real World*. My parents didn't enjoy hearing how many people I'd slept with.

THE REUNION

I didn't really get to talk to people, but what were my overall impressions? Well, Rachel and Sean are beautiful. Kameelah's really nice. Lindsay is such a little spark! She's a lightbulb! Basically, I like everybody I met. Rebecca was really nice. Everyone is a lot more gorgeous in person than you'd ever imagine. Elka and Genesis, oh my God!

I saw more camaraderie among the other casts than among ours. Not that they were having some huge lovefest, but still we were definitely the least close! I didn't care that Matt and Colin weren't there. I was just happy to see my cast mates from *The Challenge 2000*.

FASHION GOOD

Although I regret wearing those ridiculous high platform shoes on the hike with Colin, I thought that was funny! I looked so out of place!

FASHION BAD

Any shot of me in my bikini! People are so rude about me being in a bathing suit—especially in chat rooms and message boards. They're rude about all of our looks. I also really regret wearing those capri pants all the time! I guess they were OK at the time, but now I can't stand the look!

SOMEONE ELSE'S FASHION BAD

That colorful Hawaiian shirt that Colin wore, but that's not fair, 'cause he bought it because it was so ugly.

CRINGE

You know what's embarrassing? When I referred to myself as the baddest girl in my sorority. I totally got made fun of for that!

KEEPING IN TOUCH

I've spoken to Colin a few times but I rarely see him. When I saw him, it was the same, meaning nothing. I saw Matt at the American Comedy Awards. I guess it's Teck who I speak to more than anyone else. If Ruthie moved to L.A., I'd see her more. It's hard to base a friendship on being on a TV show together.

TO FUTURE *REAL WORLD*-ERS

Don't go into the confessional when you're drunk!

he weirdest thing about *The Real World?* Man, the camera doesn't do me justice. I think the camera put twenty pounds into my lips.

Also, I look a lot taller on the show. I look like I'm Goliath or something. I'm only five-one! Everyone's always telling me I'm much tinier than they imagined! And that I look a lot better!

I stopped watching the show. I just wanted to remember my experiences as they were, not as they

were shown. I'm not saying the show is a brainwash. It's just that you only see part of the story, not the whole story. The show definitely makes me do a lot of thinking. I talked to Rachel from the San Francisco season and she was like, "Six years later, I'm still processing!" My response to that is, "Oh my God, that's crazy!" The funny thing is, she still gets questions about what happened six years ago as if it happened yesterday. People will come up to her and be all "So, what's with Puck?" I can see that happening to me. People will always ask me, "How are Matt and your sister?" All I think is, "Jeez, you watch too much TV."

People also ask me if I'm still drinking. Well, yes, I go out. Yes, I hang out. Yes, you saw me get drunk on the show. Enjoy it! But, now my life is my business.

If I remember correctly, I said I would not drink for the rest of the show. And that's that. I never promised to do anything otherwise. I never said I wasn't going to drink for the rest of my life.

I get a lot of fan mail. I have fans ranging from 8 to 50 years old. I take time once a week just to read my fan mail. People tell me their life stories. They come out of the closet to me. They tell me their deepest darkest secrets. They tell me about their experiences with alcohol and drugs and suicide. This one girl told me she got a bunch of pills, went into the bathroom, and was about to swallow them, but then thought of me. She told me that what went through her mind was: "Would Ruthie do something like this?" She realized I wouldn't, and she didn't take the pills. She told me the reason she was sad was because she had a best friend who ditched her and she felt like her world was falling apart. I was moved by it. I wrote her back a two-page letter. I told her that at 14, you have your whole life ahead of you. I'm 22, and I feel like I have my whole life ahead of me.

Graduating is one of the most important things that I'm going to do. After that, anything is possible. I'm going to move to Los Angeles. I'd like to do commercials and be in videos and publish a book with my poetry in it.

The Real World has made being back in college strange. The craziest thing is when people I haven't seen for a while come up to me and say something like, "I don't know if you remember me, but..." It's like they think I get on television and forget who I am and who everyone in my life is! People act like I'm going to be stuck-up. I even had a teacher tell me, "You know you're nothing special."

I want to get past *The Real World.* People feel like they identify with the me they saw on the show, but you know what? I'm so much cooler than that! Seriously, half of who I am was on *The Real World.* I'm not being conceited, but I think that if people really got to know me they'd love me.

RUTHiE

FAVORITE MOMENT
I would say the first episode, when I jump into the pool naked. I remember what it felt like, that moment. That and snorkeling in Maui with Colin. I love the outdoors!

LEAST FAVORITE MOMENT
Falling at the bar and everything that happened after that. That was the worst thing to watch. I didn't even know what had gone on, and then *bam!* I'm watching it four months later.

FASHION GOOD
I thought I looked fine. Whatever!

FASHION BAD
My biggest fashion regret: having too many black G-strings. I should have made it more colorful, so people didn't think I have the same underwear. Now I even wear designs.

CRINGE
How does it feel watching myself getting kicked out? It was like it wasn't me. I was sitting there, feeling like, "Wow, those roommates suck." I was rooting for me, thinking "F**k these guys. They're a bunch of boring f***s."

ON THE STREET
On the street, people just scream "Ruthie" at me. I was at a Mariah Carey concert, and this girl almost passed out. She kept screaming: "I'm obsessed with Hawaii!" She kept fanning herself. She told me I was her ultimate *Real World*-er. I just grabbed her and hugged her and told her to calm down.

People mostly ask me if I still party. Or they want to know, "Does Amaya really cry that much?" I don't really get asked questions about the other cast members that much.

KEEPING IN TOUCH

I don't feel like I got to know Teck until after the show, and now I consider us friends. We've seen each other. Kaia acts weird whenever I see her. Amaya I saw at the Reunion. Colin, I hear that he's stuck-up, thinks he's too good and stuff. Matt, he just disappeared off the face of the earth. I heard he didn't come to the Reunion because he wants to move on, put the experience behind him.

Of all people, I'm the person who's supposed to have issues. I'm the one who should be boycotting the Reunion. But I wouldn't even consider that. They're all just wimps!

TO FUTURE *REAL WORLD*-ERS

I guess, if you want to "come off well," then follow Teck's lead. He came off the best, definitely. He gave them only what he wanted to. He was never really on camera, and for him, that was the smartest thing he could have ever done.

FAMILY AFFAIR

My dad saw me in *Rolling Stone,* and he framed it. He and I never used to talk, but because of *The Real World*, we're back in touch. My dad and I have a great relationship now.

My sister Sara graduated from college, and I haven't spoken to Rachel since the show—but I will soon. I feel slightly resentful after the way she was in Hawaii. I mean, she wrote Matt a six-page love letter during the show. It's like I'm getting kicked out of the show and Rachel's all after Matt. Matt's after Sara. And Sara's the only one saying, "I just want to be there for you, Ruthie."

LOVE AFTER *THE REAL WORLD*

I talk to Jess all the time. She's still one of my best friends, though she's going out with someone else. I know people might think it's weird that we have this friendship after going out, but I'm going to keep in touch with her for life. If she needed me, I'd be there. If I needed her, she'd come running. She's that kind of friend.

No, I'm no longer in contact with Malo. Let's just say that after *The Real World* aired, I wasn't so interested.

What's my love life like now? Oh my God. It's a whirlwind. My friends can't keep up. It's like who? Which one? Who are you dating? Is that the same one as last night? I guess I'm just exploring my options. I'm a single girl at heart, but who knows? Maybe one day I'll settle down. Maybe someone will sweep me off my feet.

Dear Readers: ❧ Here's an application to be on *The Real World*. We're hoping that if you're interested in being on the show (and you appear to be between the ages 18 and 24), you'll fill it out. Be honest, and sincere, and tell us what issues are of interest to you. Show us why you should be on *The Real World*. ❧ And to the readers who are not interested in being on the show: Why not fill it out anyway? It'll give you insight into the casting process—after all, all previous cast members had to fill this out. And, hey, you might learn something.... ❧ Good luck!

How to get on THE REAL WORLD

Mary-Ellis Bunim and Jonathan Murray

How can you do this? Read on for step-by-step directions.

Call *The Real World* Hotline: (818) 754-5790 or check out the Bunim/Murray Productions Web site at www.bunim-murray.com.
This number will give you the latest information on applying, the deadlines for next season, and where to send your application.

Write a cover letter.

We want you to tell us a little bit about yourself. Why do you want to spend six months in a house full of strangers? What activities will you pursue? Please include a snapshot of yourself in this cover letter.

Make a videotape.

We'd also like to see you as well as hear from you. Make a ten-minute videotape of yourself talking about whatever you think makes you a good candidate for *The Real World*. Remember, we want to see if you are a person who is open and willing to express what's important to you.

Sometimes, the best videos are simple—like someone sitting on their bed talking about what makes them tick. Just be honest and sincere. And don't overthink it. (Also, make sure there's enough light on your face and that you're close enough to the microphone to be heard.)

Fill out the enclosed application.

Answer all the following questions as honestly as you can. Please keep your answers to a paragraph in length. And please be sure to type your answers or write legibly.

DATE RECEIVED:

NAME: ADDRESS:

PHONE: E-MAIL ADDRESS:

SOCIAL SECURITY NO.:

PARENTS' NAMES:

ADDRESS: PHONE: E-MAIL ADDRESS:

SIBLINGS (NAMES AND AGES):

RACE (OPTIONAL: FOR STATISTICAL PURPOSES ONLY):

HAVE YOU EVER ACTED OR PERFORMED OUTSIDE OF SCHOOL?

EDUCATION: NAME OF HIGH SCHOOL: YEARS COMPLETED:

NAME OF COLLEGE: YEARS COMPLETED AND MAJORS:

OTHER EDUCATION:

WHERE DO YOU WORK? DESCRIBE YOUR JOB HISTORY:

WHAT IS YOUR ULTIMATE CAREER GOAL?

WHAT ARE YOUR PERSONAL (NOT CAREER) GOALS IN LIFE?

WHAT KIND OF PRESSURE DO YOU FEEL ABOUT MAKING DECISIONS ABOUT YOUR FUTURE? WHO'S PUTTING THE PRESSURE ON YOU?

WHO ARE YOUR HEROES AND WHY?

WHAT ABOUT YOU WILL MAKE YOU AN INTERESTING ROOMMATE?

IF YOU'RE LIVING WITH A ROOMMATE, HOW DID YOU HOOK UP WITH HIM OR HER? TELL US ABOUT HIM OR HER AS A PERSON.
DO YOU GET ALONG? WHAT'S THE BEST PART ABOUT LIVING WITH HIM OR HER? WHAT'S THE HARDEST PART ABOUT IT?

HOW WOULD SOMEONE WHO REALLY KNOWS YOU DESCRIBE YOUR BEST TRAITS?

The Real World Application Form

155

HOW WOULD SOMEONE WHO REALLY KNOWS YOU DESCRIBE YOUR WORST TRAITS?

DESCRIBE YOUR MOST EMBARRASSING MOMENT IN LIFE:

DO YOU HAVE A BOYFRIEND OR GIRLFRIEND? HOW LONG HAVE YOU TWO BEEN TOGETHER? WHERE DO YOU SEE THE RELATIONSHIP GOING? WHAT DRIVES YOU CRAZY ABOUT THE OTHER PERSON? WHAT'S THE BEST THING ABOUT THE OTHER PERSON?

HOW IMPORTANT IS SEX TO YOU? DO YOU HAVE IT ONLY WHEN YOU'RE IN A RELATIONSHIP OR DO YOU SEEK IT OUT AT OTHER TIMES? HOW DID IT COME ABOUT ON THE LAST OCCASION?

DESCRIBE YOUR FANTASY DATE:

WHAT QUALITIES DO YOU SEEK IN A MATE?

WHAT ARTISTIC TALENTS DO YOU HAVE (MUSIC, ART, DANCE, PERFORMANCE, FILM/VIDEO MAKING, WRITING, ETC.)? HOW SKILLED ARE YOU?

DO YOU LIKE TRAVELING? DESCRIBE ONE OR TWO OF THE BEST OR WORST TRIPS YOU HAVE TAKEN. WHERE WOULD YOU MOST LIKE TO TRAVEL?

WHAT DO YOU DO FOR FUN?

DO YOU PLAY ANY SPORTS?

WHAT ARE YOUR FAVORITE MUSICAL GROUPS/ARTISTS?

DESCRIBE A TYPICAL FRIDAY OR SATURDAY NIGHT:

WHAT WAS THE LAST UNUSUAL, EXCITING, OR SPONTANEOUS OUTING YOU INSTIGATED FOR YOU AND YOUR FRIENDS?

OTHER THAN A BOYFRIEND OR GIRLFRIEND, WHO IS THE MOST IMPORTANT PERSON IN YOUR LIFE RIGHT NOW? TELL US ABOUT HIM OR HER:

WHAT ARE SOME WAYS YOU HAVE TREATED SOMEONE WHO HAS BEEN IMPORTANT TO YOU THAT YOU ARE PROUD OF?

WHAT ARE SOME OF THE WAYS YOU HAVE TREATED SOMEONE WHO HAS BEEN IMPORTANT TO YOU THAT YOU ARE EMBARRASSED BY, OR WISH YOU HADN'T DONE?

IF YOU HAD TO DESCRIBE YOUR MOTHER (OR YOUR STEPMOTHER, IF YOU LIVED WITH HER MOST OF YOUR LIFE AS A CHILD), BY DIVIDING HER PERSONALITY INTO TWO PARTS, HOW WOULD YOU DESCRIBE EACH PART?

IF YOU HAD TO DESCRIBE YOUR FATHER (OR YOUR STEPFATHER), BY DIVIDING HIS PERSONALITY INTO TWO PARTS, HOW WOULD YOU DESCRIBE EACH PART?

HOW DID YOUR PARENTS TREAT EACH OTHER? DID YOUR PARENTS HAVE A GOOD MARRIAGE? WHAT WAS IT LIKE?

DESCRIBE HOW CONFLICTS WERE HANDLED AT HOME AS YOU WERE GROWING UP (WHO WOULD WIN AND WHO WOULD LOSE, WHETHER THERE WAS YELLING OR HITTING, ETC.)?

IF YOU HAVE ANY BROTHERS OR SISTERS, ARE YOU CLOSE? HOW WOULD YOU DESCRIBE YOUR RELATIONSHIP WITH THEM?

DESCRIBE A MAJOR EVENT OR ISSUE THAT'S AFFECTED YOUR FAMILY:

DESCRIBE A QUALITY/TRAIT THAT RUNS IN YOUR FAMILY:

WHAT IS THE MOST IMPORTANT ISSUE OR PROBLEM FACING YOU TODAY?

IS THERE ANY ISSUE, POLITICAL OR SOCIAL, THAT YOU'RE PASSIONATE ABOUT? HAVE YOU DONE ANYTHING ABOUT IT?

DO YOU BELIEVE IN GOD? ARE YOU RELIGIOUS OR SPIRITUAL? DO YOU ATTEND ANY FORMAL RELIGIOUS SERVICES?

WHAT ARE YOUR THOUGHTS ON: ABORTION?

OTHER SEXUAL ORIENTATIONS?

WELFARE?

AFFIRMATIVE ACTION?

DO YOU HAVE ANY HABITS WE SHOULD KNOW ABOUT?

DO YOU: SMOKE CIGARETTES?

DRINK ALCOHOL? HOW OLD WERE YOU WHEN YOU HAD YOUR FIRST DRINK? HOW MUCH DO YOU DRINK NOW? HOW OFTEN?

DO YOU USE RECREATIONAL DRUGS? WHAT DRUGS HAVE YOU USED? HOW OFTEN?

THE REAL WORLD AND _ROAD RULES_ HAVE A ZERO TOLERANCE DRUG POLICY. IF YOU USE DRUGS, CAN YOU GO WITHOUT FOR SEVERAL MONTHS?

DO YOU KNOW A LOT OF PEOPLE WHO DO DRUGS? WHAT DO YOU THINK OF PEOPLE WHO DO DRUGS?

ARE YOU ON ANY PRESCRIPTION MEDICATION? IF SO, WHAT, AND FOR HOW LONG HAVE YOU BEEN TAKING IT?

HAVE YOU EVER BEEN ARRESTED? (IF SO, WHAT WAS THE CHARGE AND WERE YOU CONVICTED?)

WHAT BOTHERS YOU MOST ABOUT OTHER PEOPLE?

DESCRIBE A RECENT MAJOR ARGUMENT YOU HAD WITH SOMEONE. WHO USUALLY WINS ARGUMENTS WITH YOU? WHY?

HAVE YOU EVER HIT ANYONE IN ANGER OR SELF-DEFENSE? IF SO, TELL US ABOUT IT (HOW OLD WERE YOU, WHAT HAPPENED, ETC.)

IF YOU COULD CHANGE ONE THING ABOUT THE WAY YOU LOOK, WHAT WOULD THAT BE?

IF YOU COULD CHANGE ONE THING ABOUT YOUR PERSONALITY, WHAT WOULD THAT BE?

IF SELECTED, IS THERE ANY PERSON OR PART OF YOUR LIFE YOU WOULD PREFER NOT TO SHARE? IF SO, DESCRIBE
(I.E.: FAMILY, FRIENDS, BUSINESS ASSOCIATES, SOCIAL ORGANIZATIONS, OR ACTIVITIES)

IS THERE ANYONE AMONG YOUR FAMILY OR CLOSE FRIENDS WHO WOULD OBJECT TO APPEARING ON CAMERA? IF SO, WHY?

ARE YOU NOW SEEING, OR HAVE YOU EVER SEEN, A THERAPIST OR PSYCHOLOGIST?

WHAT IS YOUR GREATEST FEAR (AND WHY)?

IF YOU HAD ALADDIN'S LAMP AND THREE WISHES, WHAT WOULD THEY BE?

PLEASE RATE THE FOLLOWING ACTIVITIES/PASTIMES USING THE FOLLOWING SCALE: N: NEVER S: SOMETIMES O: OFTEN A: ALWAYS

	RATING	COMMENT
READ BOOKS		
SLEEP 8 HOURS		
WATCH TELEVISION DAILY		
SHOP		
GO OUT/SOCIALIZE		
SPEND TIME WITH FRIENDS		

	RATING	COMMENT
SPEND TIME ALONE		
WORK/STUDY		
TALK ON THE PHONE		
COOK		
CLEAN		
ARGUE		
WRITE		
READ NEWSPAPERS		
ENJOY THE COMPANY OF ANIMALS		
STATE OPINIONS		
ASK OPINIONS		
CONFIDE IN YOUR PARENTS		
VOLUNTEER		
PROCRASTINATE		
EAT		
DRINK ALCOHOL		
DIET		
SMOKE		
CRY		
LAUGH		
MOVIES		
THEATRE		
CLUBS		
PARTIES		

The Real World Application Form

LIST 4 PEOPLE WHO HAVE KNOWN YOU FOR A LONG TIME (EXCLUDING RELATIVES) AND WILL TELL US WHAT A GREAT PERSON YOU ARE: (PLEASE INCLUDE TWO ADULTS AND TWO OF YOUR FRIENDS).

1. NAME	ADDRESS	PHONE	HOW DO THEY KNOW YOU?
2. NAME	ADDRESS	PHONE	HOW DO THEY KNOW YOU?
3. NAME	ADDRESS	PHONE	HOW DO THEY KNOW YOU?
4. NAME	ADDRESS	PHONE	HOW DO THEY KNOW YOU?

HOW DID YOU HEAR ABOUT OUR CASTING SEARCH?

SIGNATURE DATE

Thank you for your time and effort in completing this form.

IT DOESN'T GET ANY MORE REAL THAN THIS!

It's the *real world* behind *THE REAL WORLD!*
Check out what happened when things got a little too "real" for TV...

In "*The Real World You Never Saw: New Orleans,*" watch the cast in their most intimate moments, with footage they don't even know exists!

In "*The Real World's Greatest Fights,*" check out the greatest screaming matches in *Real World* history, with unedited, in-your-face altercations from your favorite cast members.

Pick-up these and other *Real World* videos, including *The Real World Vacations: Behind The Scenes; The Real World Reunion;* and *The Real World You Never Saw* I, II (Boston and Seattle), and III (Hawaii)!